FORCE OF NATURE

A Celebration of Girls and Women Raising Their Voices

FORCE OF NATURE

KATE T. PARKER

WORKMAN PUBLISHING • NEW YORK

Workman
Workman Publishing
Hachette Book Group, Inc.
1290 Avenue of the Americas
New York, NY 10104
workman.com

Workman is an imprint of Workman Publishing, a division of Hachette Book Group, Inc. The Workman name and logo are registered trademarks of Hachette Book Group, Inc.

Design by Lisa Hollander and Sarah Smith
Cover design by Sarah Smith
Cover photo by Kate T. Parker

The publisher is not responsible for websites (or their content) that are not owned by the publisher.

The Hachette Speakers Bureau provides a wide range of authors for speaking events. To find out more, go to hachettespeakersbureau.com or email HachetteSpeakers@hbgusa.com.

Workman books may be purchased in bulk for business, educational, or promotional use. For information, please contact your local bookseller or the Hachette Book Group Special Markets Department at special.markets@hbgusa.com.

Library of Congress Cataloging-in-Publication Data is available.

ISBN 978-1-5235-0552-4

First edition January 2024

Printed in China on responsibly sourced paper.

10 9 8 7 6 5 4 3 2 1

Dedicated to all the girls and women who have ever questioned using their voices and the ones who have inspired me to find my own. This book is for you.

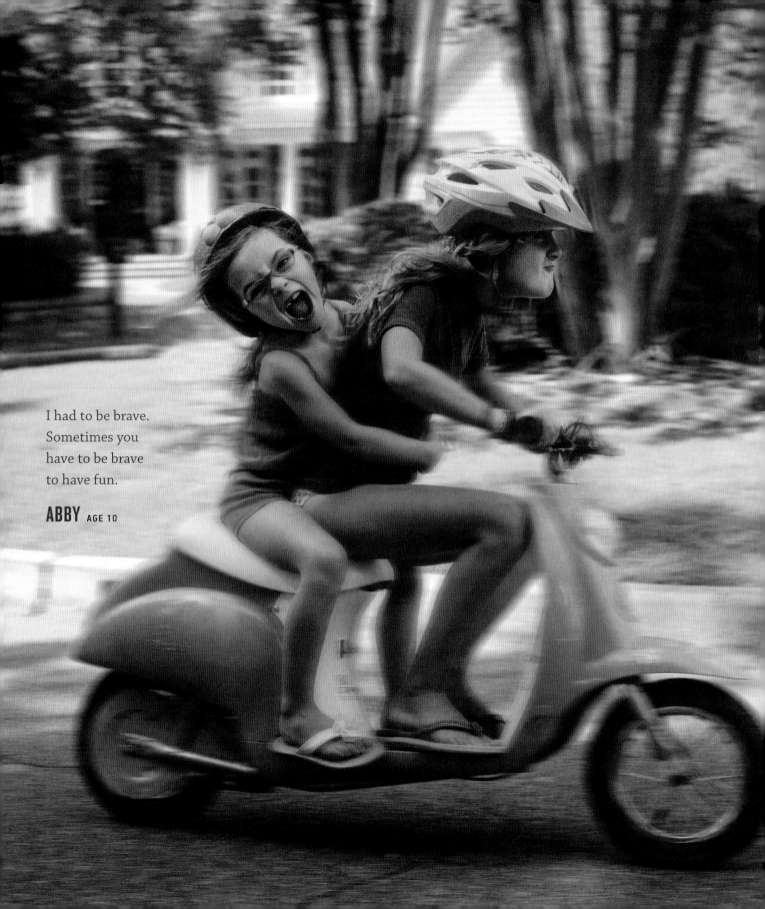

I had to be brave. Sometimes you have to be brave to have fun.

ABBY AGE 10

CONTENTS

INTRODUCTION

I FIRST PICKED UP A CAMERA not long after my oldest daughter was born, eighteen years ago. It felt as if something clicked in me (almost literally). I loved making images and sharing stories of what it was like to be young, confident, and free. I found my calling and means of expression in celebrating kids, especially girls, authentically. My first book, *Strong Is the New Pretty*, started as a project to encourage my own two girls to know that they are enough just as they are and that being who they are is enough. I've been photographing with that in mind ever since. My hobby soon turned into a passion and then into a career. Yes, it took me until I was in my thirties to find my "thing," but I am so grateful. This is my fifth book that celebrates the voices and stories of my subjects alongside images of them being themselves. I love helping to amplify their stories, told in their own words. It's the best part of what I do, and it is how I use my own voice.

As a woman and a mother to two girls, I have seen how the world tries to fit us into narrow categories with low expectations. I grew up hearing that girls are "made of sugar and spice and everything nice." I grew up in a world that suggested that girls and women be complacent and agreeable. "Don't be too loud or make a spectacle of yourself, please," society seems to say. I did not want this for myself or my girls. In fact, I wanted the opposite—I wanted to hear girls' and women's voices shouting from the rooftops! I didn't want my daughters (or any other girls, for that matter) to think they needed to stifle their thoughts, opinions, or expressions to be accepted.

The power of the female voice inspired this book. After photographing, interviewing, and showcasing thousands of people over my career, I saw firsthand how one voice can effect change. Our girls have the power to change their world and *the* world. They just need to fully realize it.

And yet, the phrase "If you can't see it, you can't be it" lingers in my mind. Representation matters. I want anyone reading this book to be inspired by the courage and strength of the girls and women featured in these pages and know that you, too, can advocate for yourself and others. These are just some of the girls and women who are speaking up, speaking out, and making change for themselves and the world around them. My hope is that you recognize yourself in their words and are able to acknowledge your own power and agency to create change.

Why celebrate girls' and women's voices, specifically? Dissenters might argue that we are all humans and should celebrate all voices. Of course we are and we should, but context is everything, and this is about equity. And when women's voices are heard and considered, society as a whole improves. United Nations research on panchayats (local councils) in India discovered that the number of drinking water projects in areas with women-led councils was 62 percent higher than in those with men-led councils. In Norway, a direct causal relationship between the presence of women in municipal councils and childcare coverage was found. Women routinely demonstrate political leadership by working across party lines—even in the most politically combative environments—by championing issues such as the elimination of gender-based violence, parental leave and childcare, pensions, gender-equality laws, and electoral reform.

Our voices matter. We, as women, need to remember that. *Force of Nature* is about celebrating that expression of self. It is not my place to define what female means. But it is my supreme honor to document, share, and amplify what it means to those I photograph, and how it feels for them to express it. In the moments we speak up for the first time; the moments we go against the crowd; the moments we find ourselves leading or otherwise commanding the room; the moments we put our true selves out there for criticism and praise, or shed light on injustice, or decide that the status quo isn't working for us anymore. The moments we decide that enough is enough.

This is a book about inspiration. About taking that breath, full of uncertainty, and then, despite the doubt and despite the discomfort, letting go and making ourselves heard, whether through writing, song, movement, images—or simply by speaking out loud. The portraits in this collection are about the sometimes indescribable moments when girls and women make change, however small or large, in an instant, in their own bodies, and in the world. I'd like to say that it's courage that is needed to become a force of nature. But truly, it's power and freedom—and when that combination and balance is achieved, we roar. We can be stronger than we ever imagined. We can be more than just a force to be considered; we can be one to be reckoned with. We are a force of nature.

Growing up Black in a predominately white area, I developed many insecurities and experienced feelings of isolation. As I've gotten older, I've found that my voice and presence can be powerful in helping others feel included in the communities I'm a part of.

KAMI AGE 15

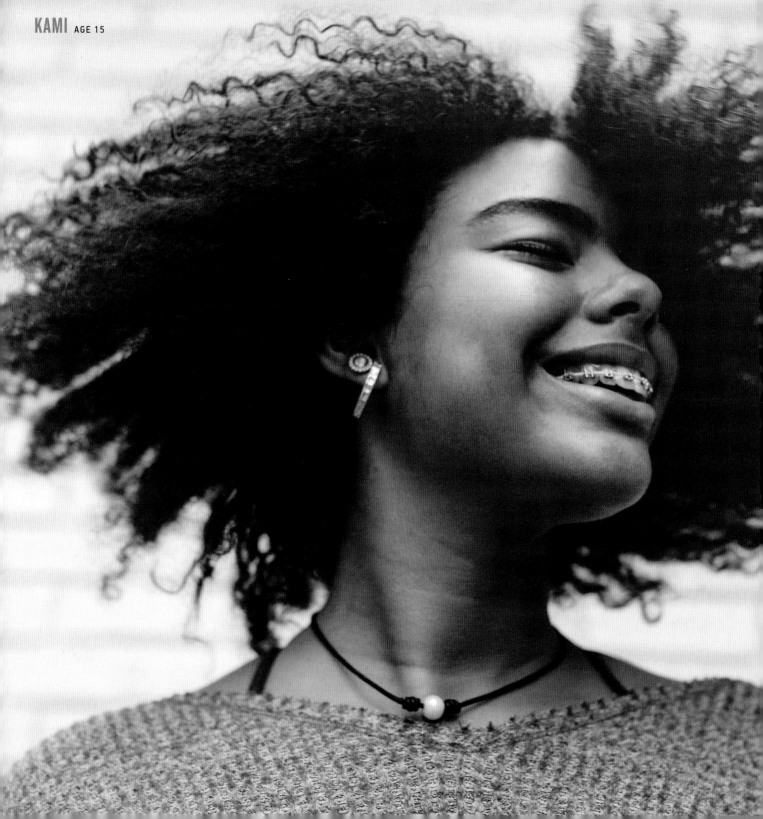

FIND YOUR VOICE

THERE IS A MOMENT WHEN WE ALL FIND OURSELVES. We see, overhear, or are a part of something that just doesn't feel right. We can feel that sense of "not right-ness" all around and deep in our gut, and what we choose to do next is everything. We choose to remain silent, or we choose to speak up.

This book is about celebrating the courage it takes to find that voice. It can be hard to hear and even harder to use—which is why it is so worth celebrating the act of speaking up. The girls and women in this chapter are doing just that. Whether it's the very first time they summoned the courage to speak up or the hundredth, they acknowledged the voice in their head that told them, "This isn't okay" or "You should say something" or "You can make a difference here"—and each time they honored that voice, it got stronger and more powerful. And so did they.

The girls and women in this chapter found their voice in individual ways, but that is not to say it was ever lost. At age seven, Amelia (page 45) has already discovered the power of her voice to turn up the volume for those who haven't found the volume knob yet. The path that Adrianne (page 10) has taken led her to awaken her most authentic self. Finding one's voice isn't about just listening to an inner monologue, it's about acting on it as well. It's about understanding that there may be consequences to voicing an opinion and speaking up anyway.

Being a force of nature goes beyond the initial discovery of your voice—it's the momentum that follows too. Like a storm, we are capable of gathering strength and changing course. We can grow and wane in intensity. Our voices can be as loud as a roar or as quiet as a whisper. Our voices can even take the form of a look of kindness or understanding aimed in the direction of someone in need. It's our ability to infuse that communication with a sense of urgency that wields power. Like gravity, we are a force.

It's not just about physical ability. It is part physical, part mental, and a lot of determination. If we don't speak up now, imagine what will happen in the future. We must change the world.

OLIVIA AGE 8

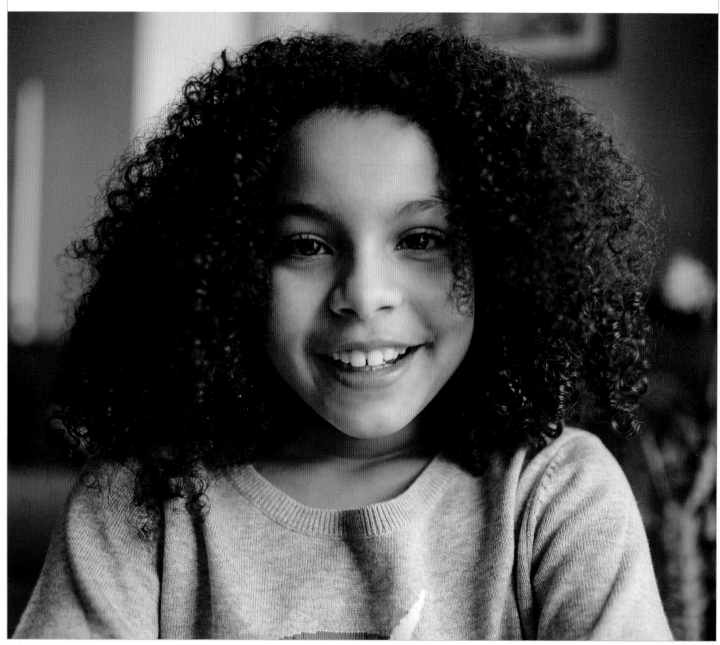

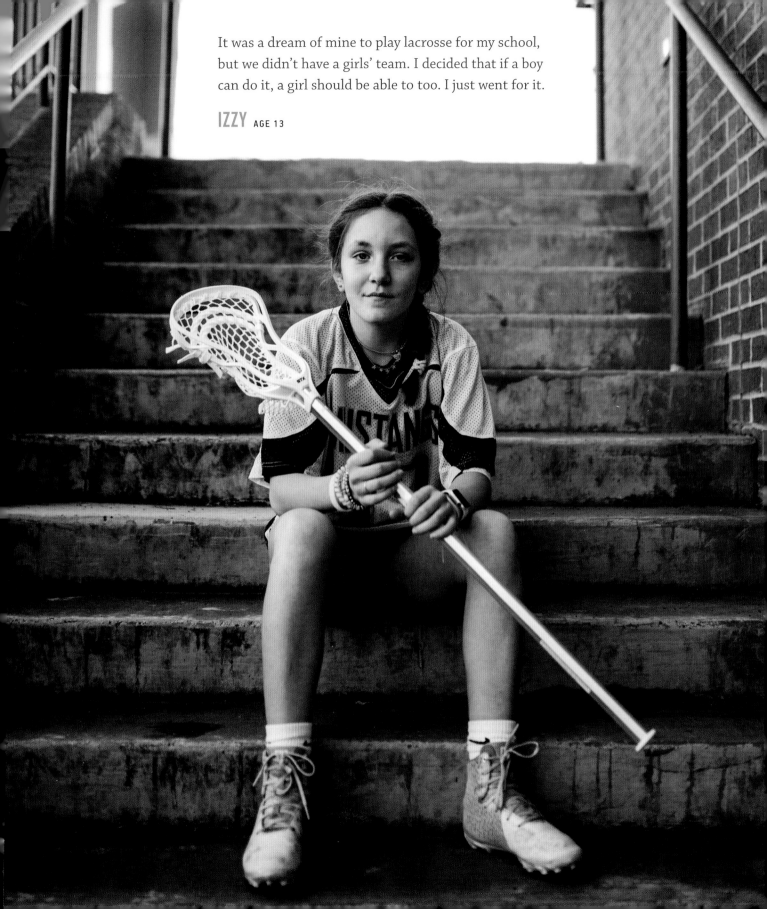

It was a dream of mine to play lacrosse for my school, but we didn't have a girls' team. I decided that if a boy can do it, a girl should be able to too. I just went for it.

IZZY AGE 13

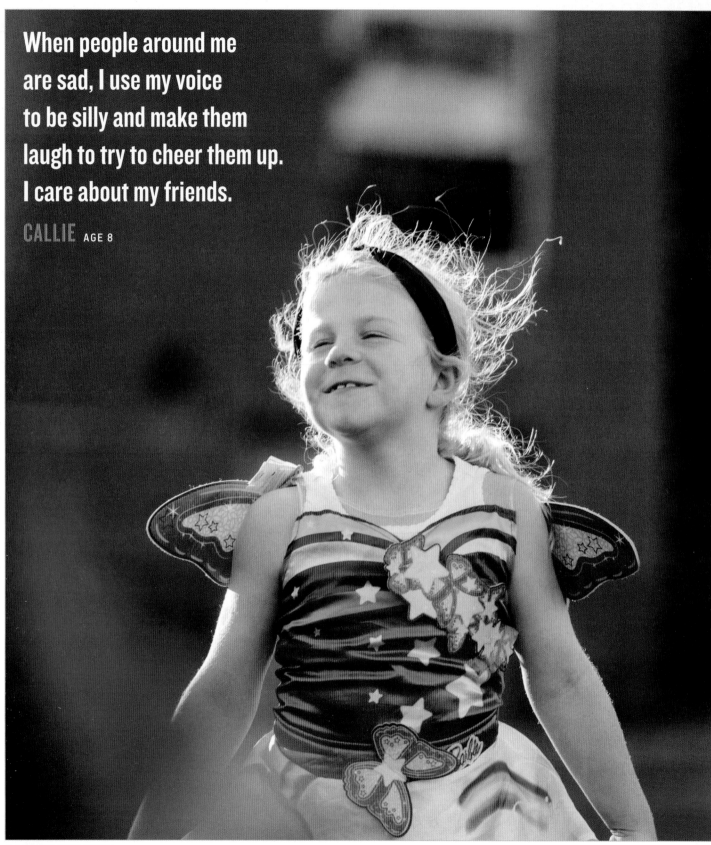

When people around me
are sad, I use my voice
to be silly and make them
laugh to try to cheer them up.
I care about my friends.

CALLIE AGE 8

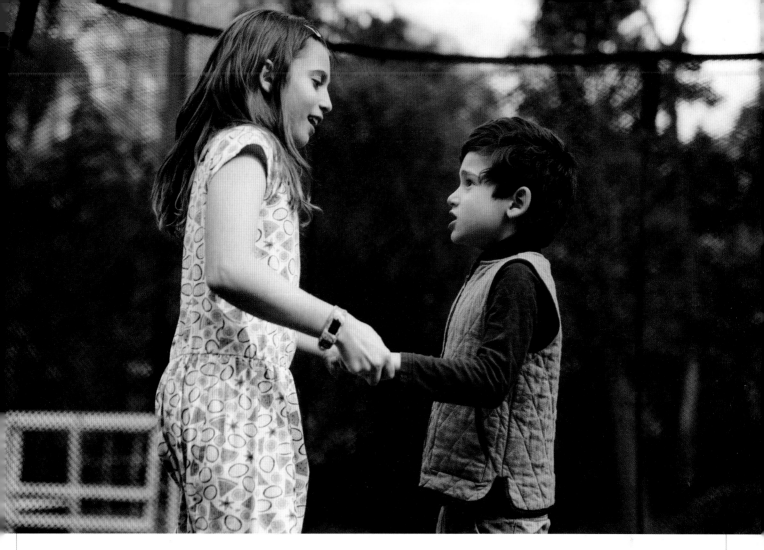

My brother lost his ability to talk after a high fever when he was little. I felt like I lost him, but during the pandemic, I learned how to connect with him through nature.

SALENA AGE 10 (WITH HER BROTHER, SOHAN, AGE 6)

Adventure sports have transformed my life in a magical way; they have helped me unleash my true potential. And now, through camp, I introduce sports as a powerful form of expression to little girls and women in Pakistan so that those who might be living my previous version of life can take charge of their own lives and realize what *they* are capable of.

SAMAR AGE 33

My sister and I both have dyslexia, which makes school harder for us. One time at the school library, they wouldn't allow me to get books at my reading level. So when I went back to class, I opened up a book and just stared at the pages because I couldn't read them. The next time, I told the librarian, and they allowed me to get the right books. My mom says I need to be the squeaky wheel all the time. But it got fixed. It makes me happy and angry.

ABBY AGE 10 (WITH HER SISTER, BRAELYN, AGE 12)

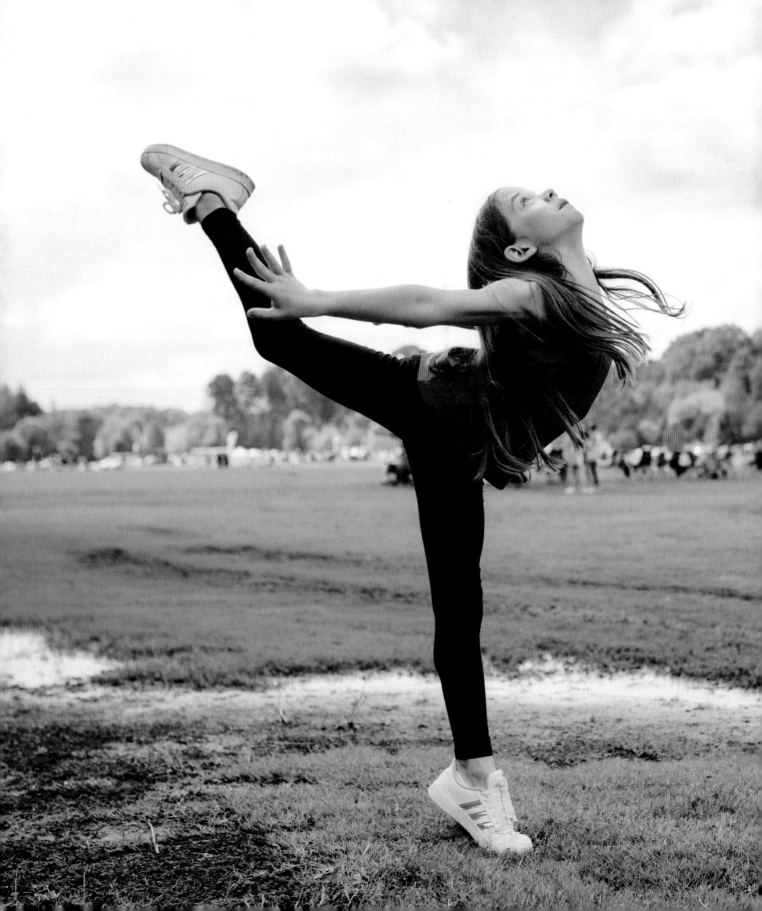

How I feel comes through when I am dancing. I choose the style of dance based on my emotion: When I am calm, I practice ballet or contemporary. But when I'm really happy or excited for something, I'll choose jazz.

HANA AGE 10

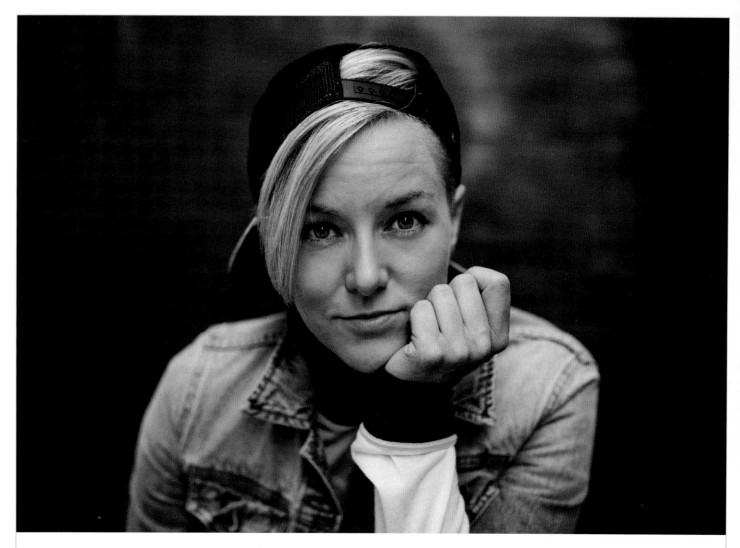

Learning to use my voice is knowing who I am and what I stand for, pursuing my most authentic self, and believing that I have worth and value exactly as I am. When I show up in these truths, using my voice is an act of honesty. And that's what I want: to be the constant creator of an honest life, which means the voice I offer to the world is magnificently as simple as that—my truth.

ADRIANNE AGE 37

I've used my voice by going to protests to end gun violence. The first March for Our Lives protest that I attended was on my fourteenth birthday, and I remember it vividly. Being surrounded by so many passionate people was incredible, and I carry that experience with me today. It taught me the importance of my voice—and that silence is part of the problem. My voice on its own might be small, but its impact is part of something much bigger. I believe in the saying "Slow progress is still progress." Change doesn't happen all at once. It's made up of tiny actions, and tiny moments every day.

MARIANA AGE 18

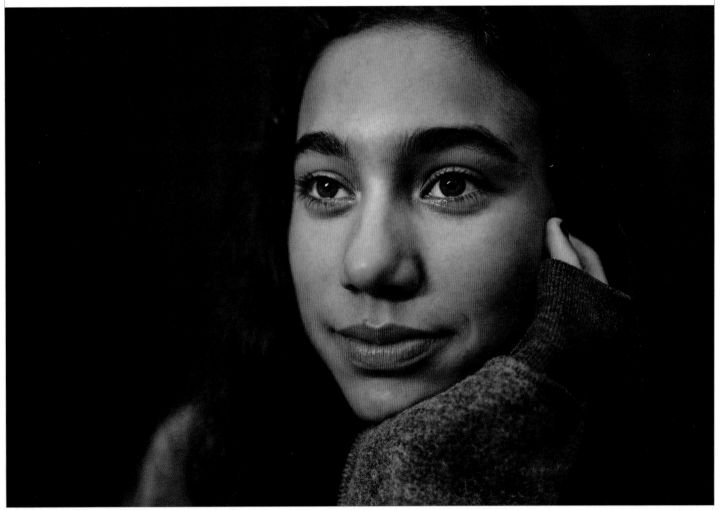

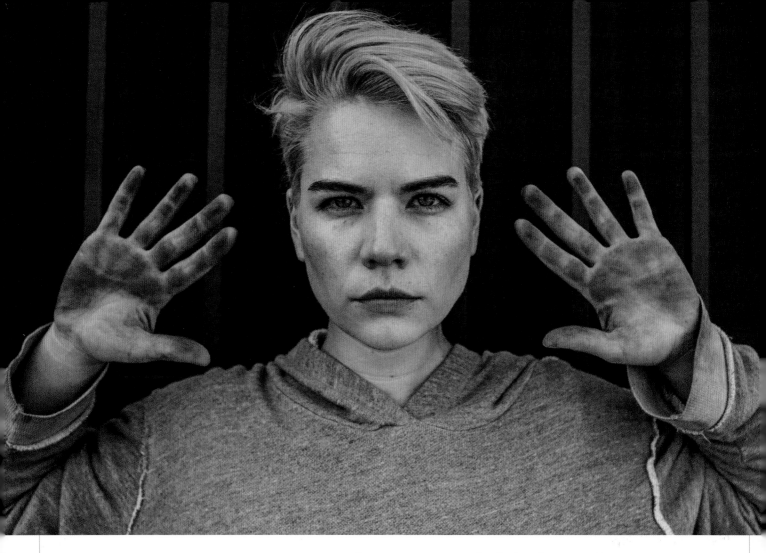

When I was younger I had a hard time finding my voice. I was a people pleaser, afraid to disagree with people and "rock the boat." I always found it easier to speak up on other people's behalf than to speak up for me. As I've gotten older, I've found my voice and know the importance to use it not only for myself, but for those who haven't found theirs yet. It's never wrong to speak up for what's right.

JENNIFER AGE 27

A lot of my friends are nonbinary or gender fluid. Some people are not open-minded about these things, so I've taken time to educate myself because I really care about my friends and want to be there for them. If someone is being disrespectful toward a friend, I try to help that person toward understanding, and if they seem like they can't or won't, I just tell them that it shouldn't affect them because it's not really their business.

CHELSY AGE 17

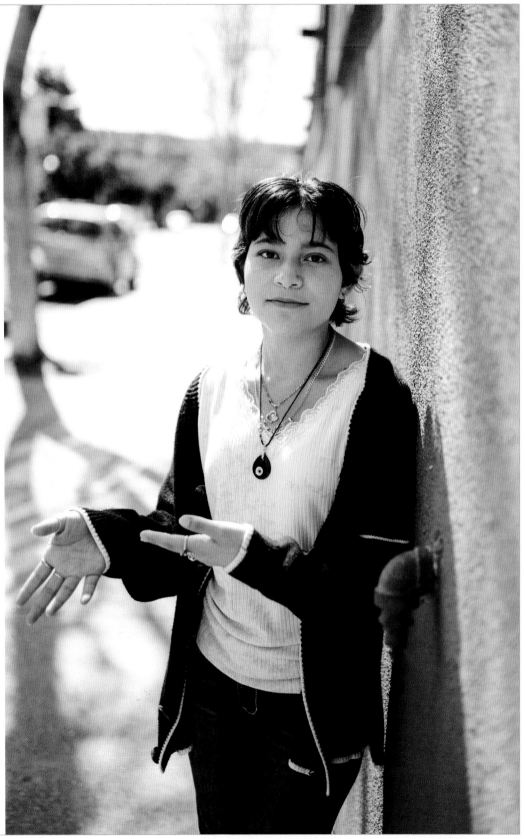

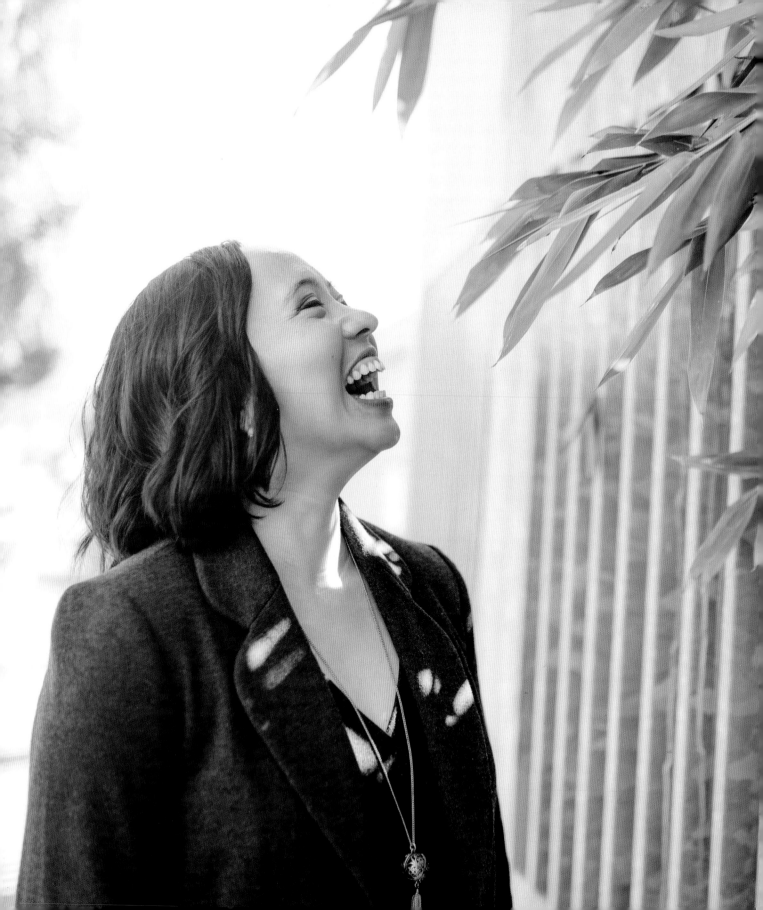

When I was younger, I was pretty shy about using my voice in school. But I gained confidence through debate and public speaking. Now through my nonprofit I work with youth, ages eight to eighteen, to help them advocate for issues that they care about and use their voices more confidently. My favorite part about someone "finding" their voice is the discovery that it was there the whole time—and the weirder and stranger and more unexpected and surprising their voice is, the more exciting it is to everyone else.

ANNMARIE AGE 38

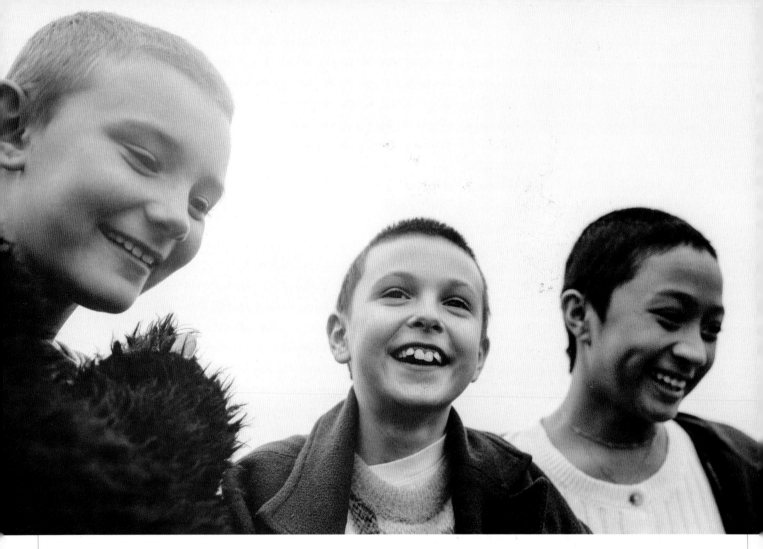

I strongly believe that people should be treated equally and nicely no matter what, so I always stand up for someone if they are being mistreated. Having to shave my head for an acting job taught me that I don't have to look like everyone else to be beautiful or feel good about myself. Being different is cool. I hope I'm always different!

HENDRIX AGE 11

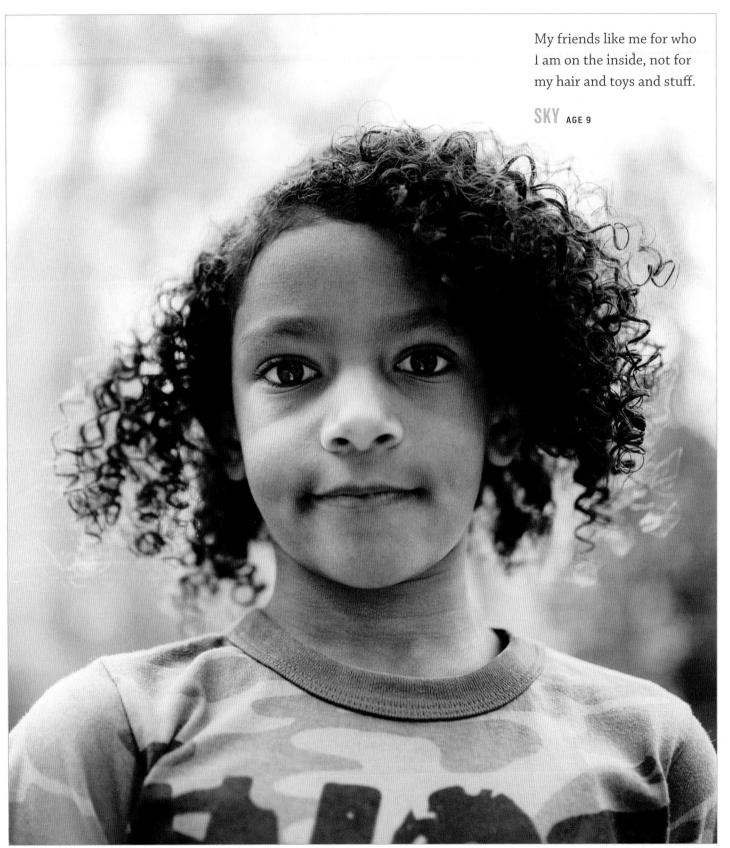

My friends like me for who I am on the inside, not for my hair and toys and stuff.

SKY AGE 9

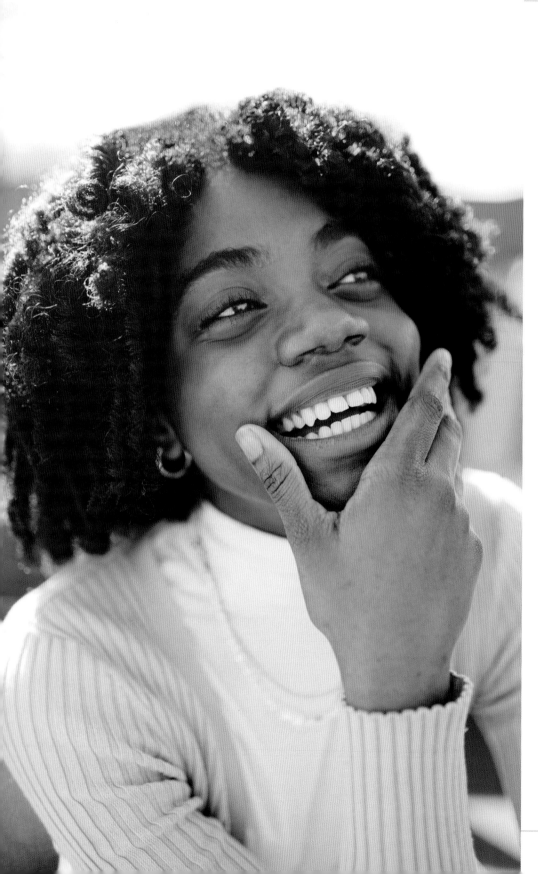

I never even knew I had curly hair. My hair was just always relaxed and straight. My sister went natural first, so she did most of the research. Because I'm younger, I copied whatever she did, so of course, I copied her hair. After my sister and I went natural, my mom was like, "What?" I think she really liked it though, because then she also went natural.

Honestly, I don't see myself as someone who speaks out much. I just try to be the best version of myself. And sometimes, just making a small change can inspire a chain reaction.

MERCY AGE 16

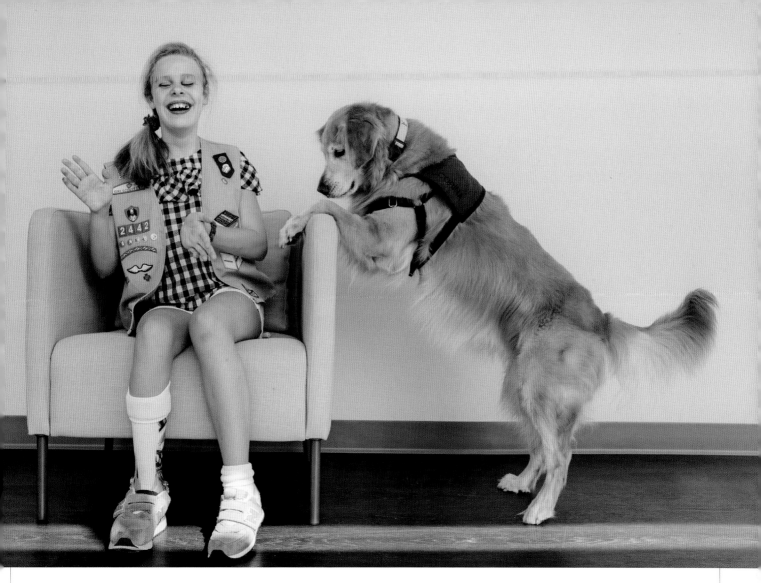

I prefer being called differently abled. I want to do anything my friends do and hope I can inspire others to be fearless.

SAMMIE AGE 13

Playing soccer has taught me confidence and encouraged me
to speak up. I use my voice to help those in need, to make my
community the best it can be. Everyone will hear my roar!

LEA AGE 13

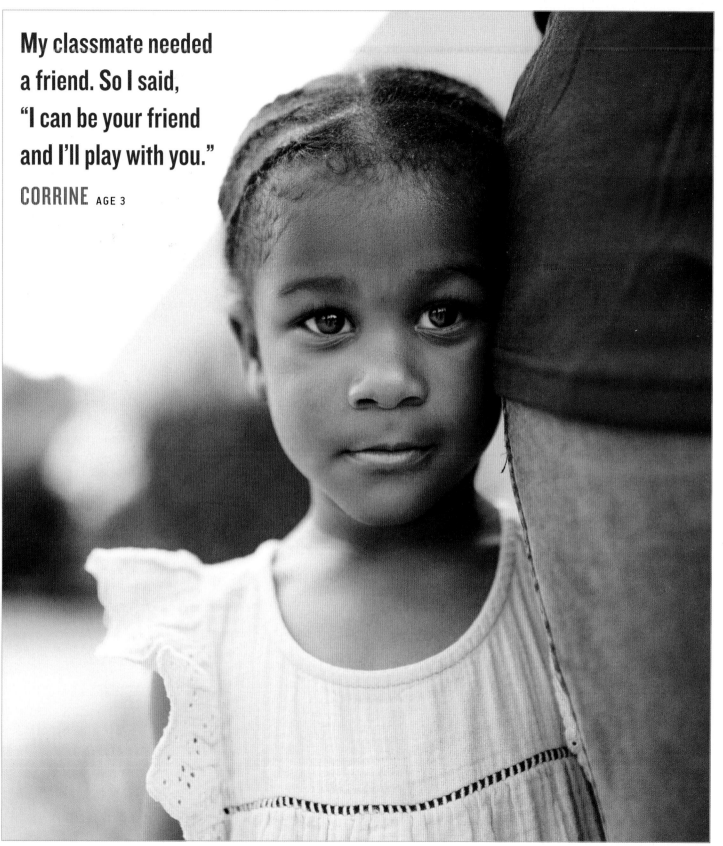

My classmate needed a friend. So I said, "I can be your friend and I'll play with you."

CORRINE AGE 3

ADI AGE 12

I LOVE PLAYING BASKETBALL. Before the start of one season, I went with my father and older brother to the mall to buy new basketball sneakers. I was really hoping that a store would have the new sneakers released by the WNBA's Mystics star Elena Delle Donne. They had just come out, and I wanted to see them and try to convince my dad to buy them!

Delle Donne is one of my role models. She is an incredible basketball player, but also, from what I can tell, an amazing human being. She helped design her signature sneakers with her older sister, Lizzie, in mind. Lizzie has special needs, and the sneakers have magnets and can fold open so that someone who may have difficulty putting shoes on can easily slide their feet into them.

We looked to see if Dick's Sporting Goods carried the shoes. We asked if they had Washington Mystics gear and Delle Donne sneakers. Unfortunately, they didn't have any Mystics merchandise at all, which was surprising since the Mystics had just won the WNBA championship and we were in a DC-area store. The store carried lots of Nationals gear, and they had just won a championship too. Store employees said they were working on getting attire from women's professional sports teams in their store.

We then decided to look in Foot Locker. When we entered, I asked an employee, "Do you have Elena Delle Donne sneakers?" He replied, "I do not know what that even means. What is Delle Donne? Is that a brand or something?" My dad and brother explained that she is a WNBA player on the Mystics and that she had just released new sneakers. The employee laughed and said, "I would rather watch paint dry on a wall than watch women play sports."

> This isn't just about equality. . . . It is also about sending the message to all girls and women that they are strong and that they matter.

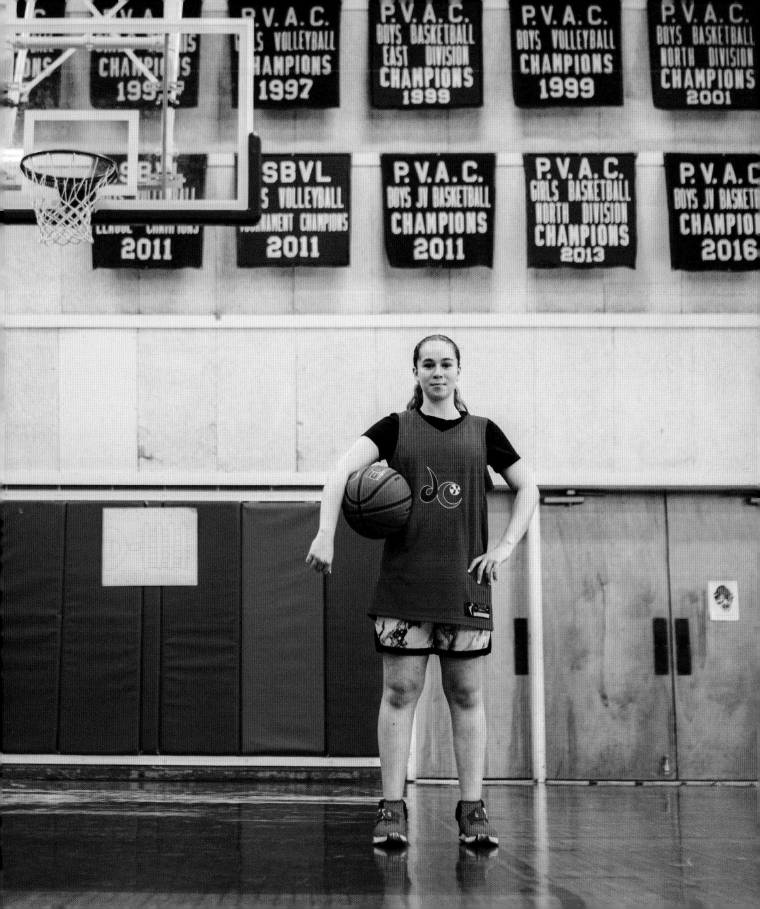

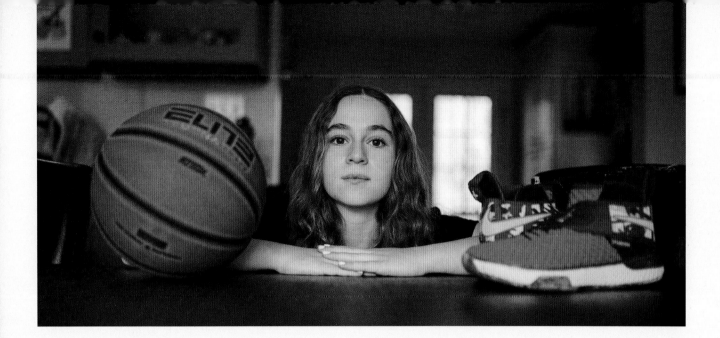

We were stunned. How could a grown man say something so offensive about women? How could he be so insensitive to a girl?

After we left the mall, I could not stop thinking about what that man had said to us. My dad sent a follow-up email to the customer care department at Foot Locker and even called the company later that day to report the incident. My dad simply asked if they would please send me an apology letter. They said that they would look into it and we were told there would be a response. My dad called several times over the next few weeks, and was told each time that they were dealing with the situation and that there would be a response. A few months went by and I never received an apology or any letter at all. Every time I passed the mall in the car, I remembered what that man said, and it hurt.

Encouraged by my mother, I decided to write an article to share my experience and use my voice to stand up for women. The article immediately went viral online, and that week, Foot Locker finally invited me to their store to apologize and set things right. Over the past couple years, I have had so many opportunities to share my story in schools, with organizations, and even on TV on the *Kelly Clarkson Show* and *Good Morning America*!

More importantly, Dick's Sporting Goods heard my story and created a Girl's Power Panel to help champion girls in sports. I continue to serve on the panel, and I love meeting with the other girls where we get to discuss sports issues, give input on products, and meet inspiring women role models. I am also now on the advisory board to HERicanes, an amazing organization that empowers girls in sports. Most recently, I was invited to donate a pair of my sneakers to the Smithsonian. They were included as part of an exhibit called "We Belong Here" at the National Museum of American History to celebrate the 50th anniversary of Title IX, which helped bring gender equality to education and sports.

I am grateful to share my story, to help bring awareness that womens' sports continue to be devalued in our society. In my opinion, athletic stores that have attire from professional teams should ensure that they have attire representing both men's and women's teams. In addition, so much more needs to be done to give employees diversity training so they can be more sensitive to issues of gender, as well as culture and race. This isn't just about equality and showing they care about women. It is also about sending the message to all girls and women that they are strong and that they matter.

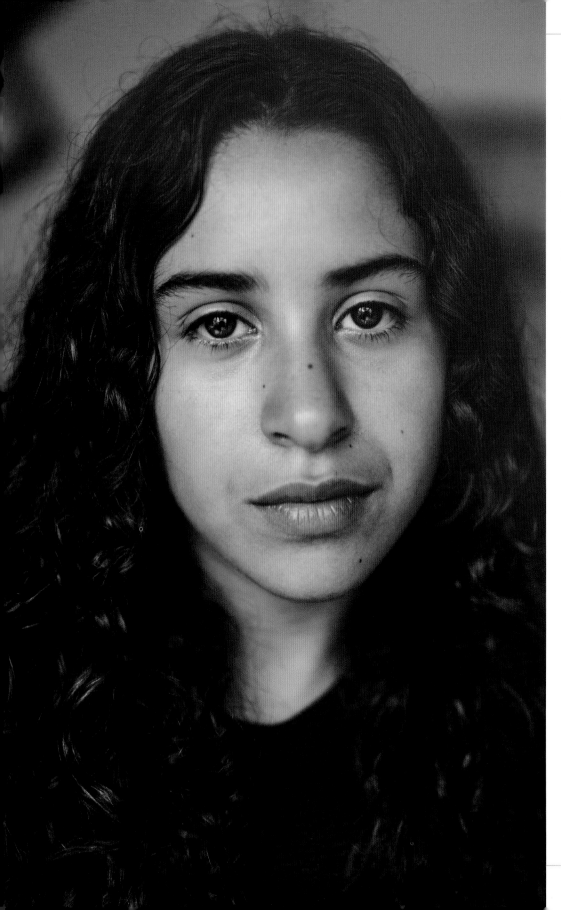

My mom is Puerto Rican, and my dad is part French, part Native American, and half Black. Growing up, I struggled a lot with not easily fitting in to any one group. I love embracing all my ethnicities, but it's really hard because other people have their own opinions. But as long as you know who you truly are—who you are on the inside—that's the thing that matters.

NA'ARAH AGE 13

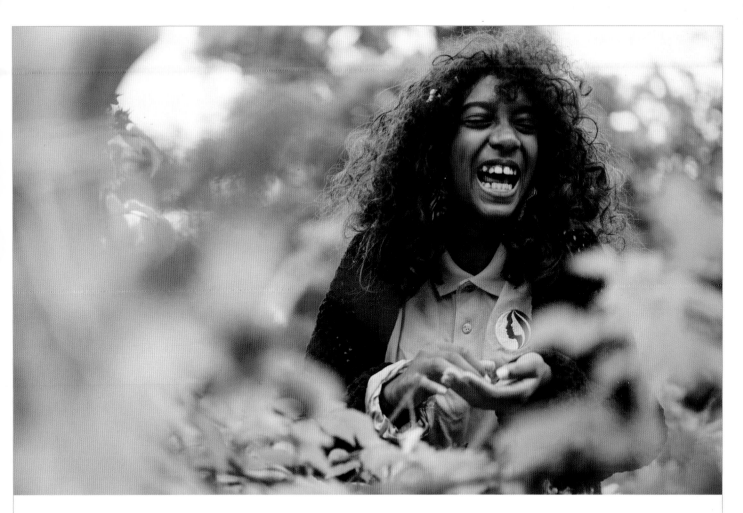

I used to be very rough and aggressive with people and plants but gardening has taught me to be more gentle. I was the sort of kid who ripped grass out of the ground for no reason. Now I've learned how to grow and be more gentle with plants, and it has also affected the way I interact with people. Gardening has been a comfort and sanctuary and a way to express myself. Whenever I'm working the earth, I'm never mad or moody. I'm just in a calm, balanced place.

MAIA AGE 11

You can be born confident,
or you can learn it. I don't
know which I am, but I don't
care. I like to talk, and I talk
a lot. I'm good at saying what
I think.

LEIGHTON AGE 11

IF I SEE SOMETHING THAT'S WRONG, I SAY SOMETHING. I REALLY DON'T WORRY ABOUT WHAT PEOPLE THINK ABOUT ME. IT'S IMPORTANT TO SPEAK UP IN CASE SOMEONE ELSE CAN'T.

TAYLA AGE 10

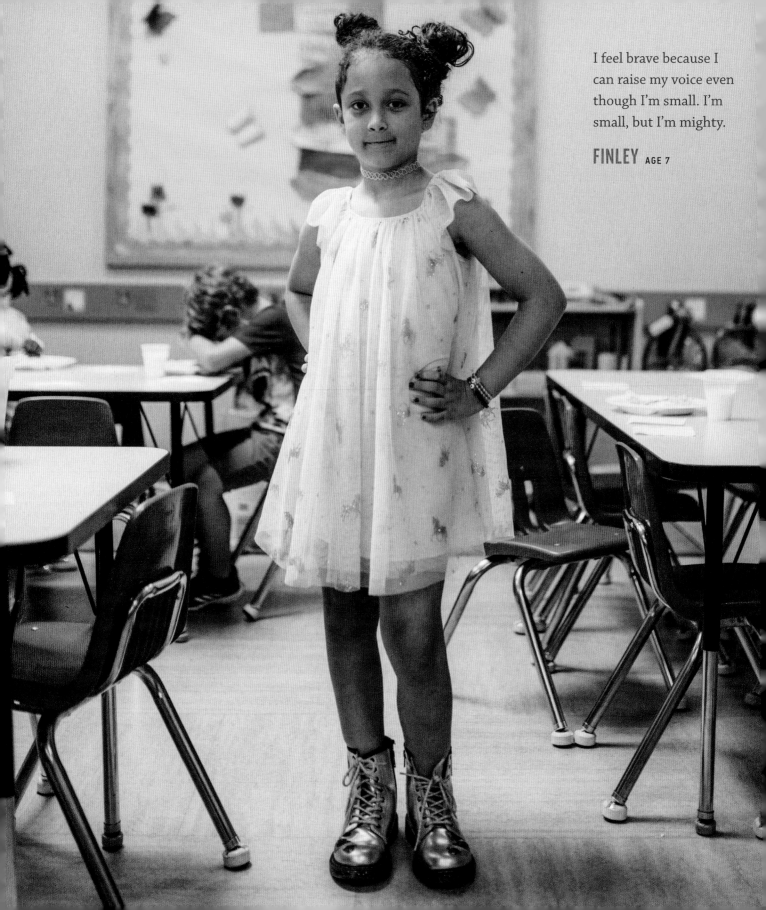

I feel brave because I can raise my voice even though I'm small. I'm small, but I'm mighty.

FINLEY AGE 7

Normally I'm the shy and quiet kid, but one day at school, one of my teachers was being rude to some of my classmates. As I watched the teacher single out the students, I felt like I needed to say something. I thought that since I was usually quiet, the teacher would listen to what I had to say. So, without even raising my hand, I called the teacher's name and said, "Give them a second chance; nobody is perfect, and sometimes we forget things." After that, the class was silent and very surprised that I had spoken up, and the teacher gave them a little bit of grace that day. I did that because I saw my friends' faces becoming red, and it looked like they were about to cry. I also did it because I have gotten second chances, and it feels good when people stand up for you.

CLAUDIA AGE 12

I don't speak out a lot, and when I do,
I don't use big words. I keep it simple.

HALEY AGE 10

BROOKE AGE 12

I JOINED THE SCOUTS IN 2020. We don't call it Boy Scouts anymore; it's just called Scouts, since they have allowed girls to be a part of it. A friend invited me to a meeting; her brother was a Scout, and she wanted to try it. Everyone was so friendly, and it seemed like something I would love, so I joined too. My mom was really encouraging. She loves outdoor stuff, like hiking and camping, and I really wanted to do more of that. We have meetings and outings. The outings are nice because you can go out and do things instead of just staying in your house for the weekend. It was just something that I thought was cool.

My troop is all girls, ages eleven to eighteen. I like that I get to interact with more people who aren't just my age but also share the same interests. We all love high adventure, having fun, and going hiking and camping. My favorite thing about Scouts is probably the outings— we do stuff like zip-lining or rock climbing. These girls are all no drama. I love that part of Scouts. It's so nice to have different friend groups, like kids at school or kids in my neighborhood and now kids in my troop!

I've learned so many things being a Scout. I learned how to survive if I were ever left alone in the woods and all the things that I should bring when hiking, like sunscreen and the ten essentials, which are a rope, food, water . . . there's a few others, like rain gear just in case it rains, and some spare clothing, because sometimes if you have bright clothing, you can tie it up on a tree so that

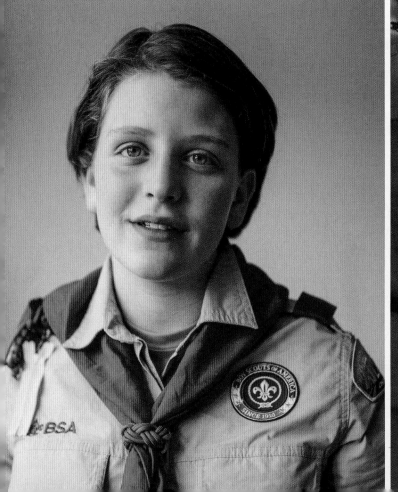

My troop has taught me the importance of being ready for whatever life throws at me. People think Scouts and the stuff we do is only for boys, but that's not true at all.

people can spot you. I've learned how to do so much without the help of adults. We have to be self-reliant. I look up to my Scout leaders and admire how they organize our meetings and seem to know how to tackle problems and other things that happen.

Our credo is "Be prepared," and that means for anything. My troop has taught me the importance of being ready for whatever life throws at me. People think Scouts and the stuff we do are only for boys, but that's not true at all. I recently cut my hair, and it made me think about how

girls can have short hair and boys can have long hair. Also, your gender doesn't matter for what kind of job you want to do. I think being part of this troop has made me realize I'm not going to be this age for very long. So especially with hair, you can just cut it and then if you decide you don't like it, it'll grow out eventually. Do the things that you like; it doesn't matter what people think or expect because you're a girl. That's my advice. Being a girl who is part of an organization that does things that people generally think are only for boys is one way I express myself.

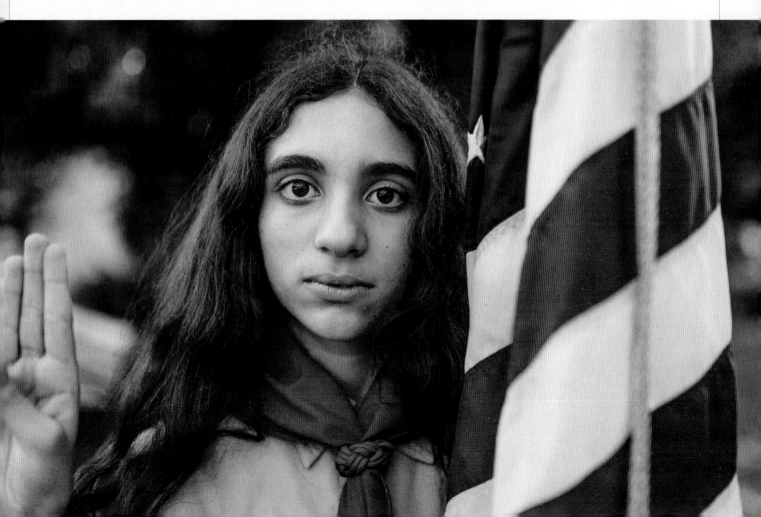

I've been dancing since I was three, and I started choreographing when I was ten. I like that I can really be myself that way. If a song is really emotional, I can use all of my emotions and facial expressions to create the personality of the dance. Making the audience feel emotions is amazing.

BROOKLYNN AGE 14

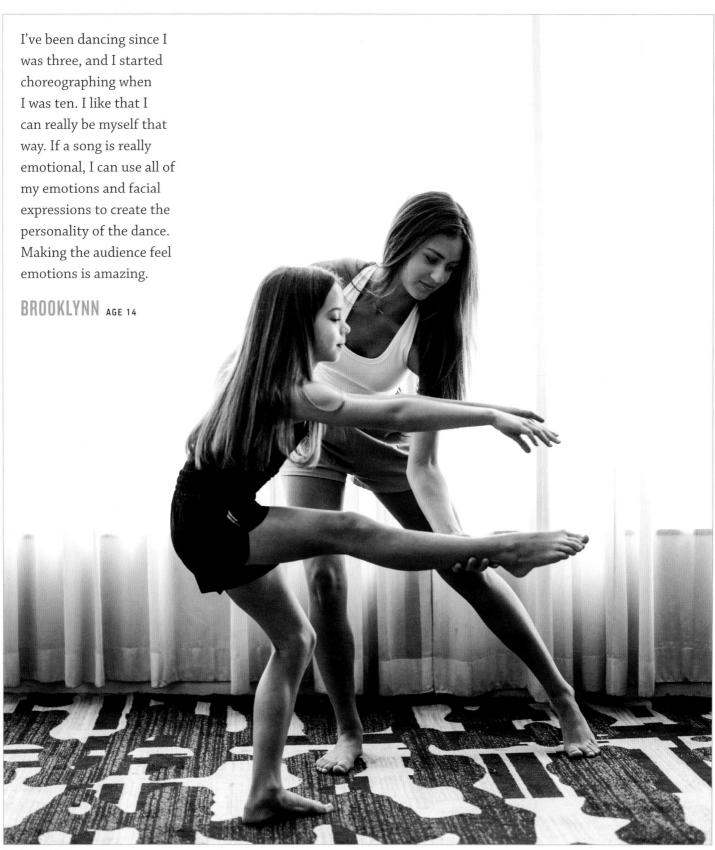

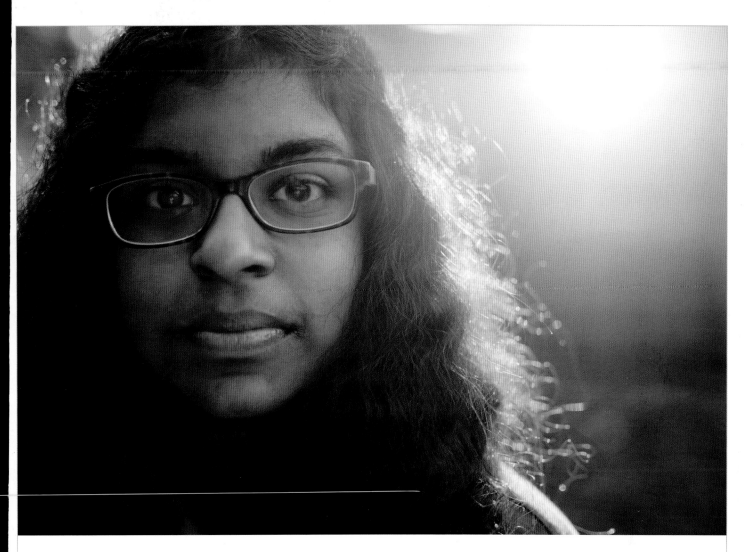

As a fifteen-year-old, I don't have many opportunities to speak out and be heard because I'm often dismissed as a child. However, as I get older, the opportunity to raise my voice on topics that I feel need to be discussed and addressed will grow. My parents have raised me to be an independent girl and to fight for what is best, and I am planning on doing that for myself and for others.

BECCA AGE 15

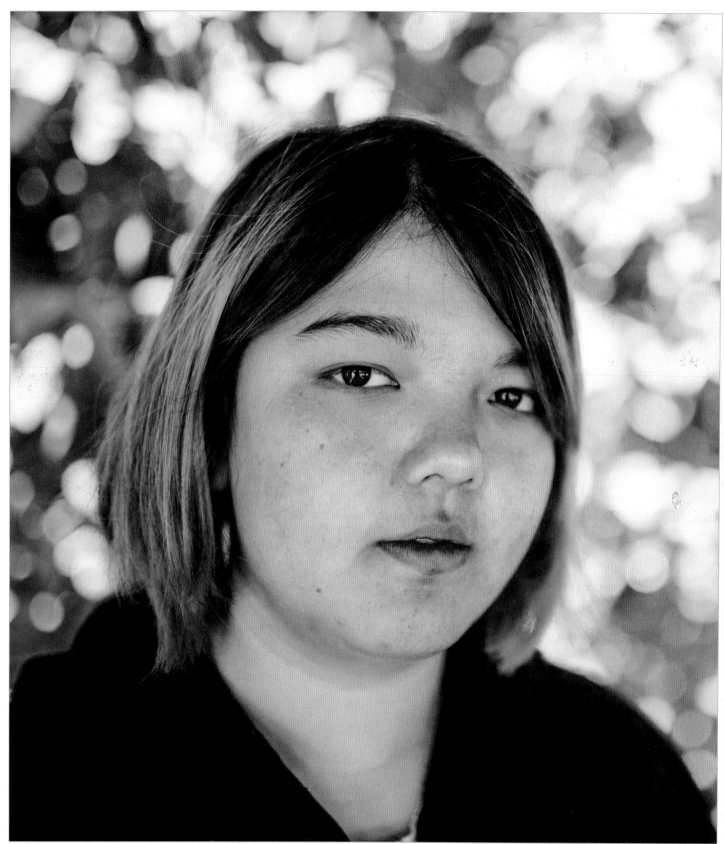

Expressing myself through my hair helps me find the courage to use my voice to communicate with others about who I am. Sometimes it's hard to speak up, but when I do, I use my voice to express myself and spread kindness where I can.

STELLA AGE 15

My mom and I talk a lot about how it's okay to say no, about how to speak up when I don't want to do something or if it feels wrong. I'm learning that it's important for me to be comfortable saying no.

CAITLIN AGE 14

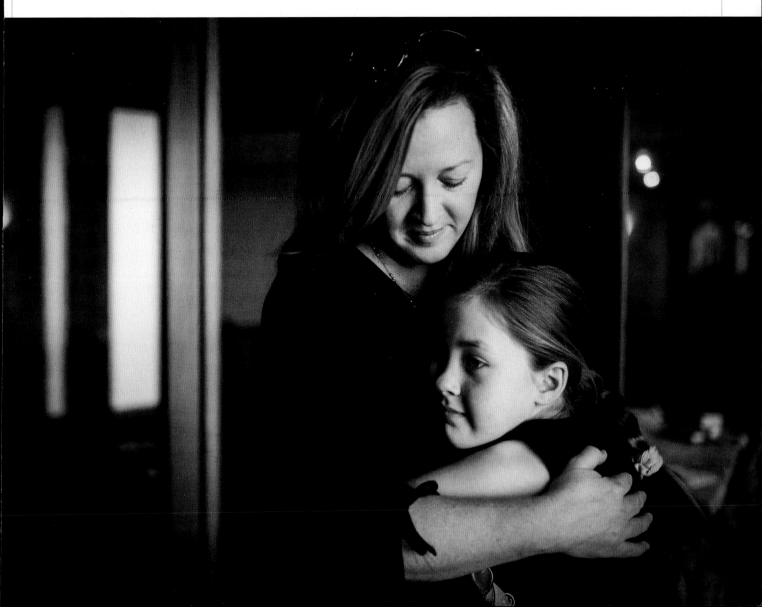

My twin brother wrestled and I asked my dad
if I could do it too. I never felt like I couldn't do
something because I was a girl.

CG AGE 15

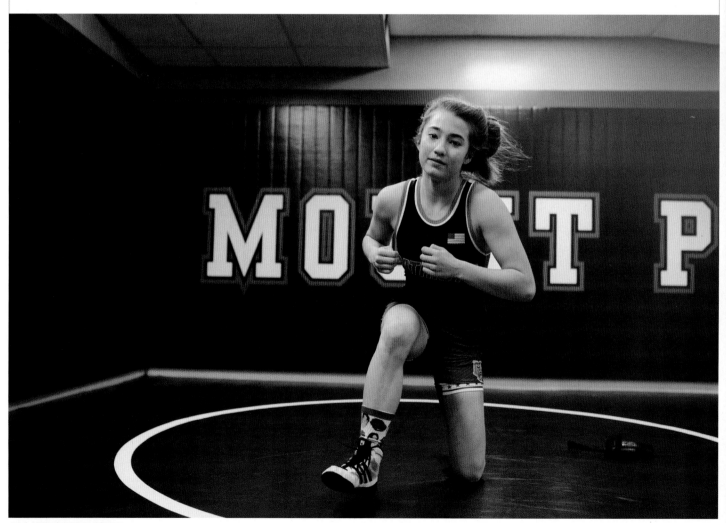

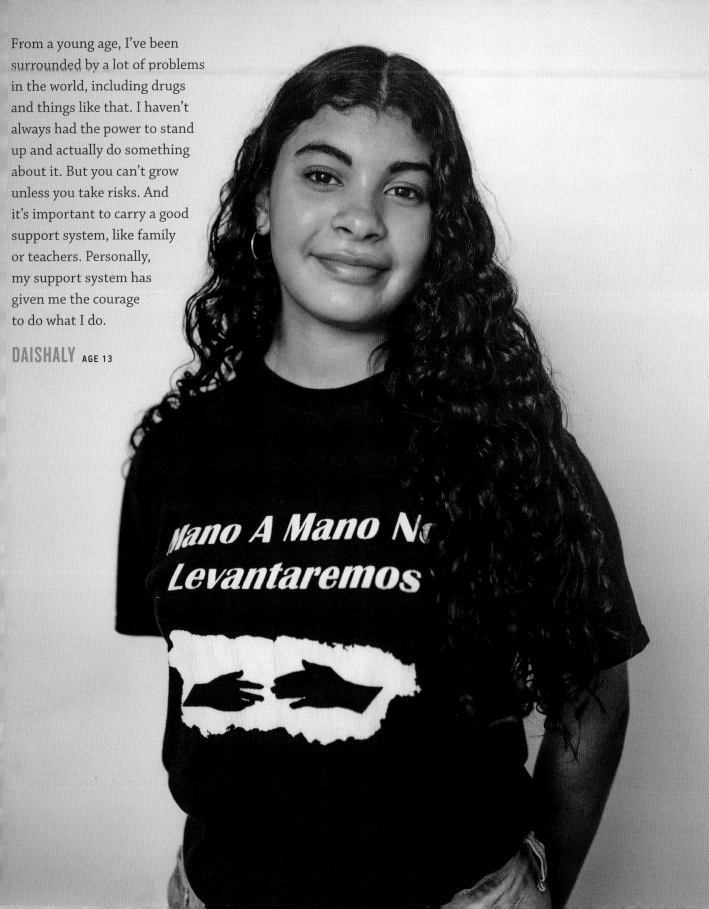

From a young age, I've been surrounded by a lot of problems in the world, including drugs and things like that. I haven't always had the power to stand up and actually do something about it. But you can't grow unless you take risks. And it's important to carry a good support system, like family or teachers. Personally, my support system has given me the courage to do what I do.

DAISHALY AGE 13

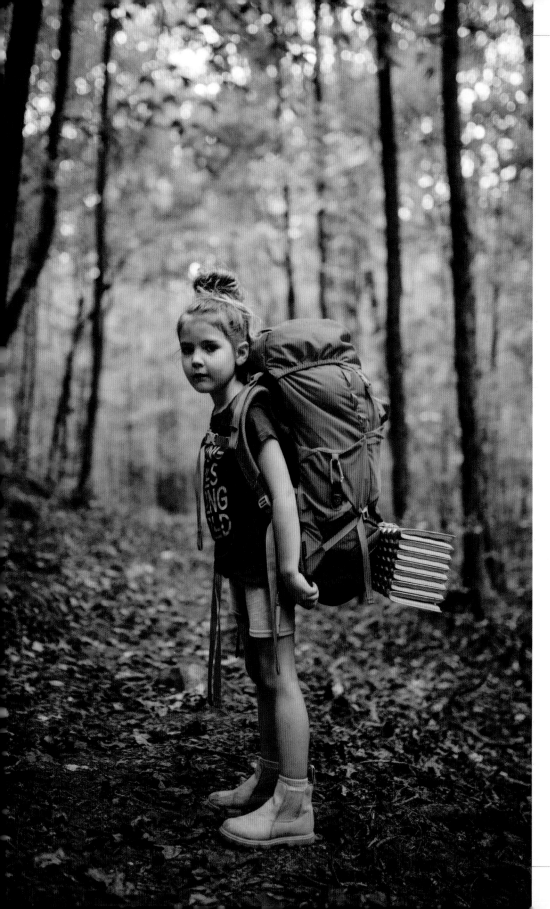

I don't think section hiking the Appalachian Trail taught me anything much. I just thought it was a good trip. But I think it taught the grown-up hikers that little kids can do anything. They were all so surprised to see me hiking with a big backpack. They were like, "Whaaaaa? Who is this kid? How old are you?"

MAPLE AGE 6

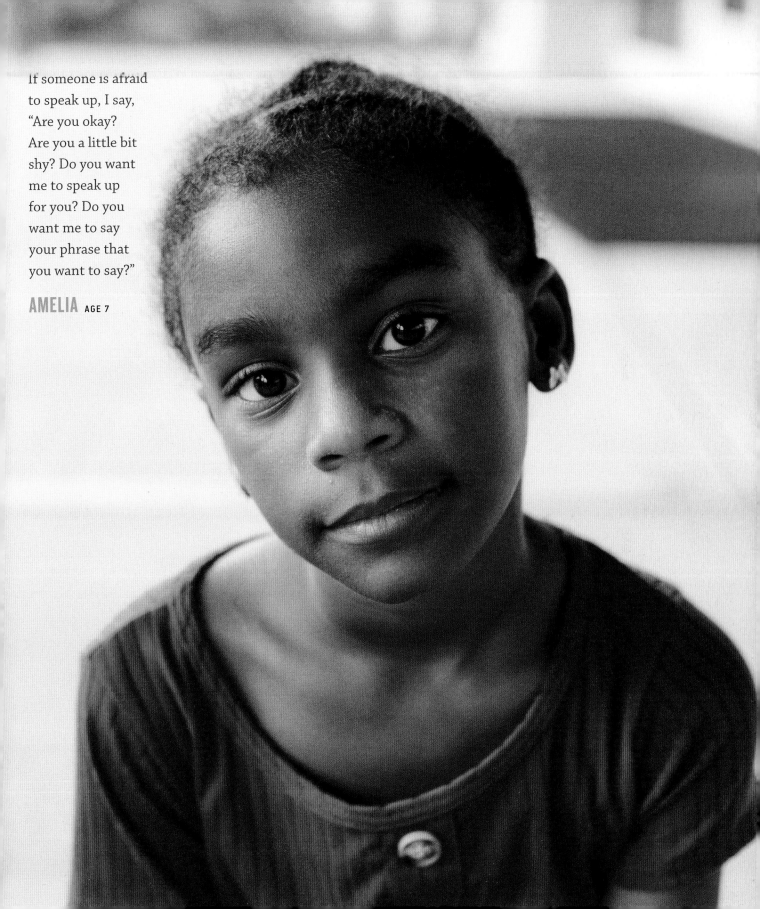

If someone is afraid to speak up, I say, "Are you okay? Are you a little bit shy? Do you want me to speak up for you? Do you want me to say your phrase that you want to say?"

AMELIA AGE 7

Art is kind of its own way of speaking up. What you make says what you have to say without saying anything at all.

RUBY AGE 5

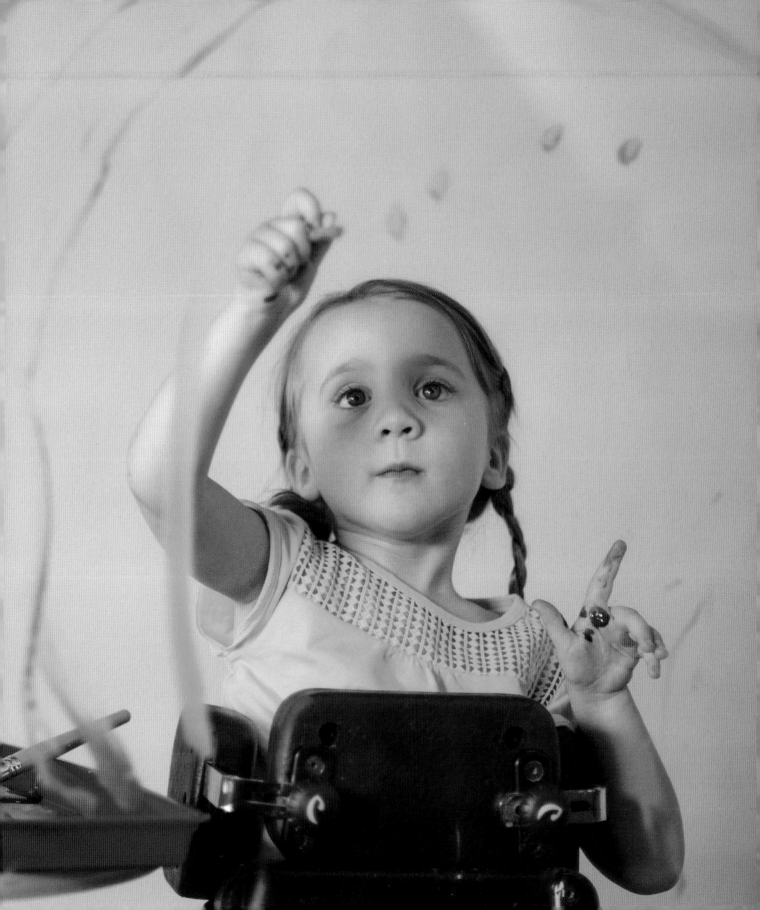

In softball, succeeding 30 or 40 percent of the time at the plate is considered impressive. Sometimes you go up to the plate and get a hit, and then there are times you might pop up or ground out. You might even strike out. The sport has taught me to recover quickly. You don't have time to get down on yourself for making a mistake—you recognize where you can make adjustments so that you are ready the next time you are presented with an opportunity to make an impact in the game.

KYA AGE 15

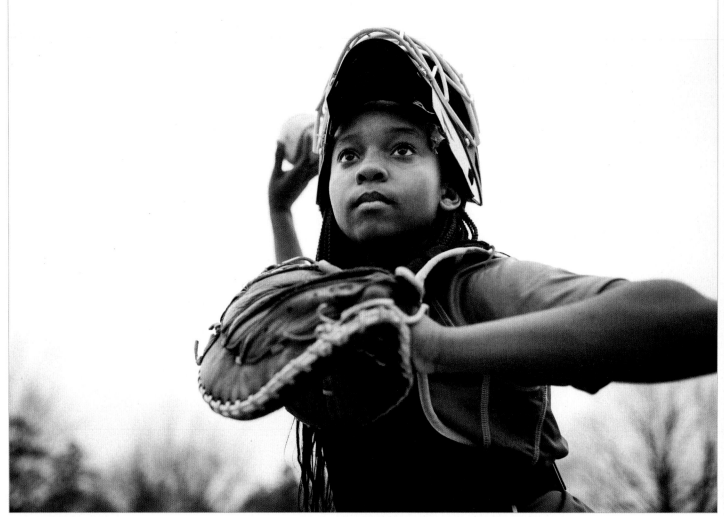

The world is so big. There are so many places and things I want to see and experience.

ELLA AGE 15

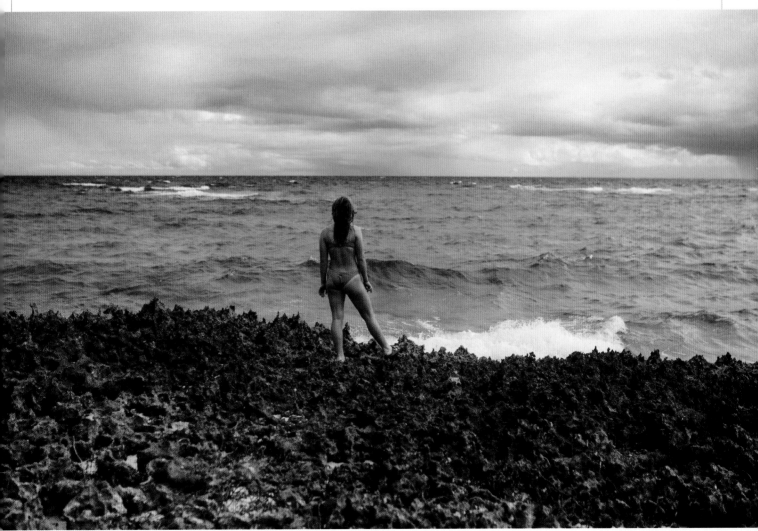

Life is full of hurdles. Obstacles are there for you to leap over and conquer. But you can't be afraid to fall, because each stumble leads to great lessons that help you achieve your goals.

KENNEDY AGE 15

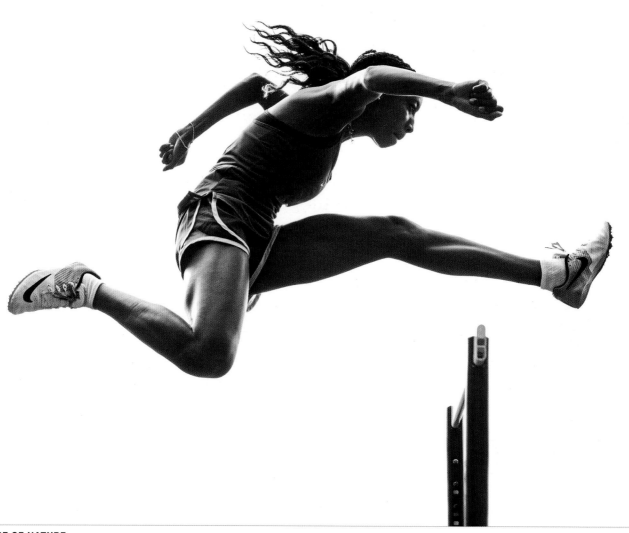

My dream is to speak up and stand up for others. When I get older, I want to inspire other children to speak out on topics that need to be addressed. I do soccer, basketball, and Bharatanatyam as my extracurricular activities. They have shown my confidence and discipline physically and mentally and have taught me to speak up in the right way.

BELLA AGE 11

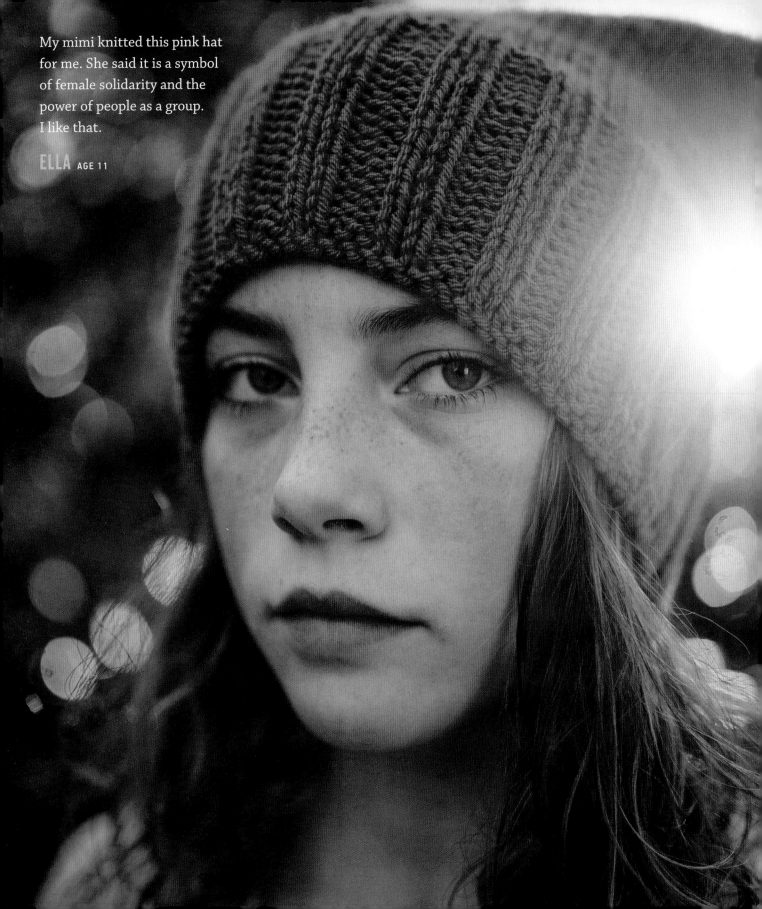

My mimi knitted this pink hat
for me. She said it is a symbol
of female solidarity and the
power of people as a group.
I like that.

ELLA AGE 11

I was born profoundly deaf and, at the time, was one of the youngest babies to receive cochlear implants. While the devices gave me access to sound, my brain still had to be taught how to interpret the digital signals it was receiving and turn them into hearing and speech. In essence, I had to physically learn to use my voice. I am immensely grateful to be able to listen and speak and have since used my voice to advocate for the positive impact of early implantation.

LANDRY AGE 14

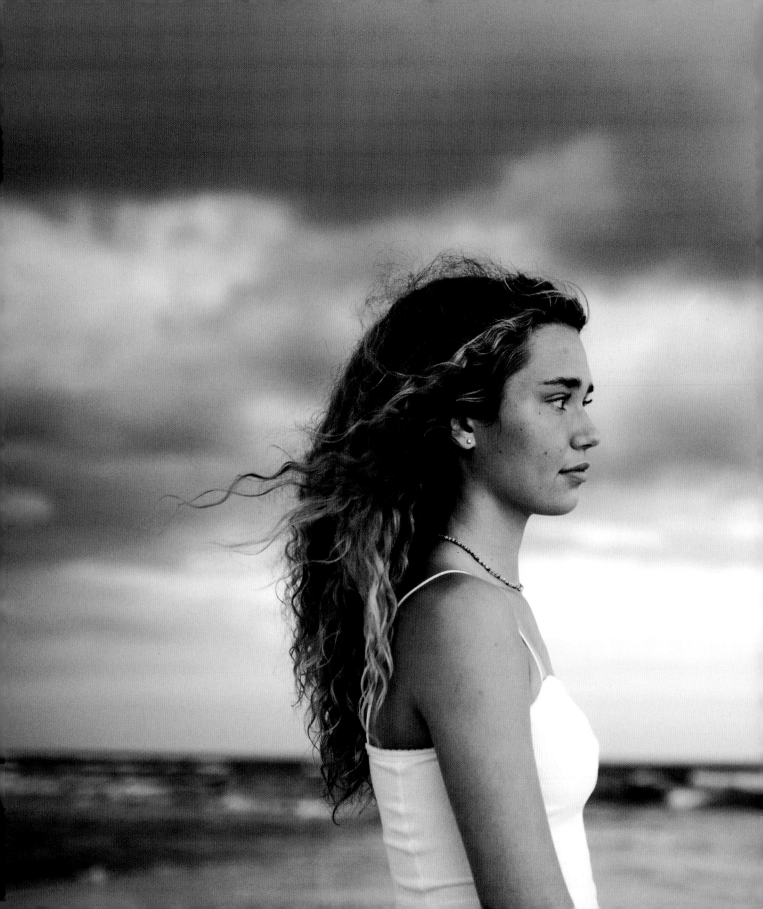

I remember waking up one morning and looking out at the beautiful sun. I was probably ten. I didn't really know how to put into words how gorgeous the view was. That was my first poem. Poetry helps me articulate what I'm feeling in a way that I can't usually with regular words. I think everyone has their own way of expressing themselves. Writing poetry speaks to me.

NEVA AGE 16

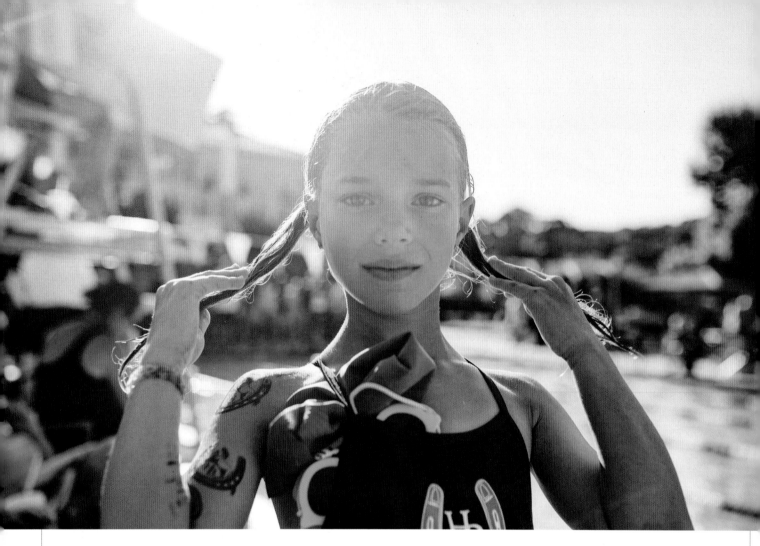

I use my voice to show kindness
and stand up for others.

ELLIE AGE 9

My sister and I wanted to help our community, so we
asked a local gift store if we could collaborate with
them. They actually said yes! We made special-edition
leather coaster sets, and the shop sold them to their
customers. Together, we raised a bunch of money and
donated it to different nonprofits in our city. I was
even interviewed on the local news, so I was able to
tell more people about our mission.

BRIANNA AGE 12

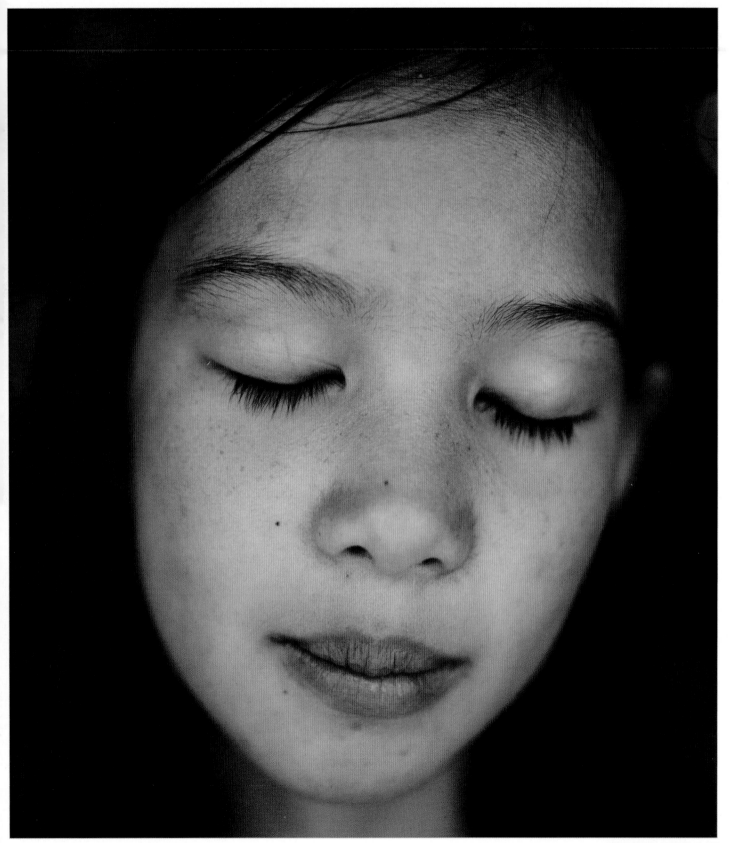

I don't like to be pushed around or told what to do. So I use my voice to make sure I'm heard and everyone knows that *I'm* the boss of me.

PERRYN AGE 6

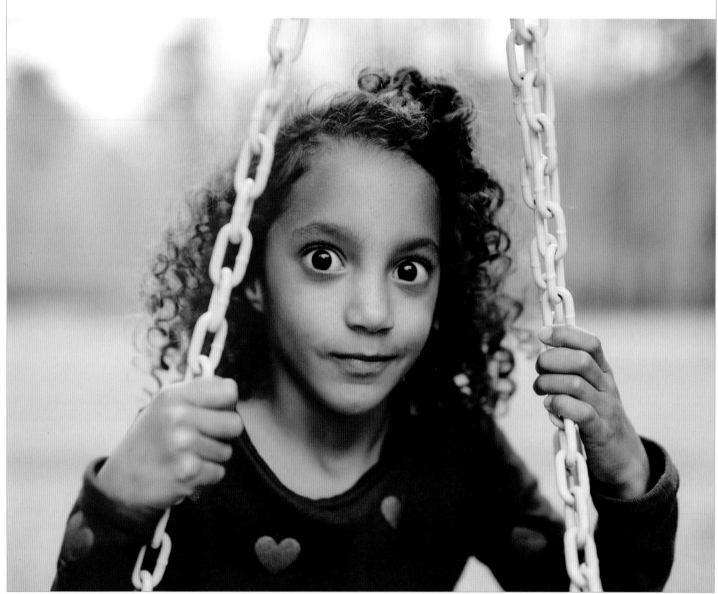

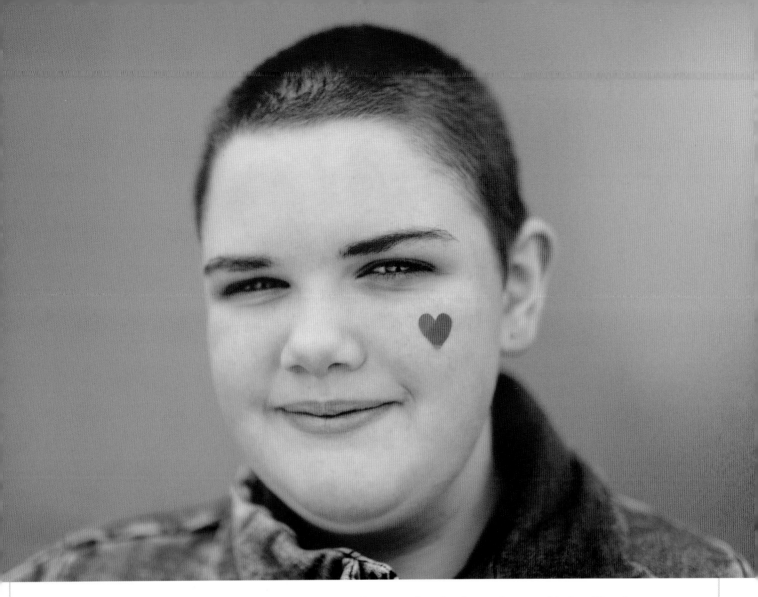

Feminine voices in the arts have a tendency to be stifled. Through ridicule, neglect, and infantilization (all of which being disadvantages most women become familiar with at an infuriatingly young age), the threat of girls being silenced creatively is clear and present. Being a girl and being deserving of recognition and respect are not mutually exclusive, and creating art is the purest form of expressing agency. I make music because it makes me happy. Writing, recording, and producing my own music has given me a voice, to celebrate and love and rage about everything that comes with femininity. Being perceived as a woman is such a complex and often frustrating experience, and I've found beauty in it through art. I use my voice to understand, to relate, to experience, and to create.

AUGUST AGE 13

I am not a gymnast. I play soccer.
So doing flips didn't come naturally
for me. But somehow, many of my
friends and sister's friends could
land a flip. I kept working at it.
And finally landed it. It made me
feel powerful because I worked
at something and finally got it.
And it's fun!

MIA AGE 13

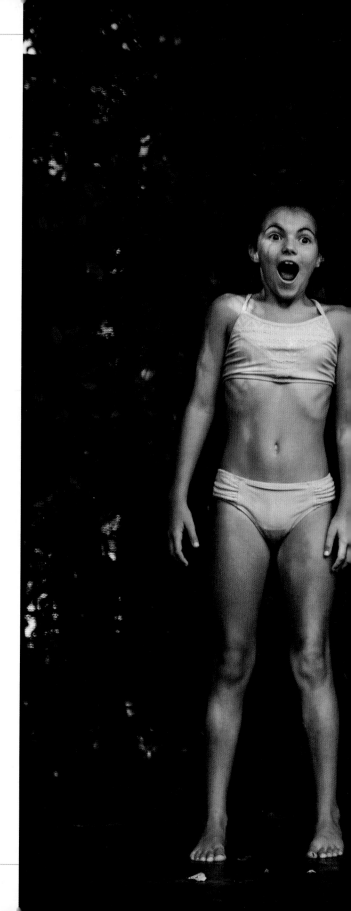

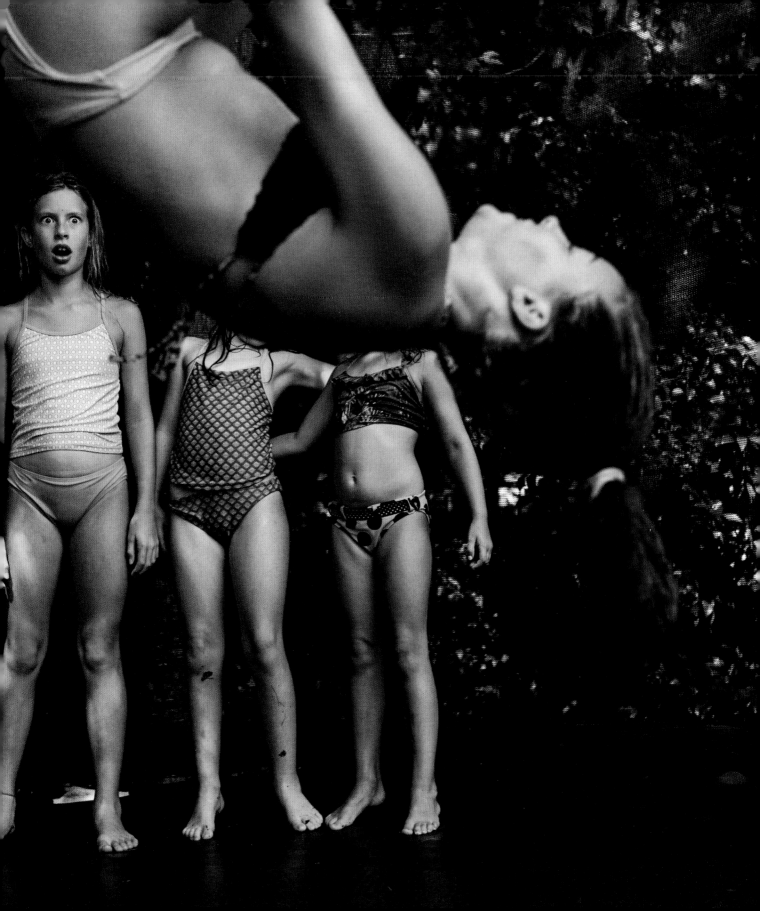

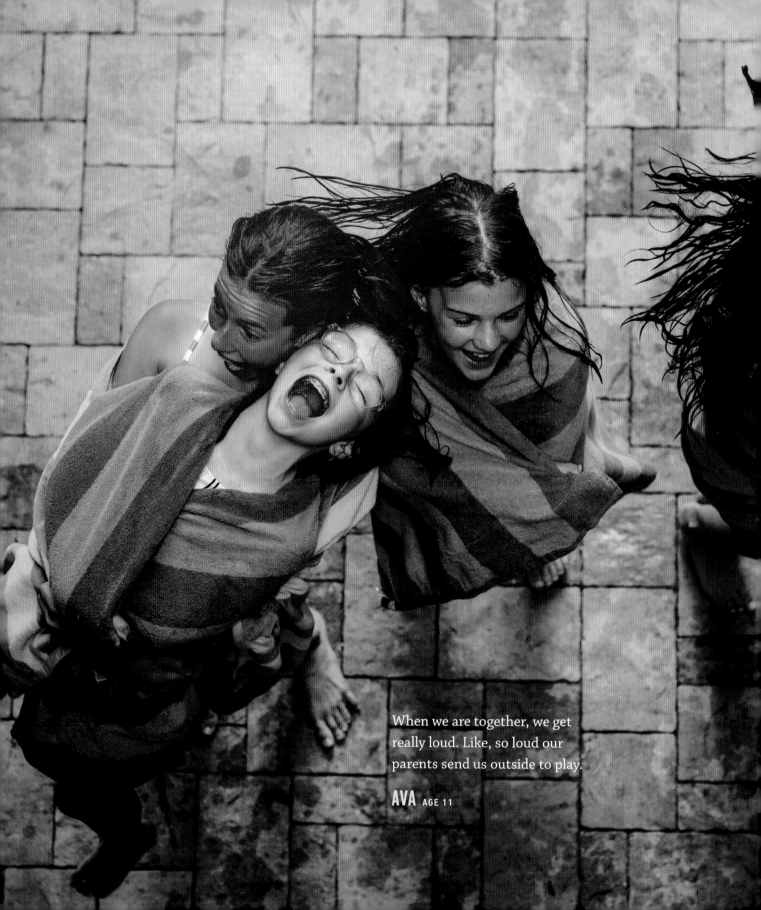

When we are together, we get really loud. Like, so loud our parents send us outside to play.

AVA AGE 11

USE YOUR VOICE

YOUR VOICE IS THE CULMINATION OF WHO YOU ARE. What are your passions? What gives you joy? What makes you angry? What keeps you up at night? What do you think is unfair? When I was meeting and photographing girls and women for this book, I was in awe of how different everyone's voices sounded. Everyone showed up in their own unique way. Some protested, some wrote, some advocated, but the commonality among them was that they showed up. They showed up for themselves and others by speaking up and out. They found the courage to use their voice. They harnessed their power and became collective forces for good.

Many found that their voice was there all along; it was in their head and heart. Sometimes they felt it as a whisper, often pushing them to take action or acknowledge something they might be ignoring. Centering that voice was their first step. Using it was the next.

As I photographed, I wanted to explore what using one's voice really meant. I wanted to know what that looked like in real life. It looks like Nya (page 68)—resolute in taking the skills of teamwork off the field to communicate clearly and confidently about next "plays" in everyday life. And it looks like Madeleine (page 81), who has discovered her own strength and focus and ability to listen reflected in her twin. It also looks like Zoe (page 82), who saw what was missing as it applied to representation in kids' toys, named it, and took action. And Michele (page 87), whose skills on the skate ramp enabled her to transcend assumed limitations based on age and gender.

Your voice is your power. And yes, using it can be hard. There is always going to be someone (or an entire group of people) who will disagree. People may even take issue not only with your message but with the fact that you chose to use your voice in the first place. That is the scary part—the unknown of what happens next—that the mere act of opening your mouth might spark outrage. The images and stories in this chapter remind me how much using our voices matters, again and again.

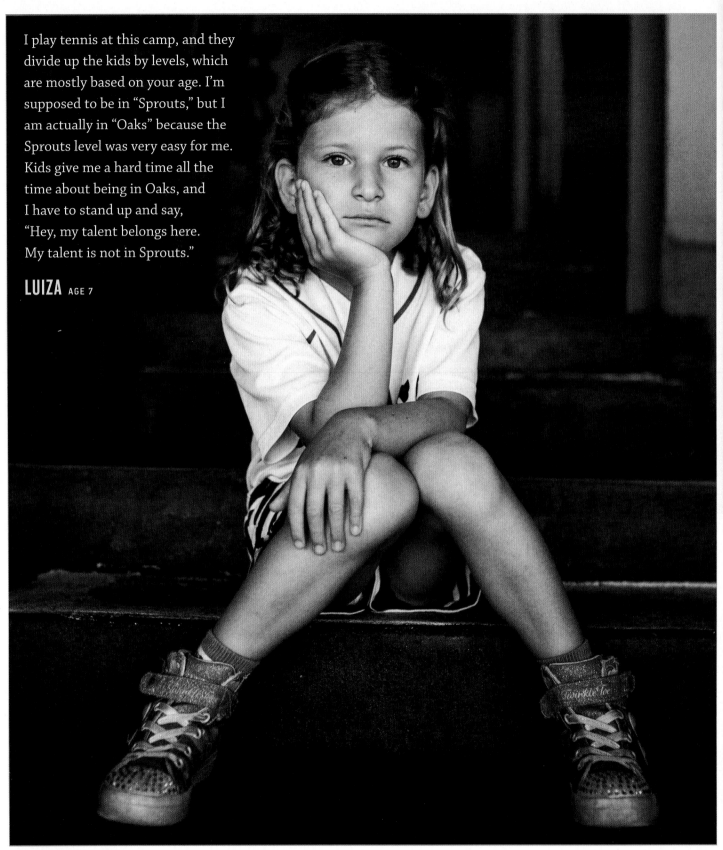

I play tennis at this camp, and they divide up the kids by levels, which are mostly based on your age. I'm supposed to be in "Sprouts," but I am actually in "Oaks" because the Sprouts level was very easy for me. Kids give me a hard time all the time about being in Oaks, and I have to stand up and say, "Hey, my talent belongs here. My talent is not in Sprouts."

LUIZA AGE 7

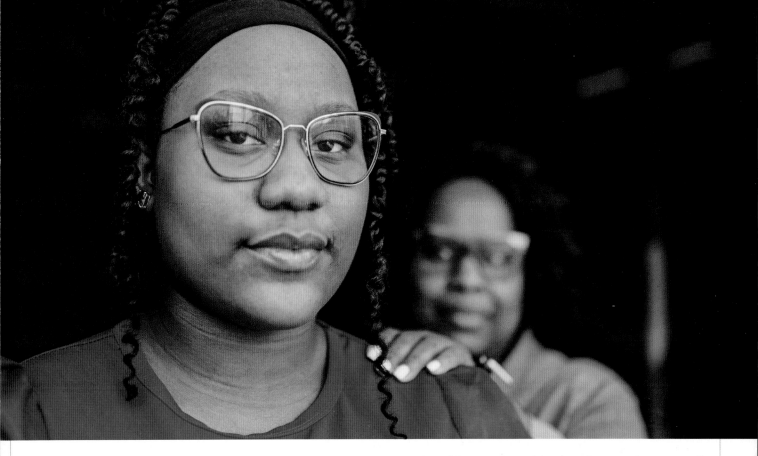

Being comfortable in my neighborhood, in my house, and with my family makes me feel safe and strong. I use my voice to speak out because I feel like my voice is powerful, and people will listen to me and to what I have to say as long as I am passionate about what I'm saying.

ABRIANNA AGE 15

I was elected a "Love Leader" at my school. I try to let people know to stay strong. Hurt people hurt people. It's not you—it's them. There's been some bullying at my school, and we've been talking about it. It's not okay. It's important to take words seriously. If I could, I would want to make school a place where everyone can just feel welcomed, safe, and comfortable. That's how school should be.

SYDNEY AGE 10

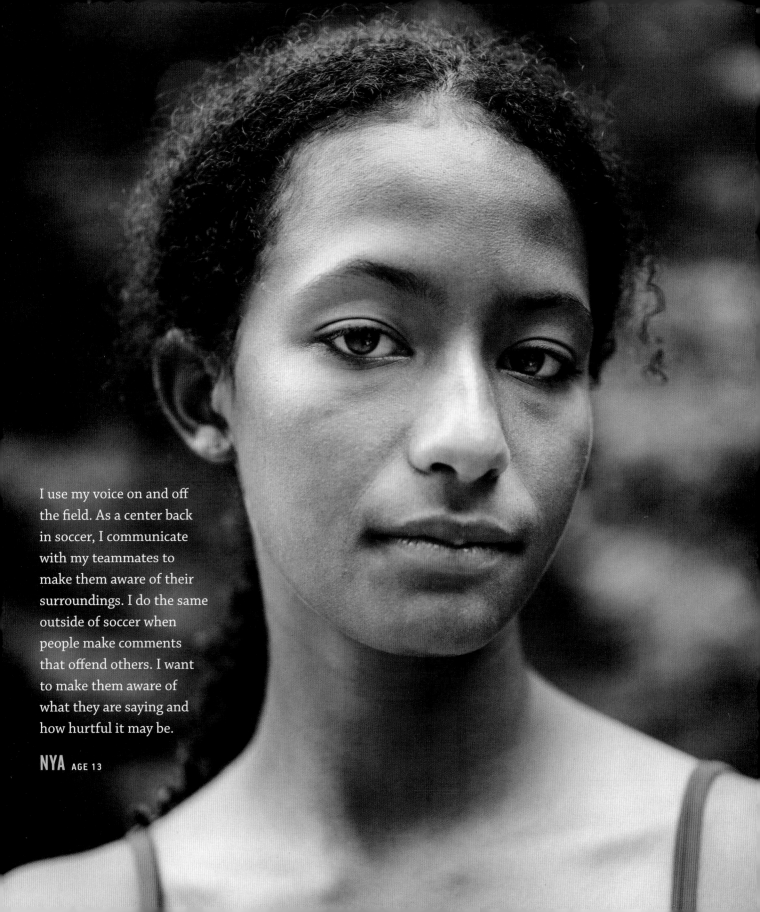

I use my voice on and off the field. As a center back in soccer, I communicate with my teammates to make them aware of their surroundings. I do the same outside of soccer when people make comments that offend others. I want to make them aware of what they are saying and how hurtful it may be.

NYA AGE 13

I use my voice to express how I feel. Whether it's to say "I love you," stand up for myself or others, argue with my sister, or apologize when I am wrong, using my voice is important.

SAMANTHA AGE 13

I may be quiet, but I do my part to share messages of equality and speak out against hate.

DANI AGE 14

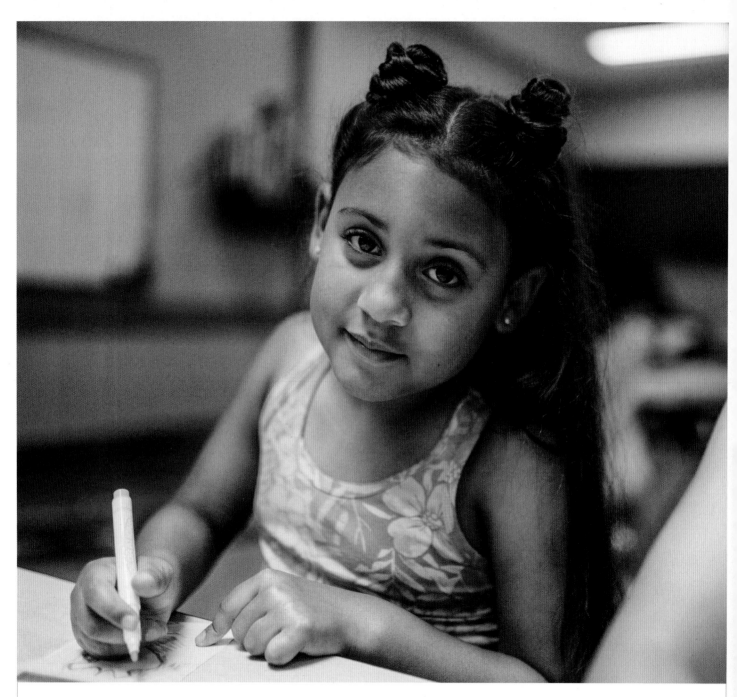

If someone spoke up for me, I would say,
"Thank you so much," and I would give
them a hug and I would cry.

AMELIA AGE 7

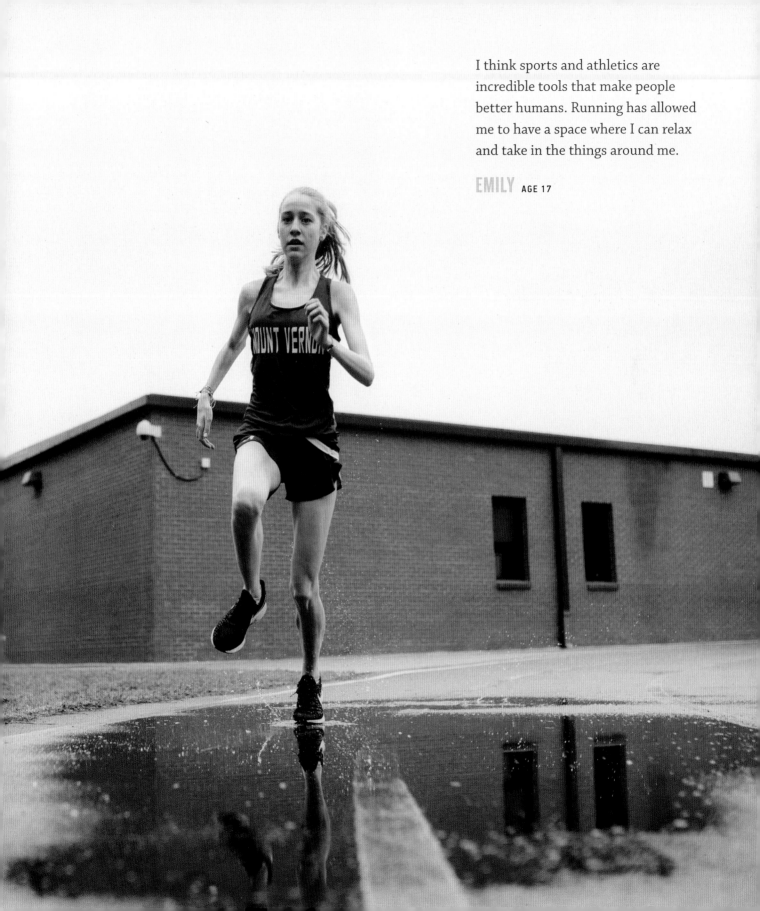

I think sports and athletics are incredible tools that make people better humans. Running has allowed me to have a space where I can relax and take in the things around me.

EMILY AGE 17

I use my voice to speak out when I believe something is unfair and should be changed. At the Black Lives Matter rally, I saw that a lot of people felt the same way as I do. It made me feel like things can change and get better.

MAE AGE 10

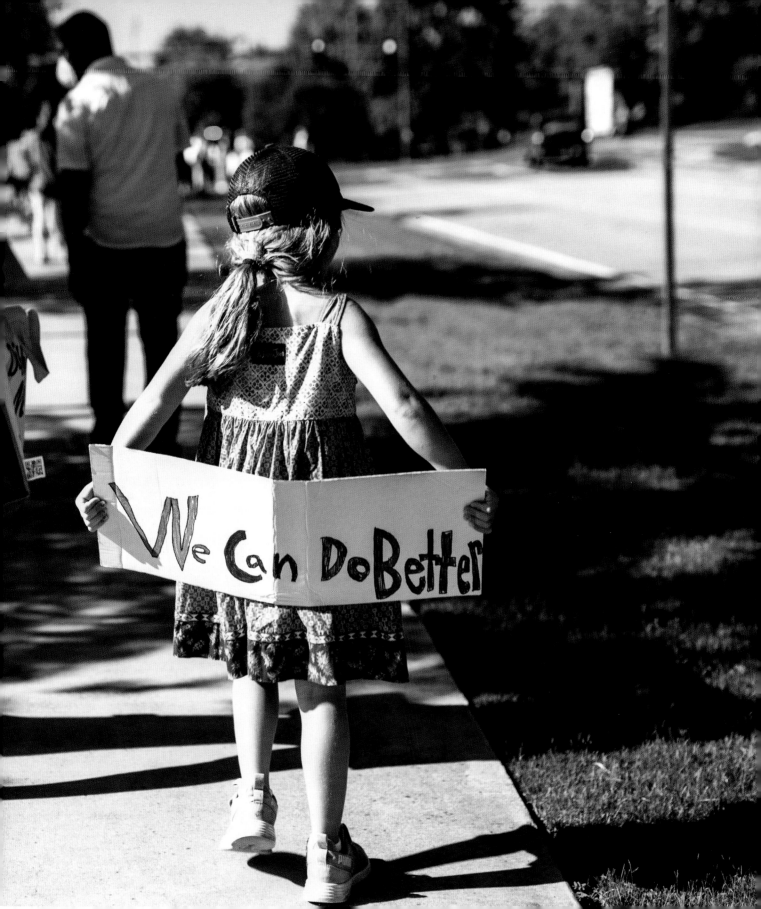

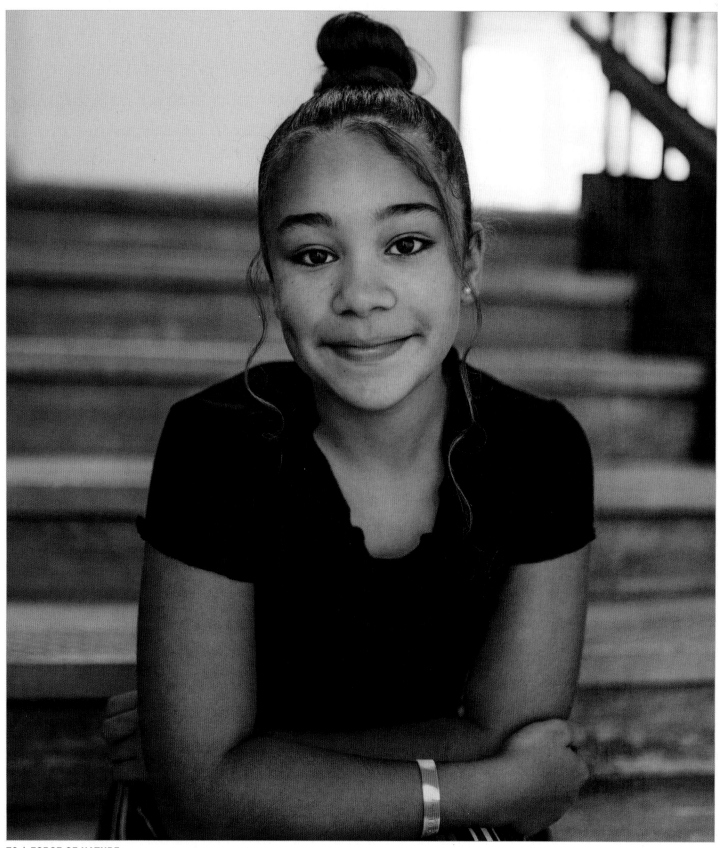

IF YOU'RE AFRAID TO DO SOMETHING BUT INSIDE, YOU KNOW THAT IT'S THE RIGHT THING, THEN MAYBE YOU SHOULD JUST GO FOR IT.

YLEISHCA AGE 11

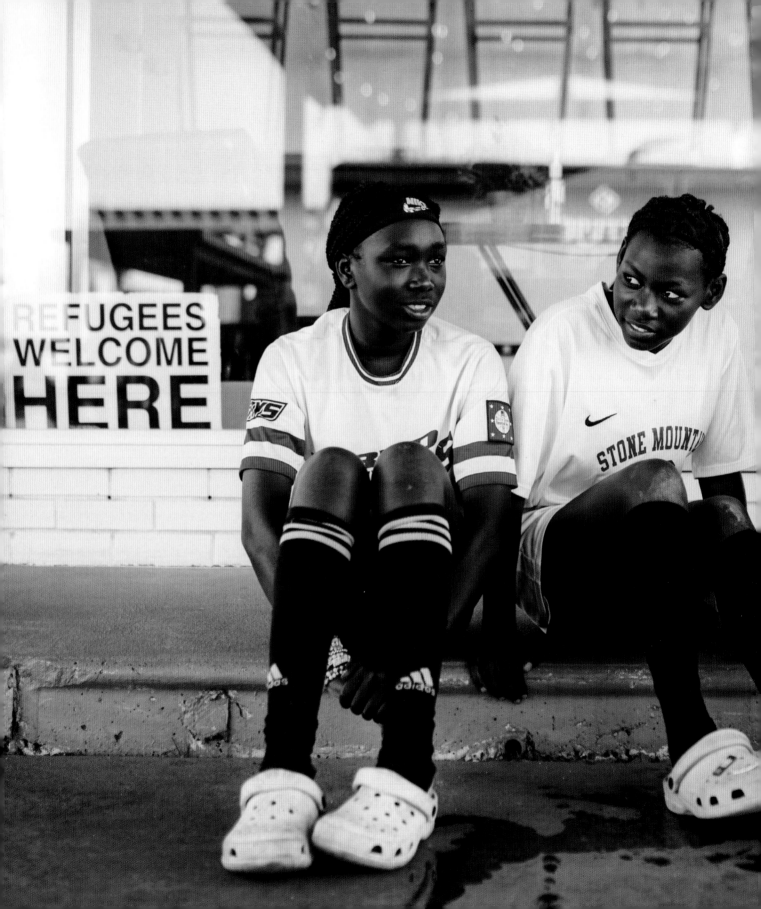

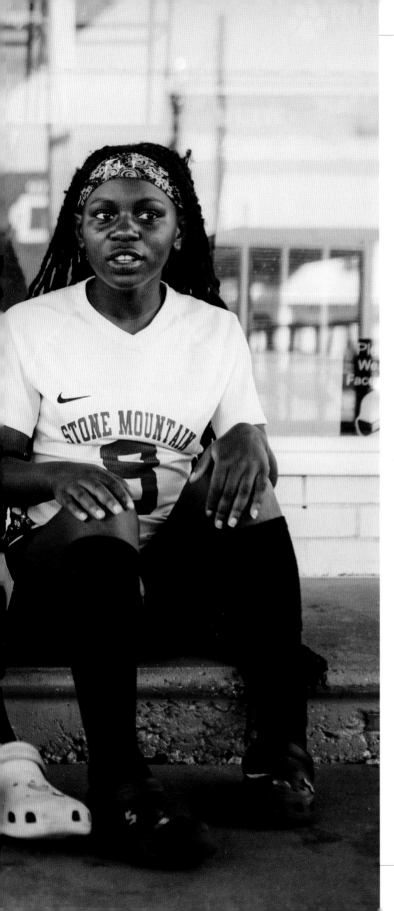

Soccer is our thing. Ever since we came to America, that has been our favorite way to spend our time.

ANNA AGE 15

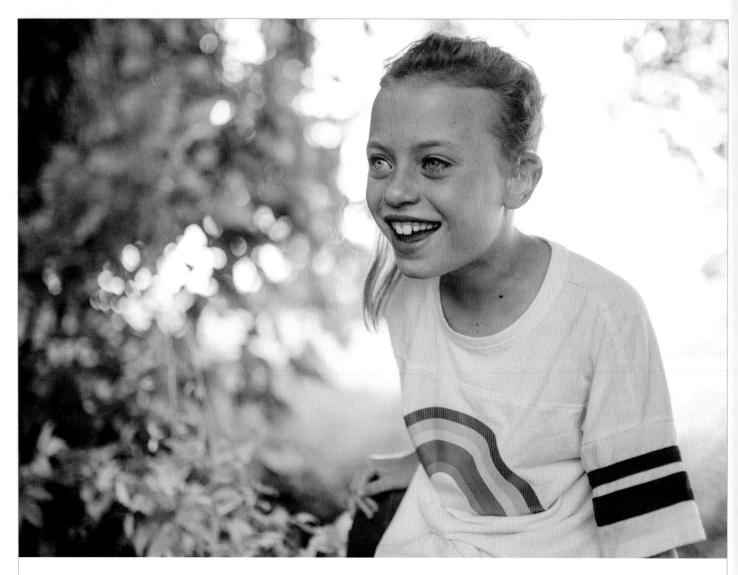

I've worn my hearing aids since I was zero years old or something. I wear them every single day to help me hear, even while doing flips at gymnastics. Sometimes people ask, "What's in your ears?" or other stuff like that. I tell them they are like glasses for your eyes, but for your ears. When I meet people who have hearing aids, I say cool, 'cause I have them too.

AVERY AGE 9

My favorite part about being a twin is having someone there to listen. Whenever I want a second opinion, I always ask my sister. We're like two sides of the same coin—she's more in tune with her emotions, and I'm more in tune with logic—so together we make a perfect pair.

MADELEINE AGE 18 (WITH HER SISTER, ALEXANDRA, AGE 18)

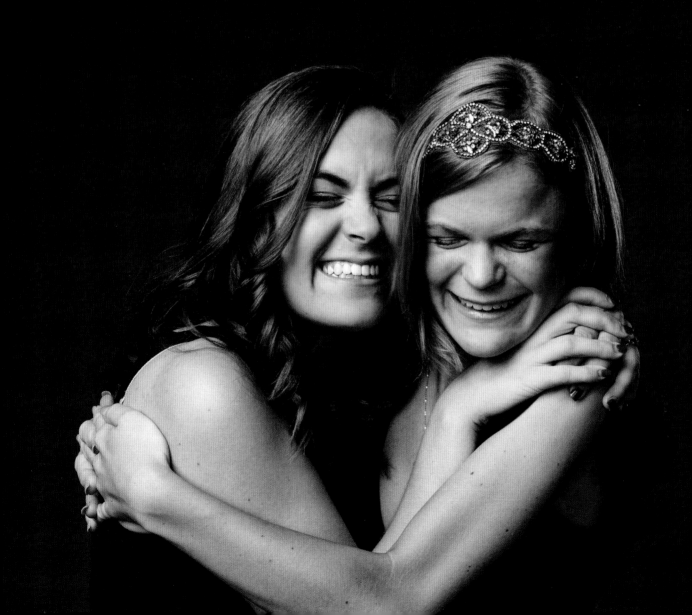

ZOE AGE 10

I'M TEN YEARS OLD AND THE CEO OF MY COMPANY,
Beautiful Curly Me, and I am on a mission to empower
the next generation of Curly and Confident girls that will
change the world! It started when I was six years old; I
didn't like my hair, and I wished it was straight like my
classmates'. I wasn't alone: Six out of ten girls do not like
their natural hair. When I shared this with my mom, she
did everything she could to help me, including getting
me a Black doll. I really liked that doll, but it did not have
hair that looked like mine, and I wanted a doll with curls
or braids. So when my mom went back to the stores and
came up short, I decided I wanted to make dolls with
relatable skin tones and hairstyles for other girls that
look like me to know that they're beautiful and smart
and can do anything they put their minds to. I love my
customers. I love hearing their reviews and their videos
saying that they love their dolls, that they feel more con-
fident, and just seeing their reactions as they open our
products is really priceless.

I hope to grow Beautiful Curly Me into a truly global
brand. We are also a social impact company, so for every
doll that's purchased on our website, we
give one to a young person in need. I defi-
nitely want to expand our giving platform.
I've given a TedX talk and I'm also work-
ing on a podcast as well as some TV show
ideas. I just want to reach kids everywhere
and teach them the importance of self-love
and confidence.

And while using your voice outwardly is powerful,
self-affirmations are also so important. What you tell
yourself is really what you believe about yourself.

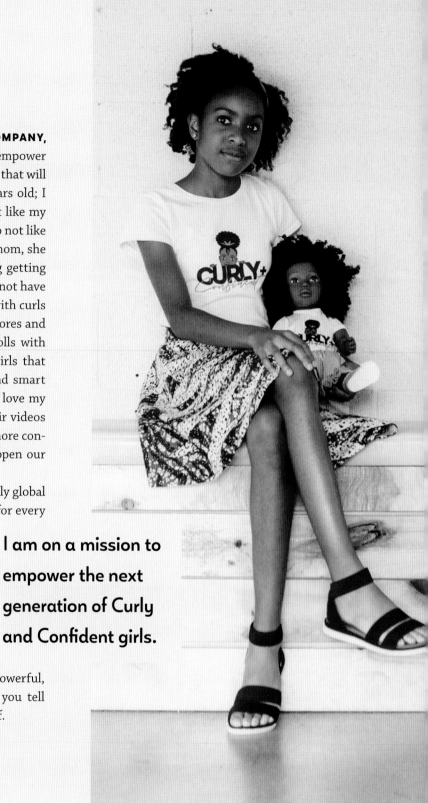

> I am on a mission to
> empower the next
> generation of Curly
> and Confident girls.

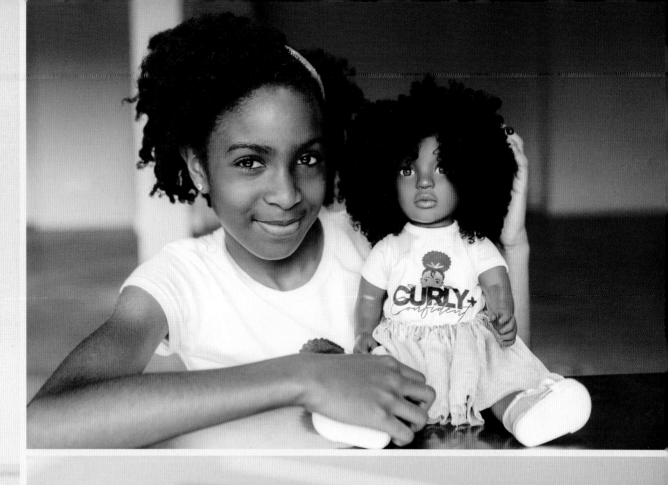
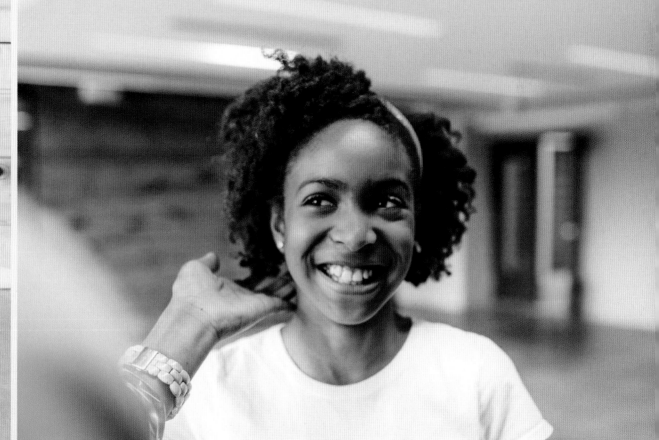

When people are bullying other people, I stand up for them by saying, "Is it true? Is it kind? Is it necessary?" Or sometimes, when someone is sad or mad, I just try to cheer them up by being funny or giving them a Band-Aid.

AMELIA AGE 7 (WITH HER SISTER, CORINNE, AGE 3)

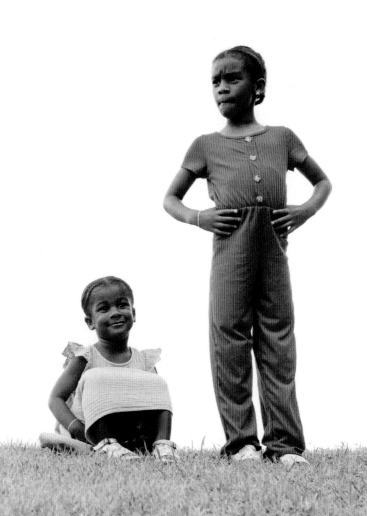

We're sisters. I'm younger. If I fall down, she will pick me up. We roar for each other. We also roar *at* each other because we're sisters.

REBECCA AGE 6 (WITH HER SISTER, WHITNEY, AGE 8)

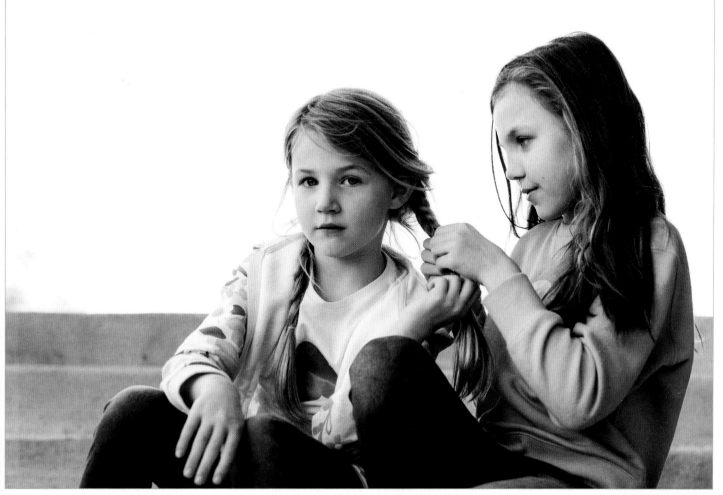

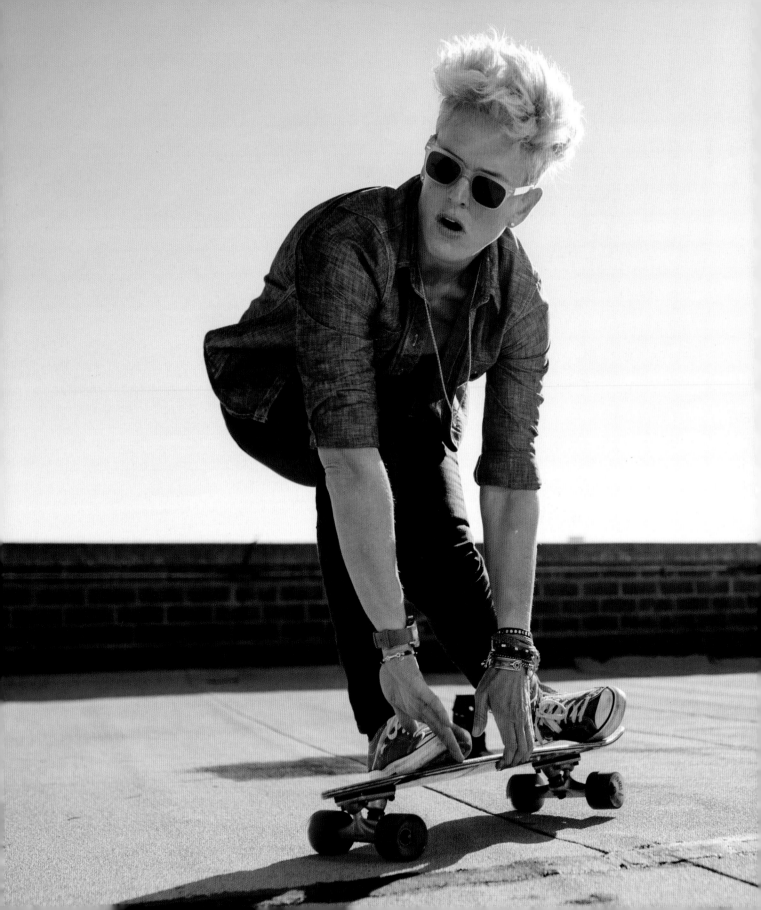

When I came out in 1991, gay marriage was illegal, gay people were banned from serving in the military, and adoption by gay couples was only sporadically allowed. Even though the gay rights movement had come a long way since the Stonewall riots of the late '60s, using our voices to speak out was still the most effective way to change public opinion. Since the day I attended the March on Washington for Lesbian, Gay, and Bi Equal Rights and Liberation in 1993, I have used my voice to fight for fairness and equality. I never considered using my voice to be a political act; I simply wanted to be part of "one nation, indivisible, with liberty and justice for all."

MICHELE AGE 49

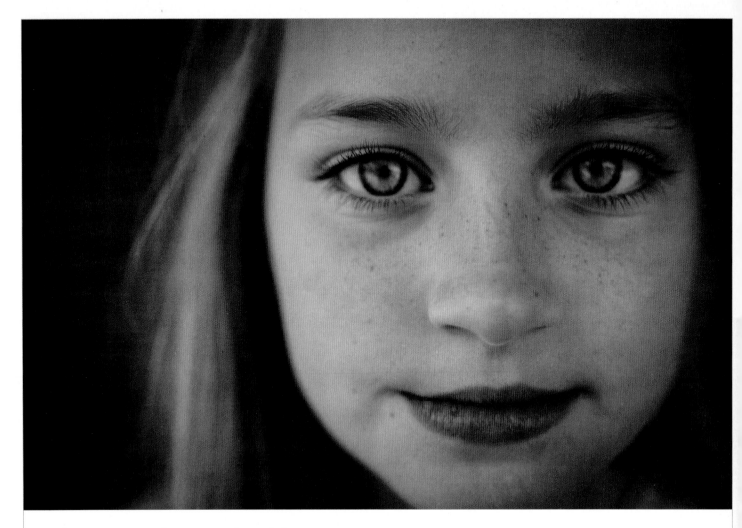

In this moment, in this picture, I was fighting my Tourette's. This is me trying not to bob my head or kick my feet. But Tourette's is something I have; it doesn't have me. I want people to know that I am not disruptive. I cannot help it. What I am is kind, loving, and a normal kid who happens to have Tourette's.

MYRENA AGE 9

I've learned that a lot of competitive climbing is about having a good mindset and control over your emotions so you don't get upset super easily. I've also learned confidence. It's made me more of an outspoken person, and I'll always try to encourage younger girls and tell them how strong and capable they are.

AMELIA AGE 10

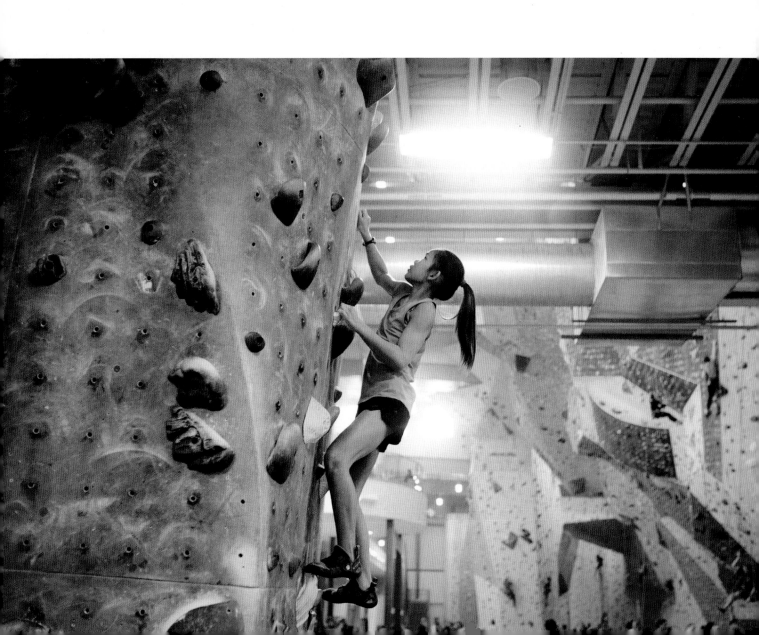

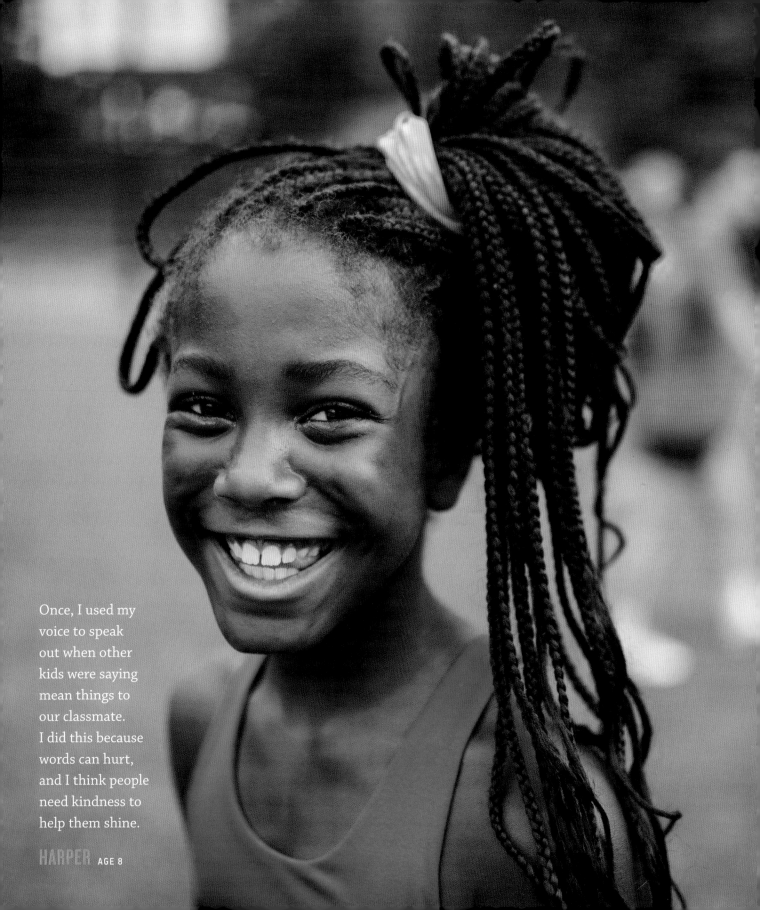

Once, I used my voice to speak out when other kids were saying mean things to our classmate. I did this because words can hurt, and I think people need kindness to help them shine.

HARPER AGE 8

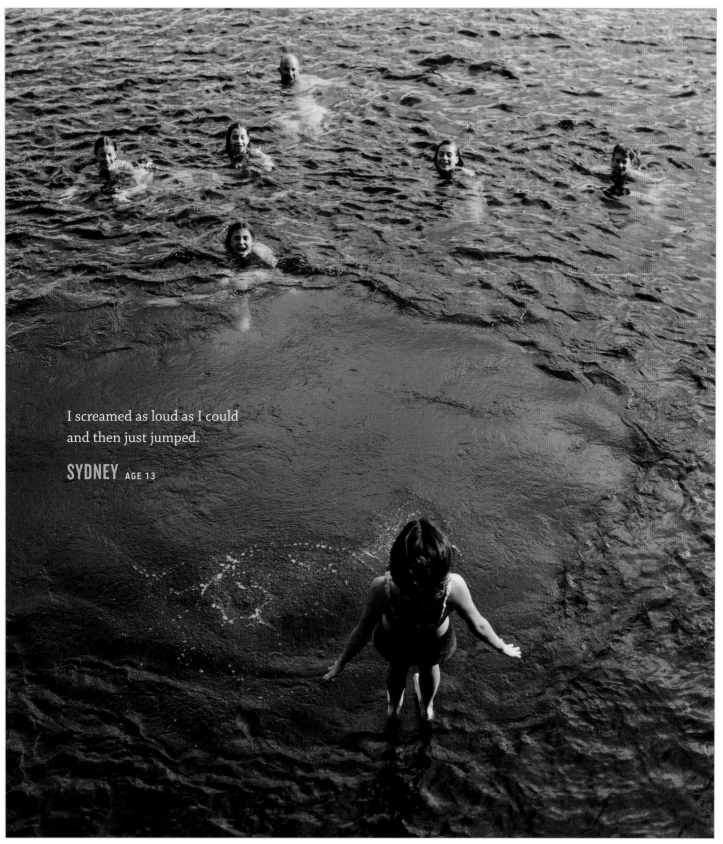

I screamed as loud as I could
and then just jumped.

SYDNEY AGE 13

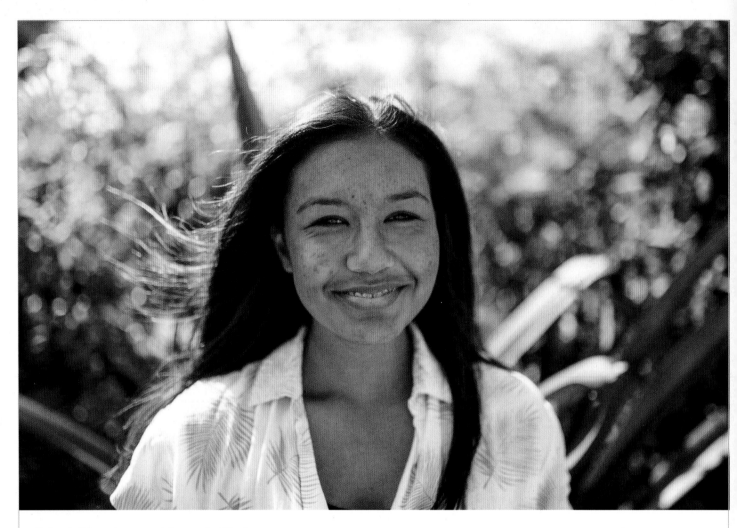

I don't like when people get bullied.
When the bullies leave, I go to the
person and ask if they are okay and say,
"Don't think about it. They're wrong."

CAYDEN AGE 14

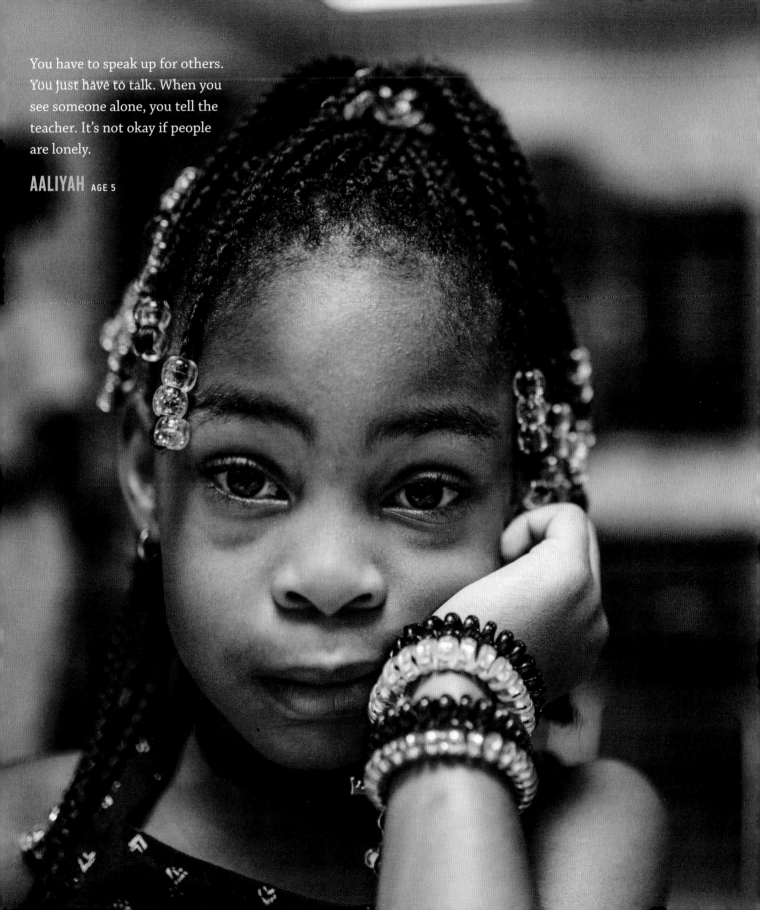

You have to speak up for others. You just have to talk. When you see someone alone, you tell the teacher. It's not okay if people are lonely.

AALIYAH AGE 5

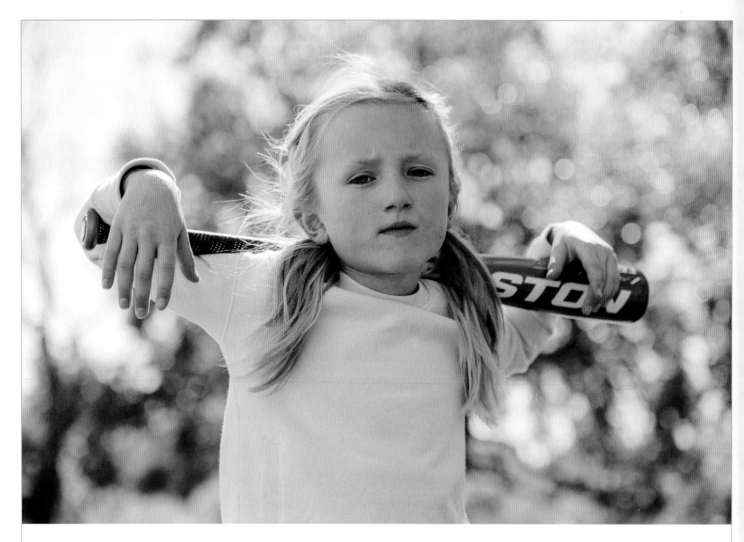

I like playing sports because I love making friends and running fast.
When my mom told me about the anti-trans bills in Texas I wanted
to go speak for myself. I've spoken at the Texas Capitol many times
and I don't like it, but I know they need to hear what it's like to be
a trans kid from a trans kid. I will keep speaking out until my voice
is heard. I'd be so sad if I couldn't play softball anymore, but it's not
just about losing sports, it's about my right to live. Hopefully kids in
the future won't have to fight like I have to.

SUNNY AGE 8

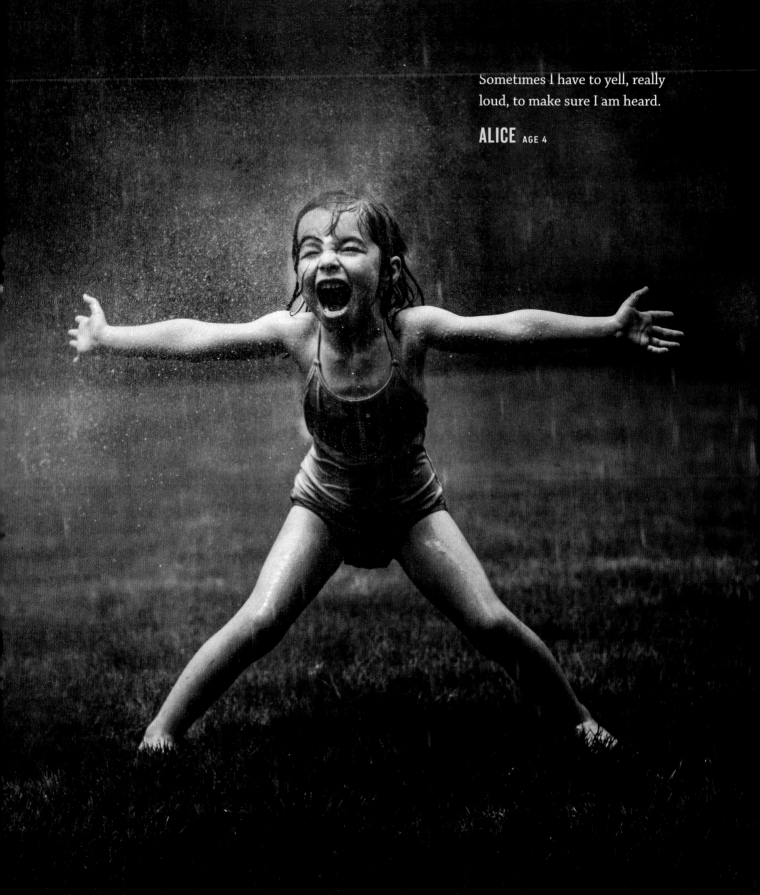

Sometimes I have to yell, really loud, to make sure I am heard.

ALICE AGE 4

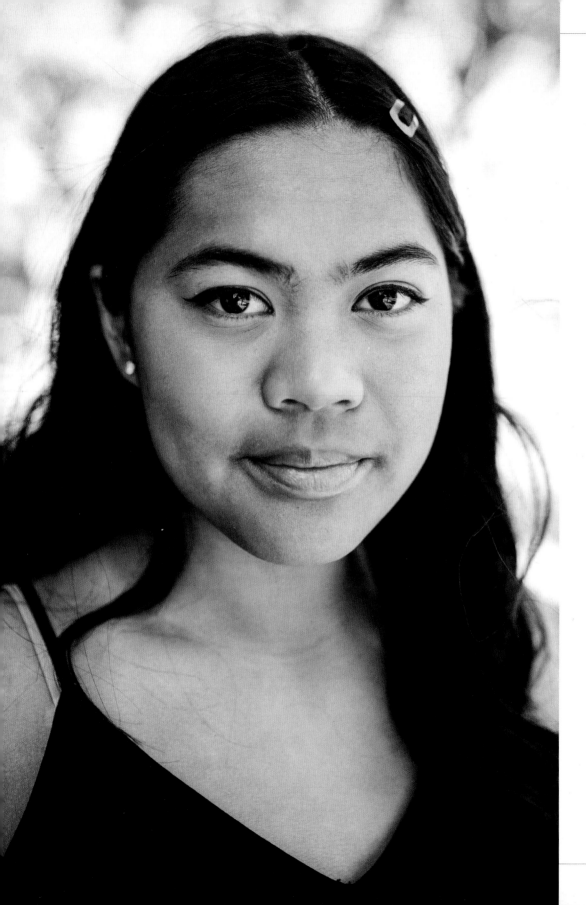

At the end of the day, your opinion and your voice are really impactful and powerful. Not everybody's going to agree with you. But being confident in your own words matters.

AVA AGE 16

This painting is called *Women Power*. In the past, I have struggled with the way my body looks and the way I looked at myself. I painted this to embrace my struggle and to help other women know that everybody has their own problems or issues. Even my mom struggles with the way she looks at herself—and she's one of the strongest people I know. This is her favorite piece of mine.

RHEA AGE 14

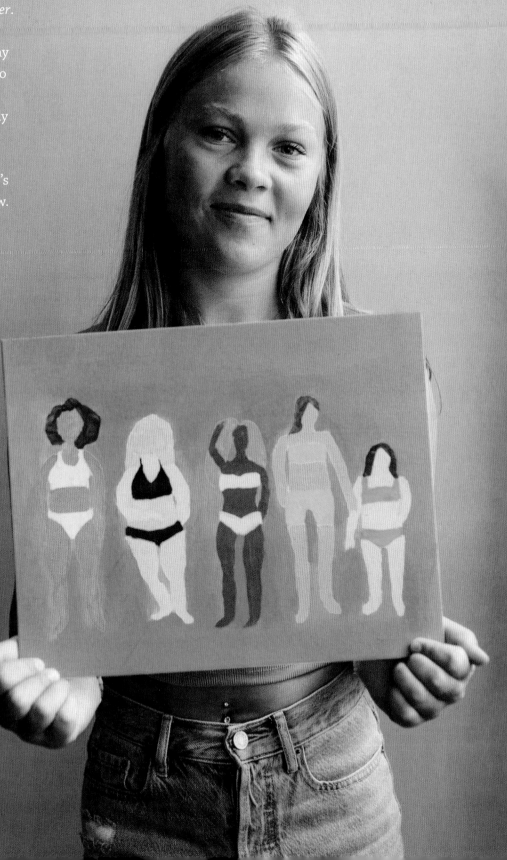

I am the oldest of four kids. The younger ones look up to me whether I like it or not, and I want to show them the right way to do things, like in school or with friends when playing sports. It's important to me to show them, through how I am, how they can be.

NYLA AGE 11

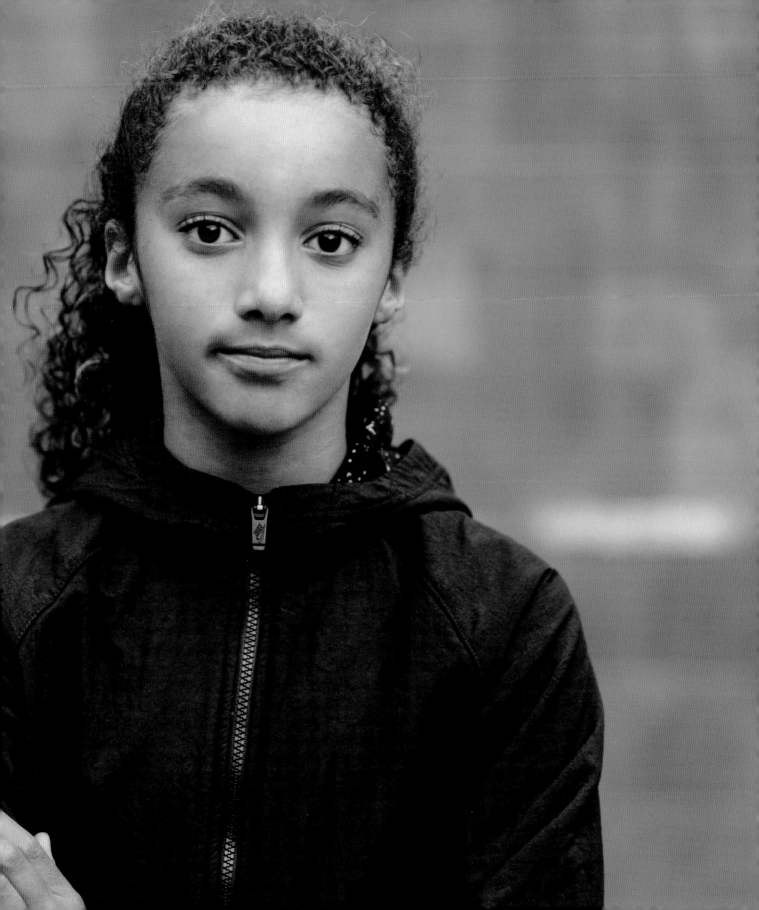

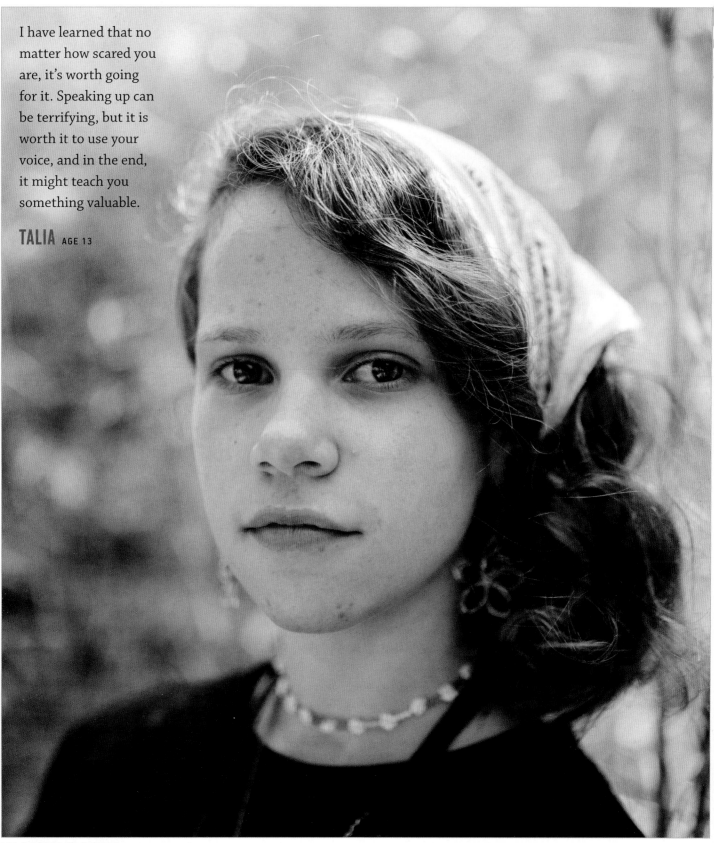

I have learned that no matter how scared you are, it's worth going for it. Speaking up can be terrifying, but it is worth it to use your voice, and in the end, it might teach you something valuable.

TALIA AGE 13

A lot of people give up,
but you can't stop me.
If you close the door,
I'll climb through the
window.

DIANE AGE 66

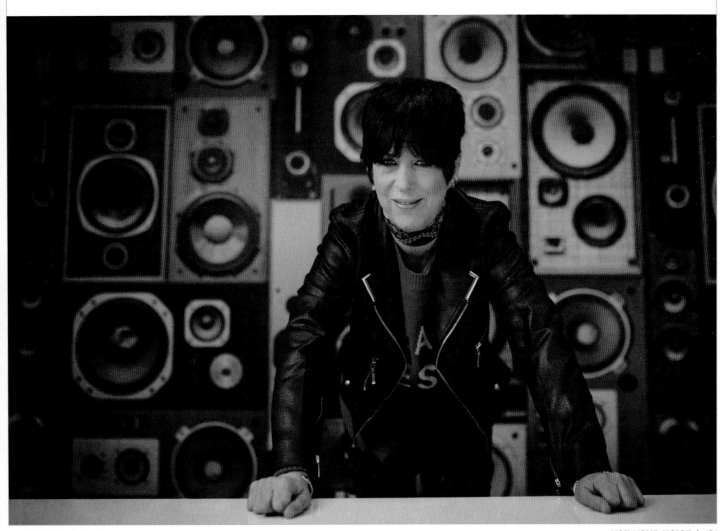

MISTURA

AGE 16

I HAVE TWO MAIN THINGS THAT I ADVOCATE FOR, and I do so through speech and debate. One is protection and treatment around sexual violence and assault. And the other is refugee and immigrant issues. I came to the United States at a very young age, so I know what it feels like growing up in a place that's not home, and then having to push yourself to call that place home. My interest in sexual assault treatment is also personal. So, basically, I'm that type of person—I take the bad and hard stuff of my life and try to turn it into something more, and I use my voice, which I see as a gift, to speak out about it. Any opportunity I have to use this gift that I'm given, I take it. Speaking out about these two main issues that I'm passionate about in whatever way I can brings me so much peace. Because I'm constantly just thinking about those who don't have a voice like I do.

> I take the bad and hard stuff of my life and try to turn it into something more.

I emigrated from Nigeria, a country in West Africa, when I was six. I remember a lot from there, and I miss it so much. I'm going back soon, for the first time in ten years, to see all my family.

I think my voice comes from a lot of years of just feeling numb, as if I was nothing. My experiences plus these strong feelings felt really heavy. At the same time, it was just like, enough is enough. It felt like a box, what I was stuck in. Quarantine during the Covid pandemic really clarified that for me. I just was like, "I can't keep putting myself in this box." So I thought, "What can I do now? What can I do to give myself back that power that I lost?"

I've always loved writing—it's my safe space. I was already in the speech and debate club when the pandemic shut everything down. I realized I was able to share my feelings through something that I love: writing. I could do this through public speaking in a way that didn't make me feel like I was being too open, because at a competition, you are in a room with six or seven other students who are also competing, plus a judge or two. That's who I'm sharing my story with. And I know that, in a way, it's going to touch them, and they're going to get something from it. I don't need to know what they're getting out of it; I don't need to see their faces. I just know.

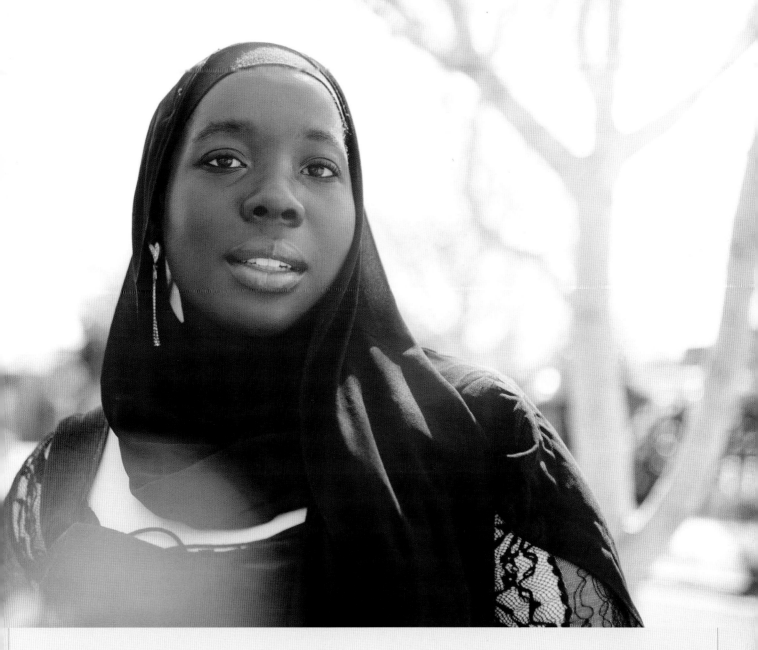

In this world where everyone wants to be different and everyone wants to be doing something, it's easy to feel small, and it's easy to feel as if what you're doing doesn't matter in the face of what everyone else is doing. But it does. And I had to realize that for myself. I still have days where I struggle with that. "Is what I'm doing enough? Are people going to care?" At the end of the day, people are going to care. It doesn't matter if you only touch one person. That one person is more than enough. And it goes a long way, because you know what?

You've touched one person, you've made a difference to one person, and they can carry that on to one more person. And then you have it, your whole domino effect based on what you have done.

You have to start somewhere. It doesn't matter where; it doesn't matter how small a gesture. Taking a step is so much better than just standing there. And that's what I did. I took a step, and that step turned into more steps, and one of these days I'm going to run. That's how I see it.

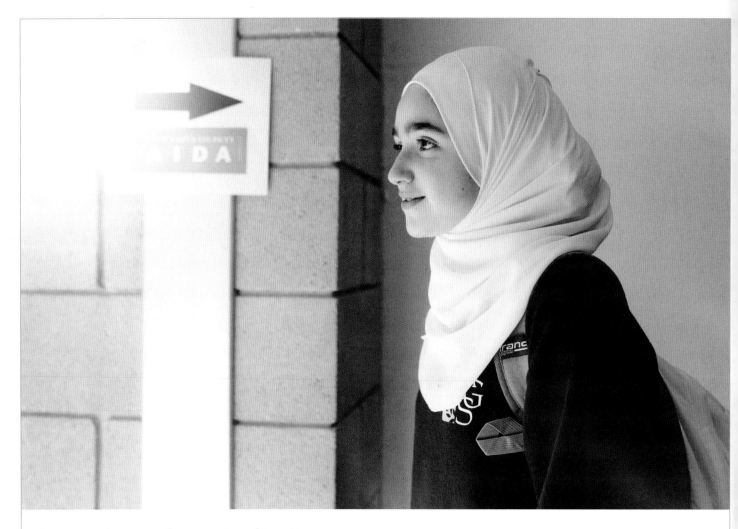

I use my voice to speak out against things I don't agree with. It is effortless to say what is right when everyone around you agrees. However, the real challenge is to say what is right even when everyone else finds it difficult.

MASA AGE 18

I would like to become a lawyer. My first step toward this goal was using my voice to lobby for and win a spot on my school's competitive debate team. My hope is to use my debate skills to effect positive change around social justice issues big and small.

SOPHIE AGE 13

ARIANNA

AGE 15

I AM A FEMALE RUGBY PLAYER. At first, I played with only boys, and I was like, "I've just got to figure this out." And then I was like, "Wait, I think this is it." I liked football, and I liked soccer, and rugby felt like both met in the middle, but also better somehow. I just haven't found anything I love more than this sport. At times, it's been a challenge to play, especially as a girl. There were no girls' teams when I started, but thankfully that didn't deter me. When I played with only boys, I felt like I had to learn the sport really quickly and that I had something to prove. I now play for the Atlanta Valkyries, an all-girls' club.

I'm really good at this. It feels good to excel. I have this whole big community that's proud of me and proud of my team, and I'm proud of my team too. The sport has definitely helped me grow and mature and develop as a person.

Rugby players come in all different shapes and sizes, and it's celebrated. The perception is that this sport is for men, but I am working to change that. Too many prospective players are like, "We'll get made fun of. Like, 'Oh, you're like a man. You hit and run and lift? Why are you working out so much? You're too muscular or whatever,' and, 'You don't look good in a dress because you're too muscular.'" I don't believe in any of that. I really look up to Ilona Maher; she's a rugby player who has played in the Olympics. I want to be in the Olympics one day.

> To me, my team is more than just rugby players; we are a family, and when we set foot on the pitch, we are a team, a sisterhood that is unbreakable.

Playing rugby takes not just strength but heart too. *And* it's a true team sport—playing what I like to call "hero ball" doesn't work. When I play rugby, I feel strong and confident and fully myself. I feel like a leader, and I take that feeling with me wherever I go—on and off the pitch. To me, my team is more than just rugby players; we are a family, and when we set foot on the pitch, we are a team, a sisterhood that is unbreakable. Tough games always get me down, but when the team starts working together and I'm able to hit hard, it makes all the turf burn and aches worth it. Being known throughout the community makes me feel a sense of pride.

The rugby community is small, and though that is not the best thing about it, I find that I like that aspect because of the amount of travel I get to do. Traveling all around the world can be tiring, but the friends I have acquired because of it are people I will always have in my life.

As my team has gone from four girls to a little over fourteen girls, I have made so many friends and seen some of our original girls grow up so much. My co-captain has gone from a quiet new rugger to one of my best friends. Being a rugby player has always made me different, so having my girls by my side makes me feel accepted. As my dad and I have developed our team, we can't wait for all of our girls to grow the sport of rugby for women everywhere, making playing it a source of pride, not something weird to do on the side.

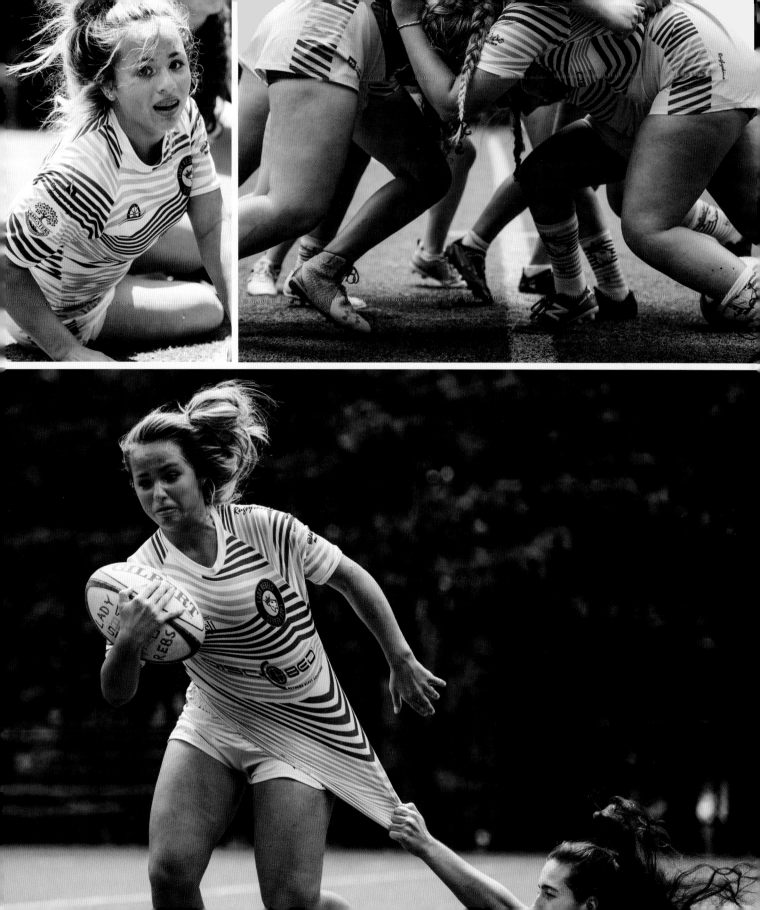

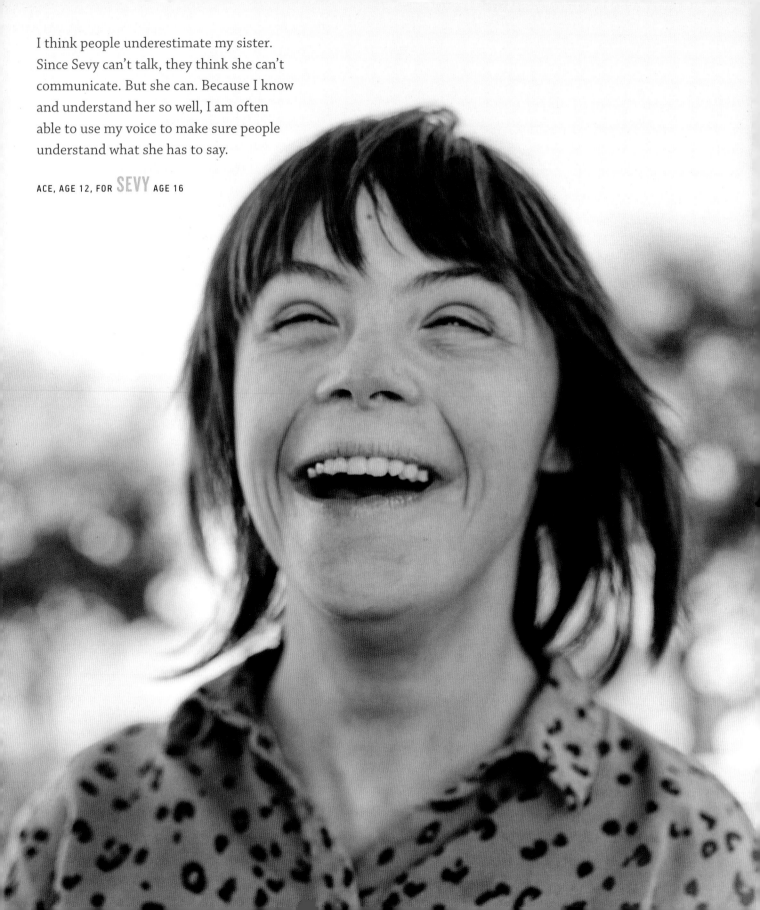

I think people underestimate my sister. Since Sevy can't talk, they think she can't communicate. But she can. Because I know and understand her so well, I am often able to use my voice to make sure people understand what she has to say.

ACE, AGE 12, FOR SEVY AGE 16

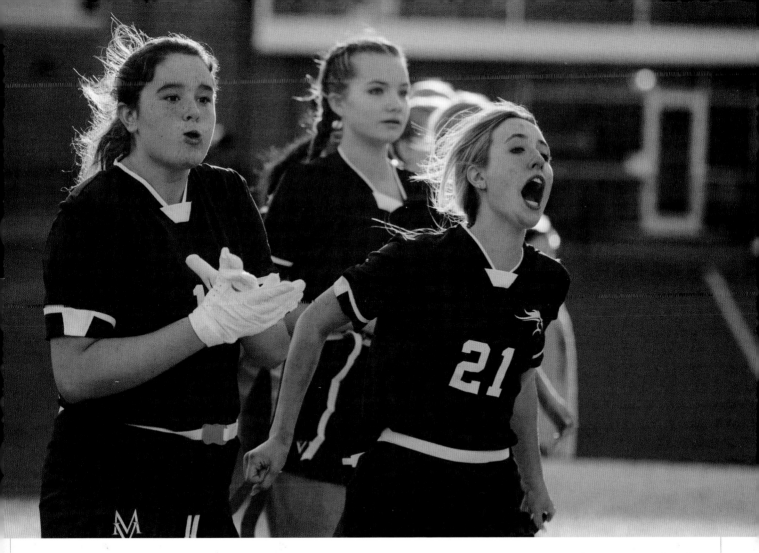

Girls should be able to be who they are and play the sports they wanna play. I play flag football and it gives me the perspective to know that girls can do the same things as guys.

EMERSON AGE 15

The hard work, discipline, and hours of training that I've dedicated to dance have provided me with much more than technique. Dance is an art form so deeply rooted in a sense of self and individuality. It's helped me discover that in myself, and I carry that with me in every situation I encounter, regardless of whether it's in a dance space.

MADDY AGE 21

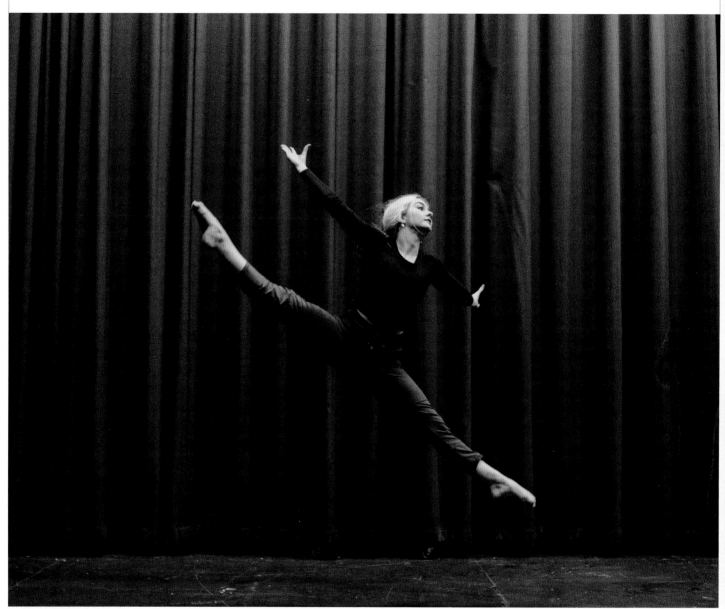

I like speaking up for what's right. I am not afraid to say, "Hey, that's not okay" to someone who has said something offensive or out of line. I will say to my parents or friends or people I know, "You shouldn't say stuff like that. That's kind of messed up. It's really offensive to the people you're talking about."

ANA AGE 18

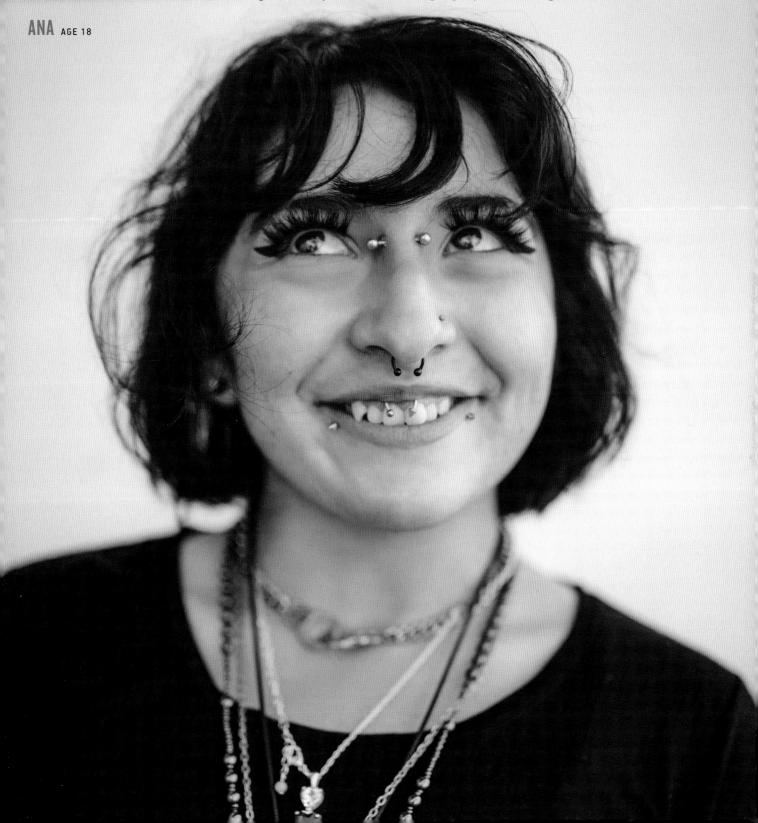

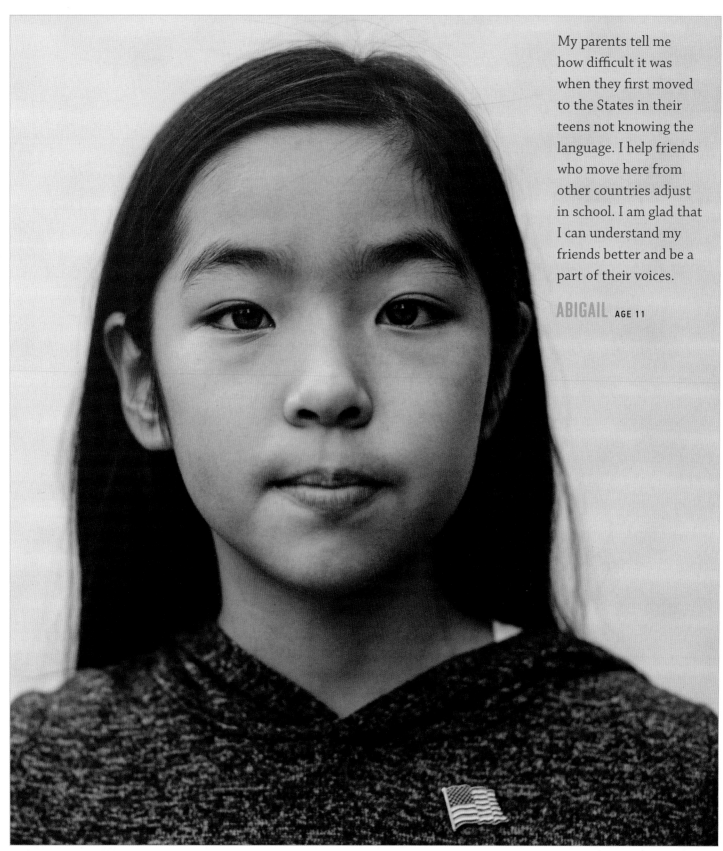

My parents tell me how difficult it was when they first moved to the States in their teens not knowing the language. I help friends who move here from other countries adjust in school. I am glad that I can understand my friends better and be a part of their voices.

ABIGAIL AGE 11

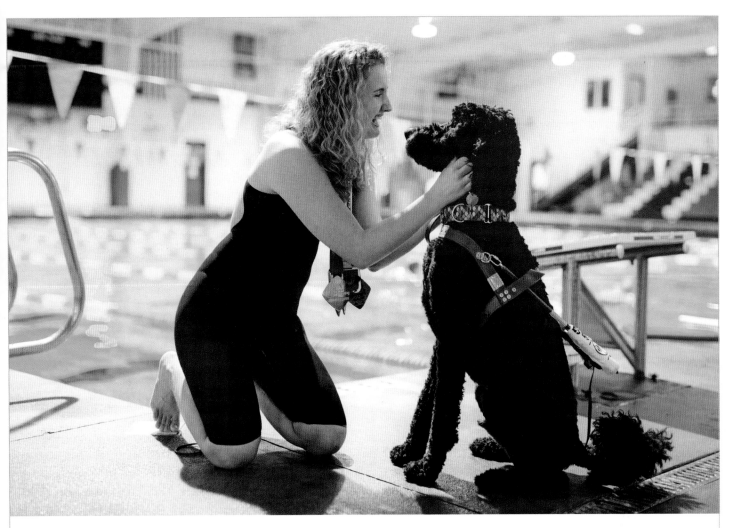

When I was eight, I began to lose my eyesight. It felt that my dreams of becoming an Olympic swimmer were dashed until I learned that I could compete as a blind athlete. I am a Paralympian who is a fighter in my everyday life as well as in the pool. I fight for the win.

McCLAIN AGE 22

I may seem shy and quiet when you first
meet me, but I am super chatty when I am
comfortable. I also have a stutter, so every time I
speak, it's likely I'll get stuck on my words. When
I meet someone new, I advocate for myself so
they are aware. People need to know that they
should be patient and keep eye contact with a
person who stutters. I also have a strong passion
for dance, and when I am dancing, I can express
myself through movement rather than words.
It's freeing.

JOLIE AGE 14

Most people do not realize that dancing is an incredible team sport. For a group dance to resonate "loudly," everyone on the team needs to execute their movements perfectly, in sync, and the same way. This means that the team members spend a lot of time rehearsing with one another and form bonds that extend beyond dance.

ANNA AGE 13

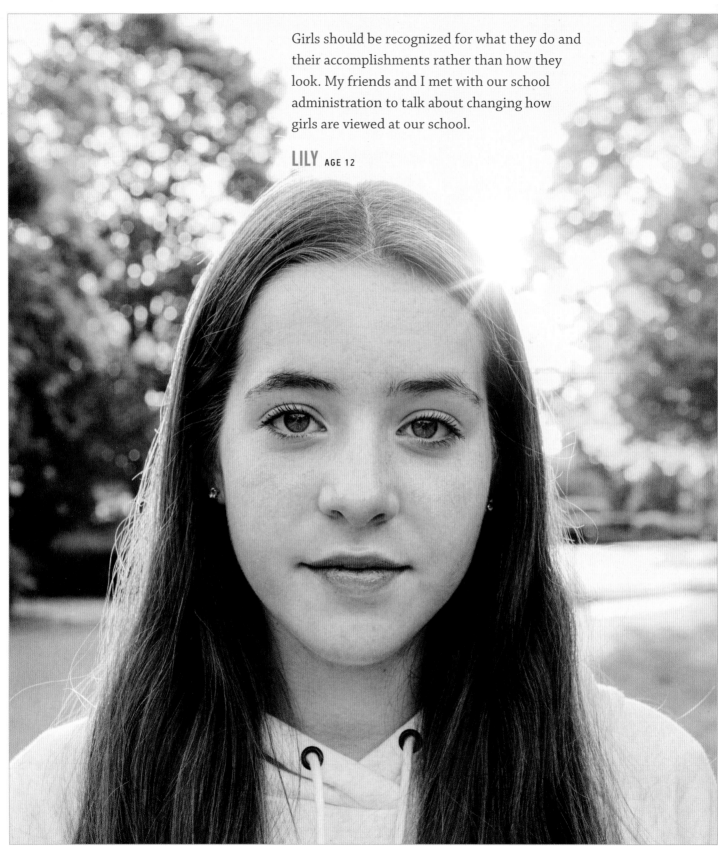

Girls should be recognized for what they do and their accomplishments rather than how they look. My friends and I met with our school administration to talk about changing how girls are viewed at our school.

LILY AGE 12

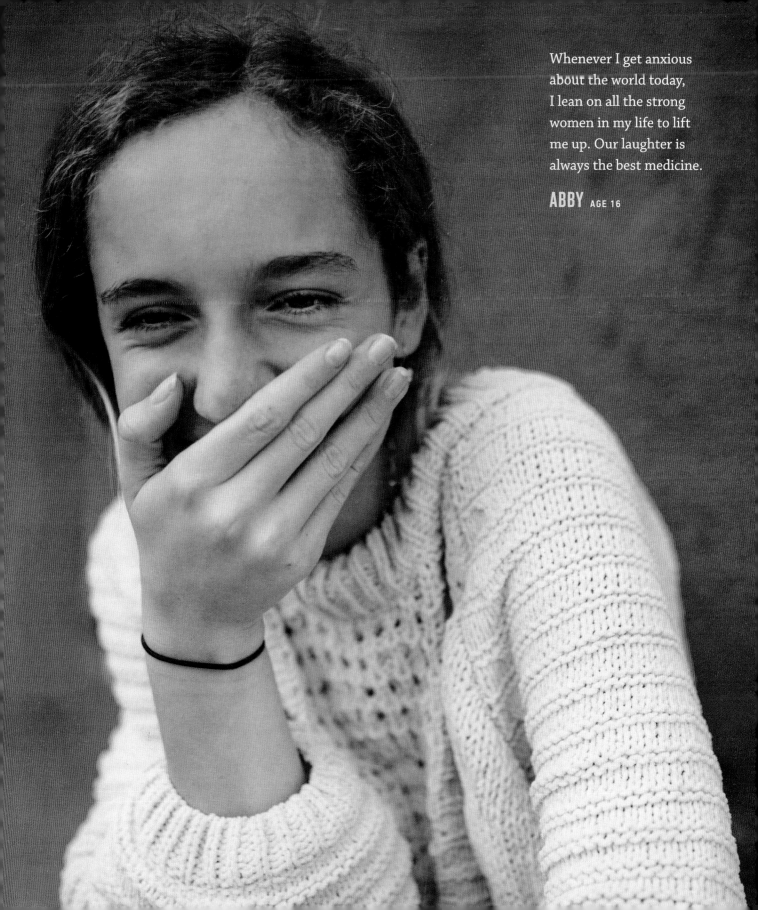

Whenever I get anxious about the world today, I lean on all the strong women in my life to lift me up. Our laughter is always the best medicine.

ABBY AGE 16

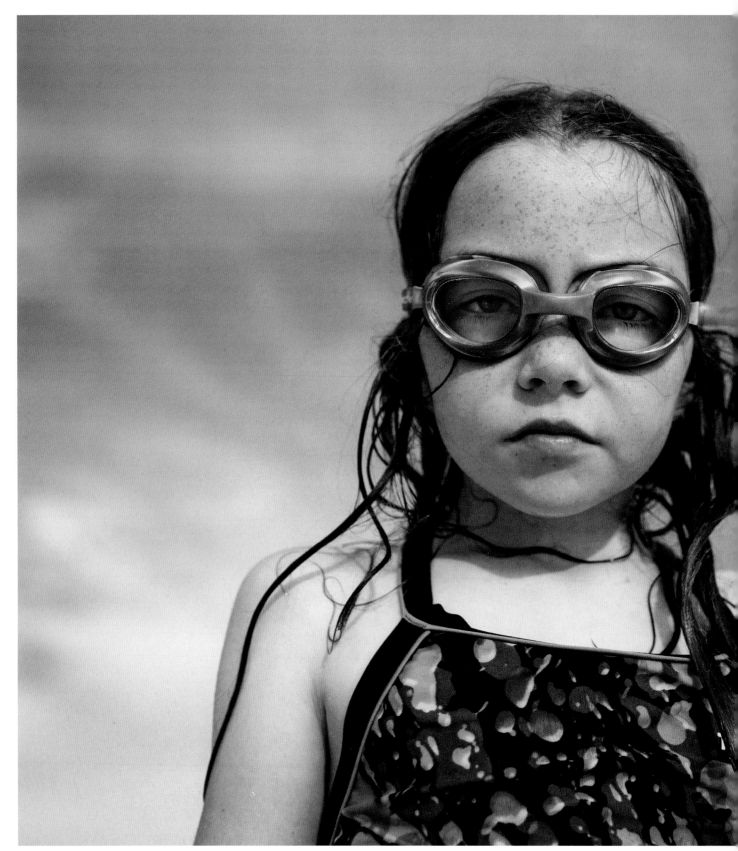

If you can make something change by using your voice or speaking up, why wouldn't you?

ALICE AGE 9

I've had arthritis since I was four years old. It's not always visible, so people don't believe I'm in pain. They don't understand how I can run one day and not walk the next. I've learned that I'm the only one that knows how I feel and that I know my body the best. I've learned that my voice is powerful to educate my family, friends, doctors, teachers, and coaches about juvenile arthritis and how it impacts my daily life. My voice helps everyone manage my care. I advocate for all people living with arthritis so we can find a cure.

EMME AGE 10

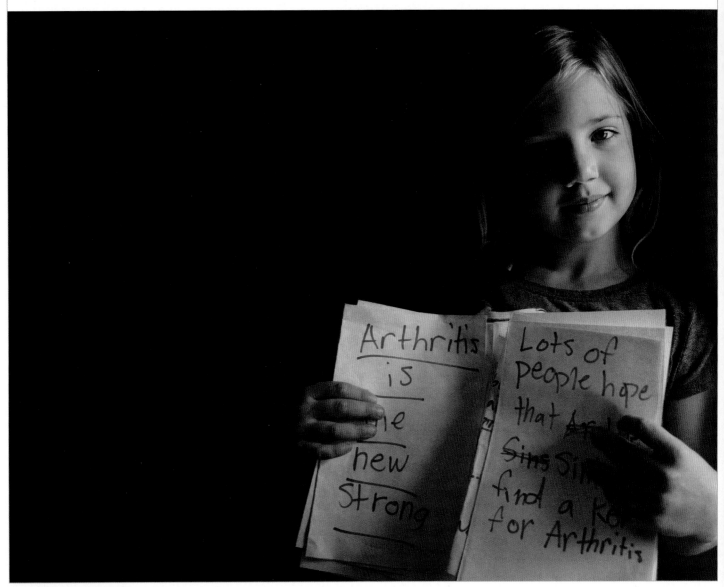

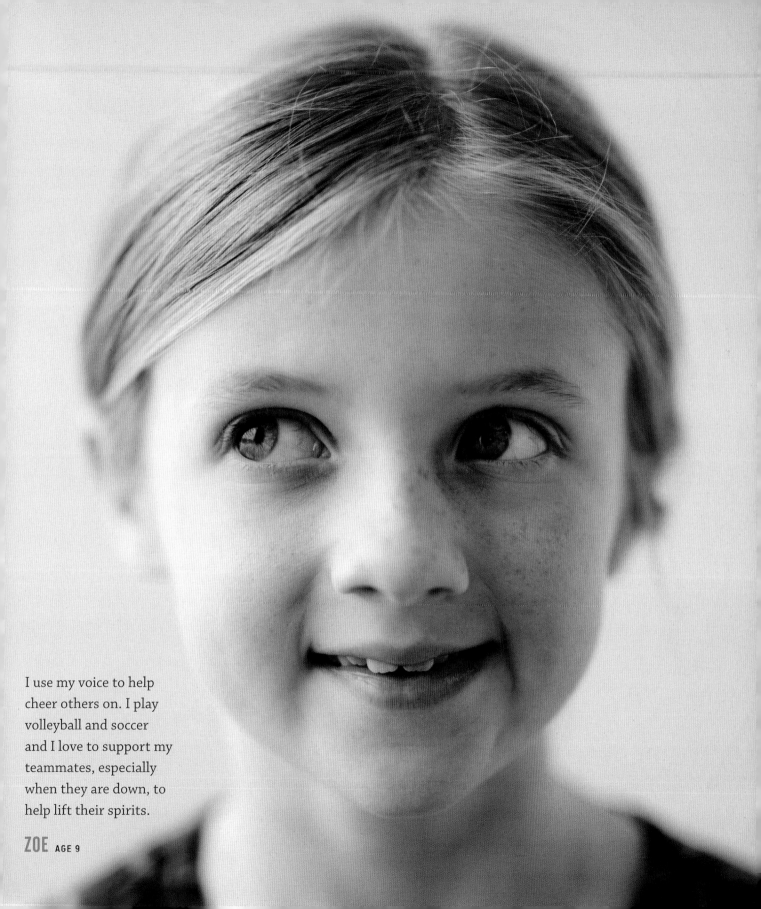

I use my voice to help cheer others on. I play volleyball and soccer and I love to support my teammates, especially when they are down, to help lift their spirits.

ZOE AGE 9

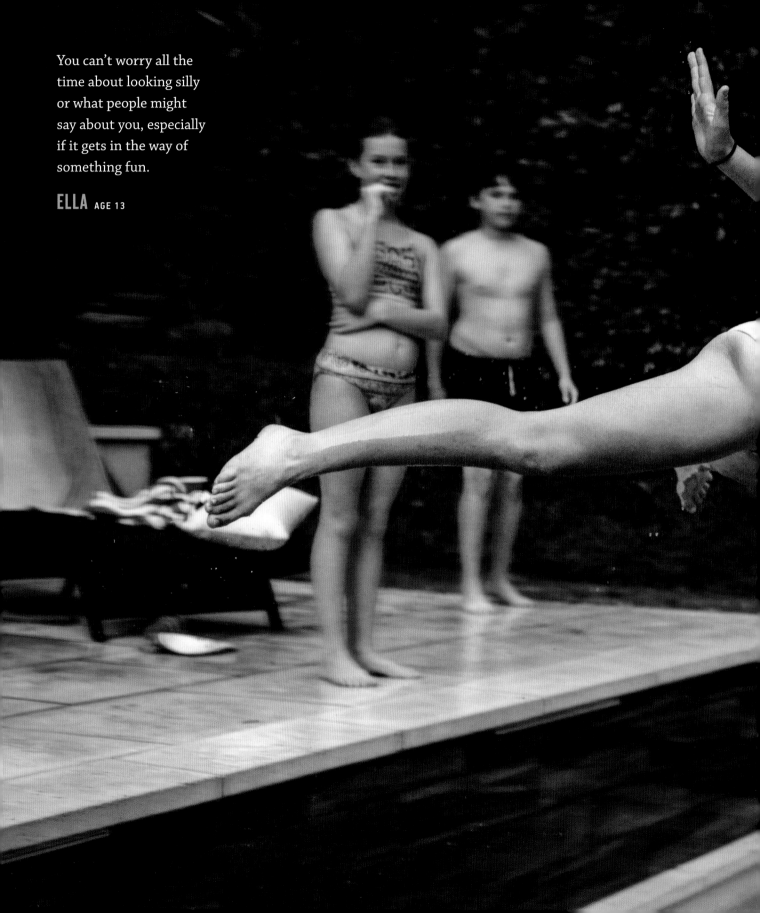

You can't worry all the time about looking silly or what people might say about you, especially if it gets in the way of something fun.

ELLA AGE 13

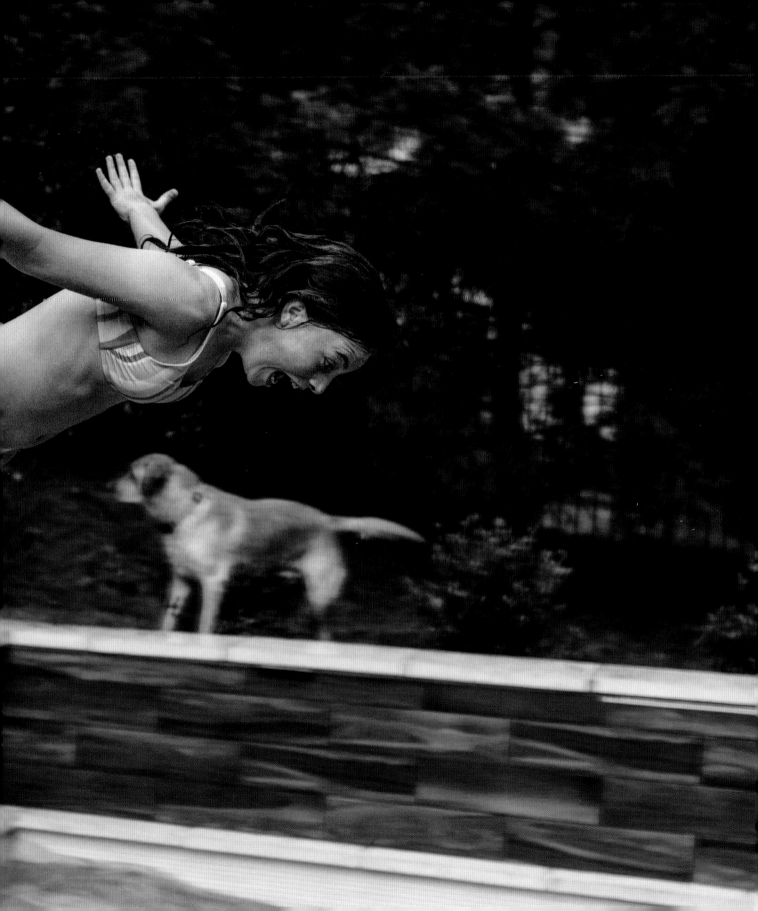

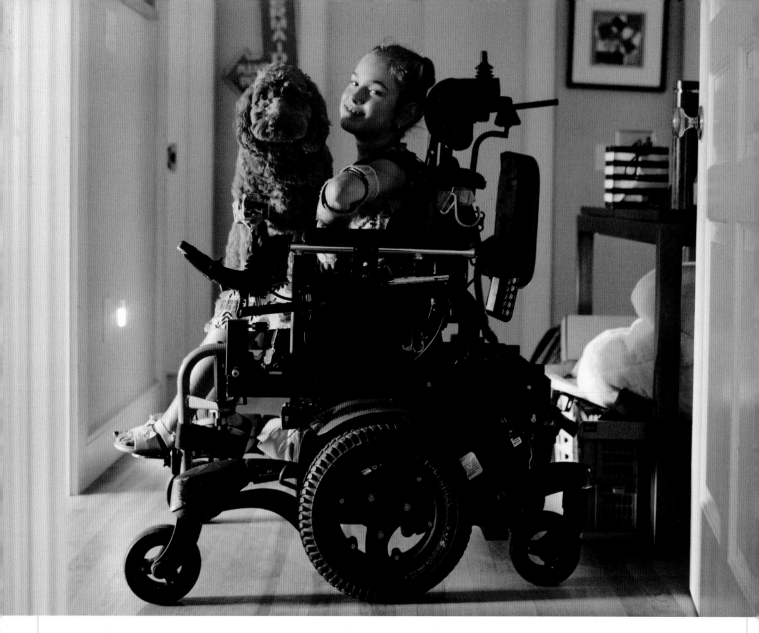

People with disabilities should be heard because we can find a way to do anything, even if we "can't" do it.

HARPER AGE 11

I was bullied when I was younger. Now I care a lot about sharing kindness, being positive, and supporting other people who might be in similar situations.

ALEXIS AGE 16

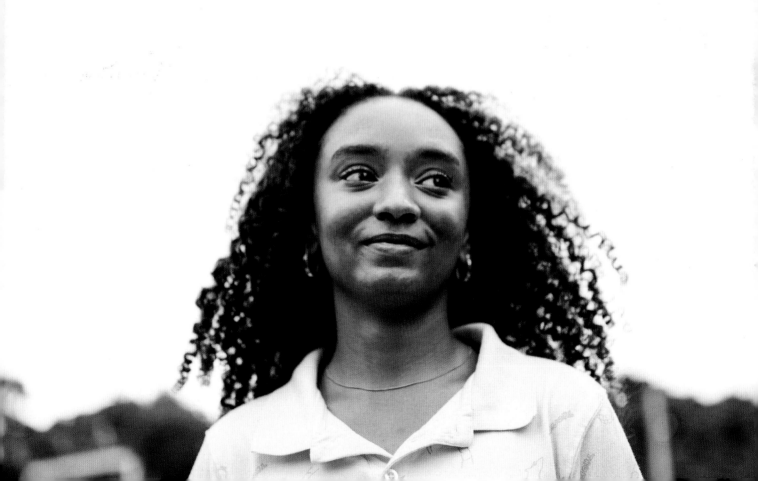

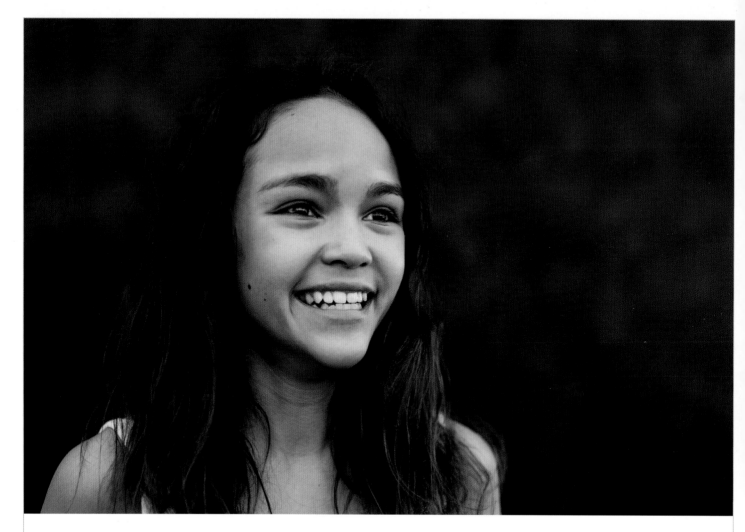

I use my voice to share my OCD and anxiety struggles with others so that other people who have similar struggles never feel alone, unsupported, or hopeless. I want to help remove the stigma of mental health disorders so people feel empowered to get the help that they need without feeling judgment or shame.

GABBY AGE 15

I am gender-fluid. My pronouns are she and they. Sometimes I feel more feminine and sometimes I feel more masculine and sometimes I kind of feel in between. I am who I am. It doesn't affect anyone else, and if they want to be in my life, they can be in my life. And if they don't, that's okay too. Either way, it's important that people know who I am.

LANIE AGE 16

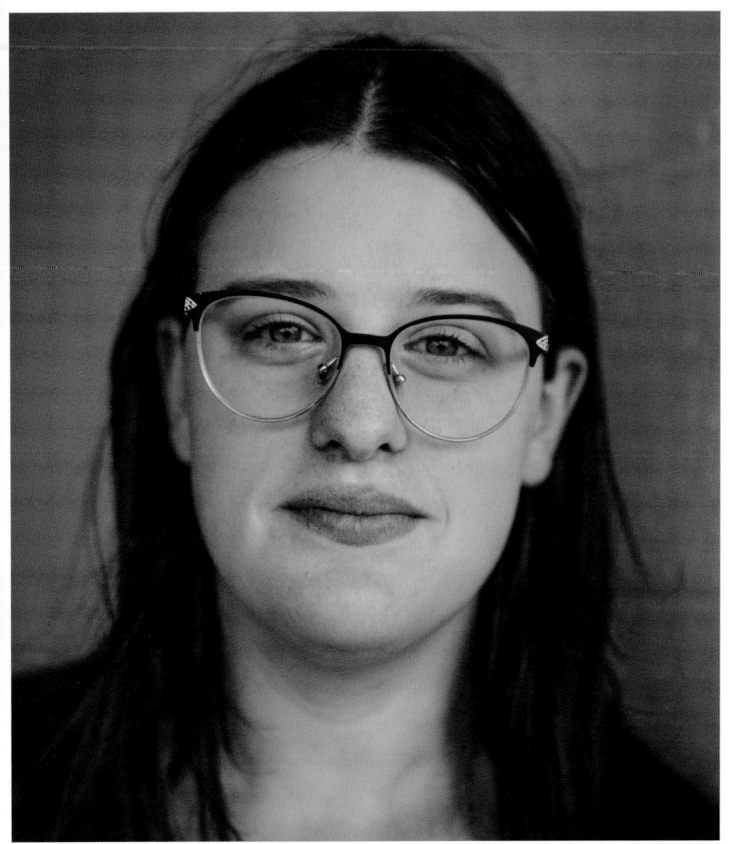

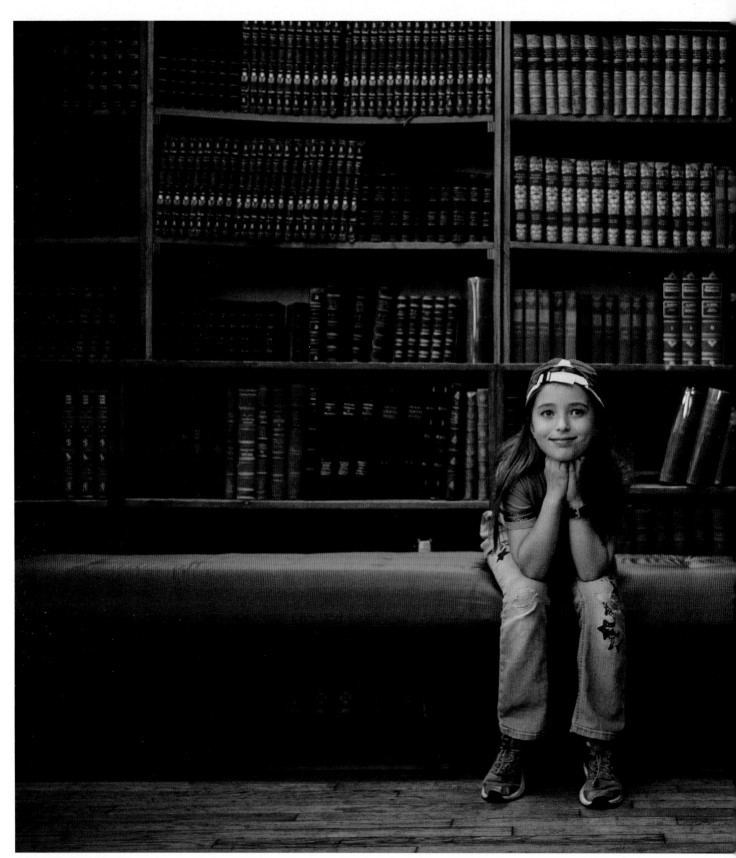

I love reading. Every book gives someone a voice, which gives birth to a million more voices. I especially love fantasy book series and the adventures of fictional heroes, but I'm also inspired by reading books about and by real people. When I was nine, I wrote a letter to an author because her book, a collection of stories about real people like me, gave me such confidence.

As I get older, I hope to use my voice to help inspire others to let their voices be heard. Together, we can be louder.

AVERY AGE 9

My whole life, I have felt a connection to the powerful women of the world. I knew I was a feminist starting at the age of five. I want to show girls that we are powerful, and that our voices can break down centuries-old barriers. Being treated equally should not be a privilege. I don't hide my opinions; I state them proudly. I raise my hand when I know the answer. I keep my head held high, and I know how strong I am. I dream of being like Michelle Obama or Malala Yousafzai with their power and confidence.

SERENA AGE 13

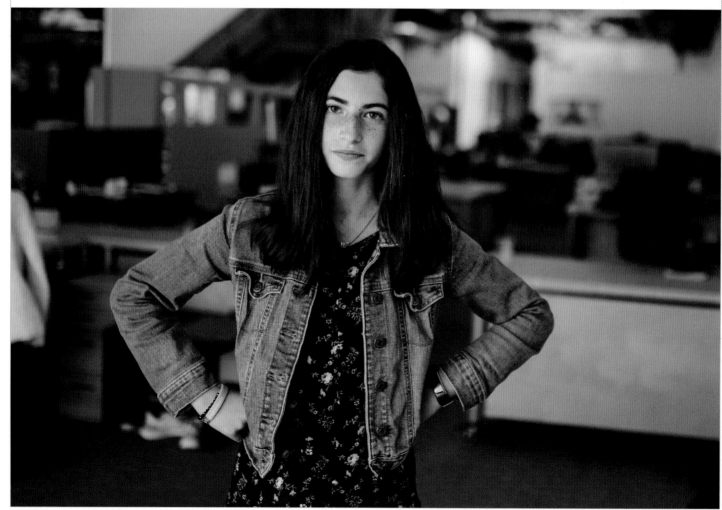

When I graduated high school, my mom asked, "Okay, what do you want to do for your graduation? You want to have a dinner?" I said, "I think I'm going to go to Peru." She was surprised and concerned, but I felt called to travel. And I had already bought the ticket!

Society values getting a degree and going into the workforce over finding one's place in a way that can culturally help to connect with other people. I feel like the pressure is on: "You have to do this by twenty. You have to do this by twenty-five. You have to do this by thirty." I don't want to wake up when I'm thirty-five and wonder, "What have I actually done? What have I seen? What life experiences do I really have?"

ELIZAVETA AGE 23

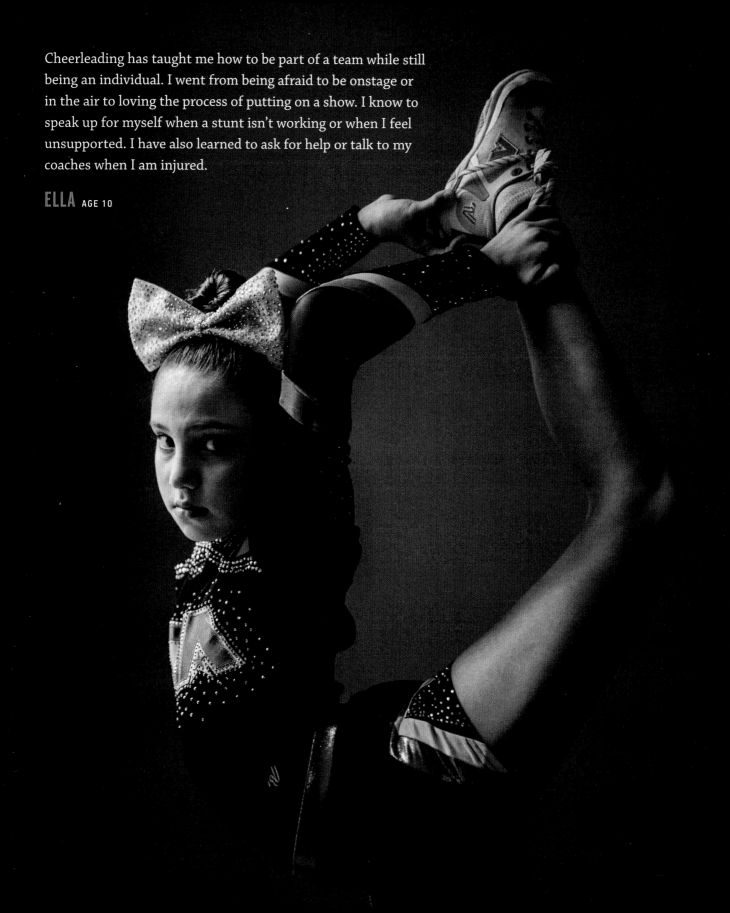

Cheerleading has taught me how to be part of a team while still being an individual. I went from being afraid to be onstage or in the air to loving the process of putting on a show. I know to speak up for myself when a stunt isn't working or when I feel unsupported. I have also learned to ask for help or talk to my coaches when I am injured.

ELLA AGE 10

I uso my voice to remind kids at school that everyone should be welcomed. I make sure to invite kids to be my friend even when others don't. I want everyone to love themselves and know that they can do anything they put their minds to.

JUSTICE AGE 14

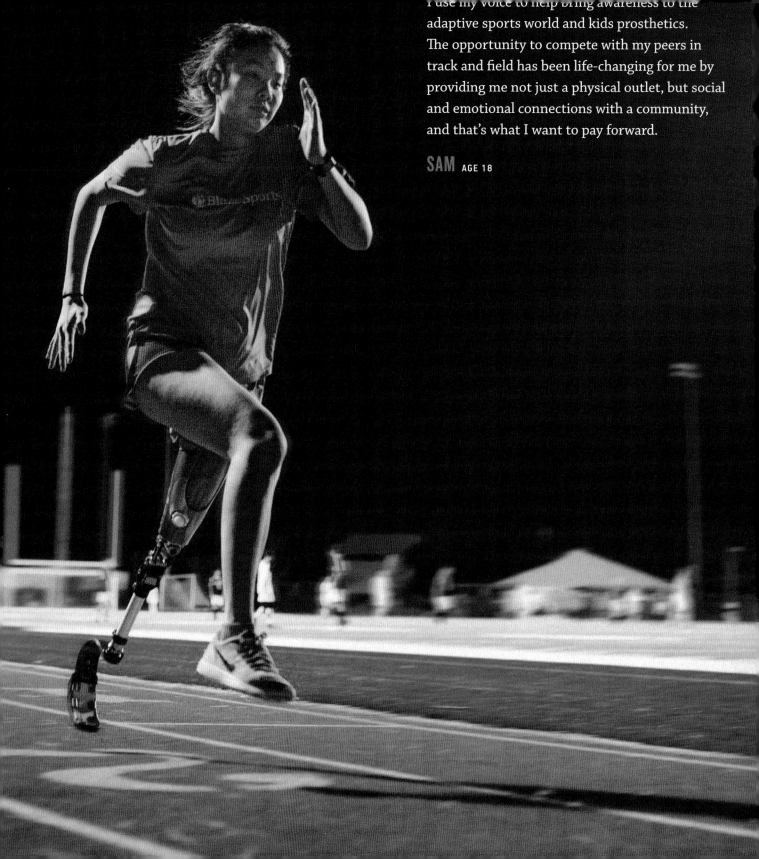

I use my voice to help bring awareness to the adaptive sports world and kids prosthetics. The opportunity to compete with my peers in track and field has been life-changing for me by providing me not just a physical outlet, but social and emotional connections with a community, and that's what I want to pay forward.

SAM AGE 18

AMPLIFY YOUR VOICE

GIRLS AND WOMEN HAVE MADE SO MANY STRIDES in terms of equality, but there is still so much work to be done. Our voices may go unheard. We may fall silent. We may be afraid to speak up or speak out for fear of repercussion. However, as uncomfortable or intimidating as speaking up can be, our voice is our power, and we need to wield it. As Madeleine Albright once said, "It took me quite a long time to develop a voice, and now that I have it, I am not going to be silent."

But beyond simply using them, how do we make our voices heard, and how do we cultivate the expectation that they will be heard? We can start at home by letting our daughters know that what they think and say matters. Seek out their opinions. Value their perspective. Don't allow societal conventions or gender norms to determine their paths. Let them define who they are, what their dreams look like, and how they want to achieve them. We can also share women's stories and support women's businesses and projects. We can be like Ace (page 147), giving voice to her siblings with Down syndrome, or Katelyn (page 151), who amplifies her voice through community outreach to help those in need.

Amplifying others' voices so we *all* can be heard is a through line in the stories I collected in this chapter—it's the "rising tide lifts all boats" mentality. Studies show that in groups, women are often interrupted by men or see their ideas go unheard until they are voiced by a male. Calling attention to this practice and positively reiterating what another woman (or other minority) has said is called "amplifying" and has been proven to work. Look for ways to give someone who is quieter or just finding their voice the space to share what they think or feel. Ask them. Listen to them. Women can be powerful influences.

In addition to amplifying others' voices, how do you amplify your own voice? Respecting your needs will help you develop the strength to lead by example. And though it seems counterintuitive, setting boundaries (and abiding by them) can turn up the volume on your voice. When your energies aren't being wasted by distractions, they can be injected into your message. If I say something, did anyone hear me? Did they listen? Was action taken? How do I adjust in order to make myself heard in a way that forces change?

I express myself through the art of acting. I love being onstage and in character. The stage allows me to express myself not only by assuming the role of a character but also by honing my acting skills, which I work hard to perfect. I love seeing the audience laugh, cry, smile, and clap; it's everything. It feels great when the crowd responds with a roar of applause.

JAI'NYE AGE 16

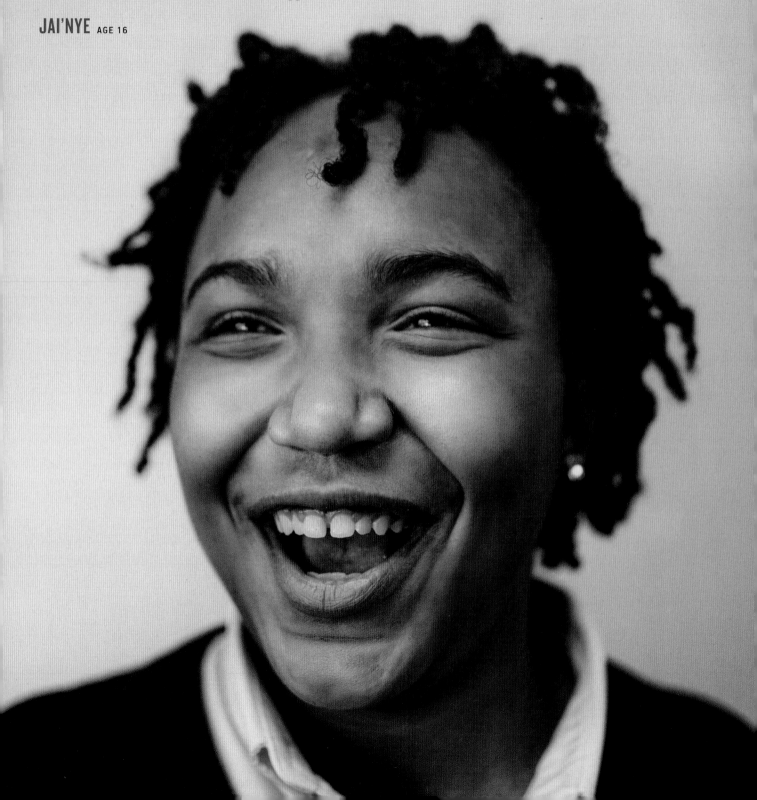

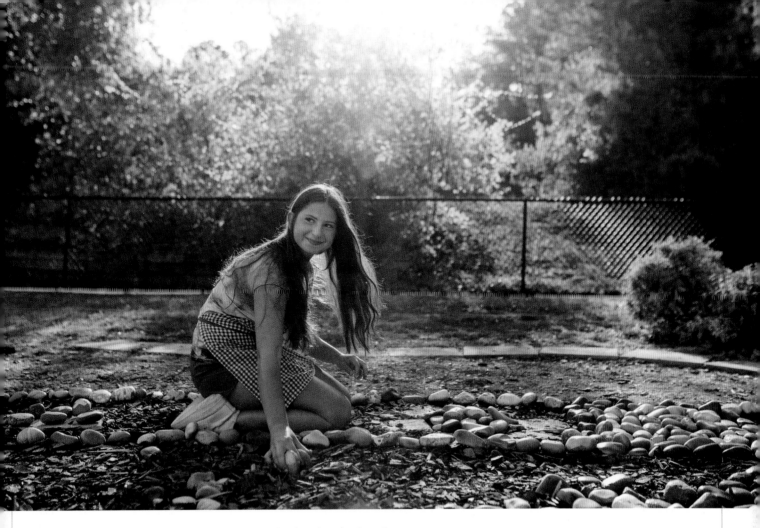

This is the Kindness Rock Garden. It can be hard to be kind, especially if you're going through your own stuff. I hope that people who need a boost can take one of these rocks and look at it and use the rock's message to help spread kindness. Kindness is such an important thing.

GABRIELLA AGE 14

I have used my words to speak out at many women's rights marches, including my favorite, the pro-choice protest this year. I participated in this march because I strongly believe that women's rights and health care are so important and that women should have the right to decide what happens in their body. This image is of me and my sister. My sister is my life; she means everything to me.

CHARLOTTE AGE 12

I went to the women's pro-choice march. My sign said, "My body, my choice," and on the other side it said, "My grandma already marched for this sh**." I love this picture because my sister is my best friend. I know that she will always be there for me, and I love her. The photo also symbolizes our friendship, and how we make each other laugh.

ROSEMARY AGE 10

ELIZABETH AGE 25

"GOD GAVE YOU A VOICE. Use it. And no, the irony of a nonspeaking autistic encouraging you to use your voice is not lost on me. Because if you can see the worth in me, then you can see the worth in everyone you meet." These words, from my 2022 valedictorian commencement address at Rollins College, tell you a great deal about my life's mission. An estimated 31 million people suffer in silence because they are affected by autism and cannot speak. My mission is to give them voices through typing so they can live happy, purposeful, and productive lives.

My fellow valedictorians selected me to represent them. It was the first time in the college's history that the students made a unanimous choice. They told me I had something special to share with the world. I worked on that five-minute speech for more than fifty hours. Every word consumed my attention and focus. And it was worth it. That speech changed my life.

Within days, the speech went viral. National TV networks and international news outlets carried the story, resulting in 4 billion media impressions. Large corporations and advocacy organizations reached out to ask how they could help. This one speech propelled my new nonprofit, Communication 4 ALL (C4A), onto a global stage. After a decade of advocacy, I knew I had to use this blessing to help those without a voice.

C4A emerged from my senior honors thesis, a one hundred-plus-page blueprint for collective action. I majored in social innovation and minored in English to learn how to be an effective advocate. My thesis offered a research-driven road map that helped to expand my network of allies for our mission.

As part of my thesis, I interviewed leaders in the disability rights movement to learn from their experiences. At the top of the list was the late Judy Heumann. At the end of our second conversation about her five decades of

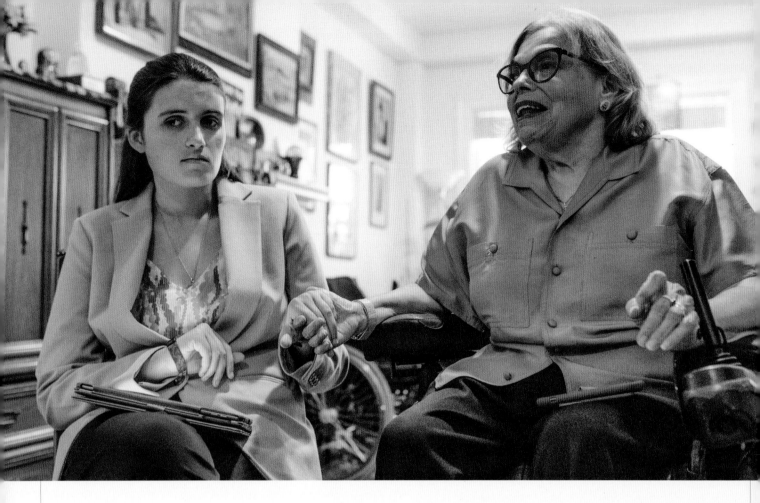

advocacy and my mission, she offered to be my mentor. Her friendship and mentorship meant the world to me. I could email or text Judy anytime to ask for her advice. Many evenings we would find ourselves on a video call where she consistently reminded me to think BIG.

With Judy's input, I zeroed in on two strategic initiatives: C4A Schools and C4A Academy. In C4A Schools, we start typer programs for nonspeaking students with schools that embrace innovation and inclusion. The Americans with Disabilities Act mandates effective communication for all students with communication disorders, yet schools routinely deny typing, which is often the student's method of choice. Our goal is for all nonspeakers to learn how to type so they may be educated. C4A Academy is our global initiative for families to teach typing to anyone in the world via the internet, free of charge. Through video-based lessons, we break down the process step-by-step. Expert coaches will be available as communication partners learn how to coach their nonspeaking family members to overcome their motor challenges and learn to type.

Another way I use my "voice" to advance our mission is through the power of music. Last year, I released

We all face obstacles. How we choose to respond to those challenges determines our paths in life. I encourage you to use your voice to serve others and celebrate your victories every day.

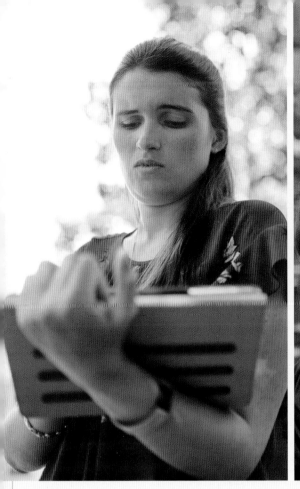
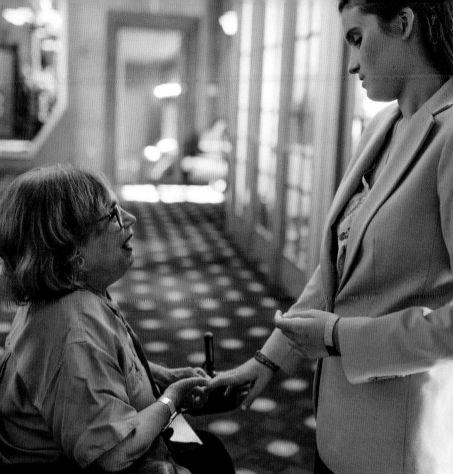

an album of advocacy songs, *I Am in Here*. I wrote the lyrics, and The Bleeding Hearts composed and performed the music. Virtually every "talk" I give includes one or more of these songs. In "Silent Cage," listeners feel what it's like to have no way to communicate. Music speaks to the heart so the head can listen.

Another song, "The Principal Principle," reflects a story I shared in my commencement address:

I have struggled my whole life with not being heard or accepted. A story on the front page of our local newspaper reported how the principal at my high school told a staff member, "The retard can't be valedictorian." Yet today, here I stand. Each day, I choose to celebrate small victories, and today, I am celebrating a big victory with all of you.

We all face obstacles. How we choose to respond to those challenges determines our paths in life. I encourage you to use your voice to serve others and celebrate your victories every day. Changing attitudes and creating positive change can feel like elusive goals, but as Martin Luther King Jr. reminded us, "The arc of the moral universe is long, but it bends toward justice." While it's easy to feel alone in our struggles, we are powerful when we join our voices together. Judy Heumann taught me about many things, including the power of collective action. Each of us can be a light in the world, and together, our lights will shine brighter. Join us at Communication 4 ALL and be a voice for the voiceless. Together, we can achieve communication equality.

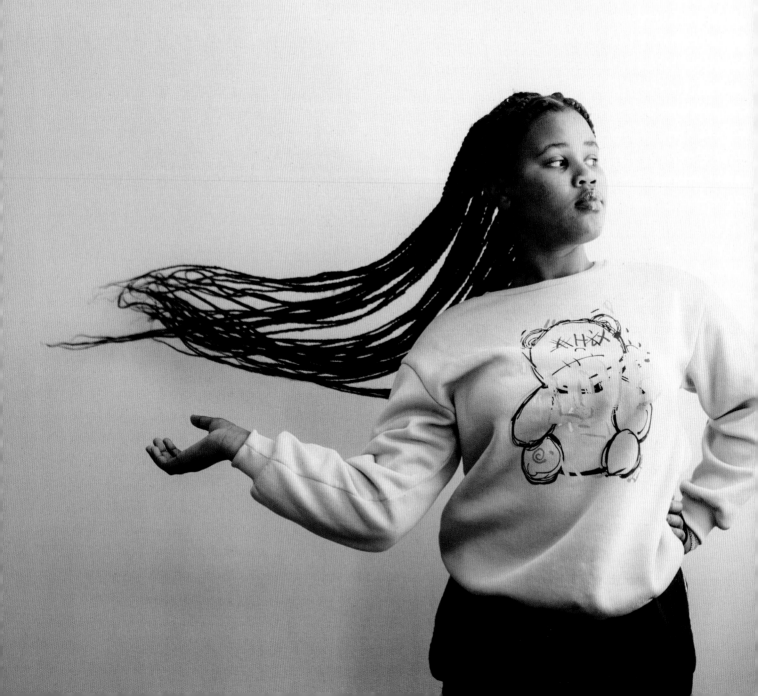

I came to America from Rwanda three years ago and it wasn't easy. Not speaking English well was hard, not just for me, but for everyone new to this country. I try to tell new people, "I know it's not easy but just stay patient." Be friendly to new people, just talk to them. In English, there's a hard word and then there's an easy word. Just talk to them in easy words, they might understand more.

DORCAS AGE 13

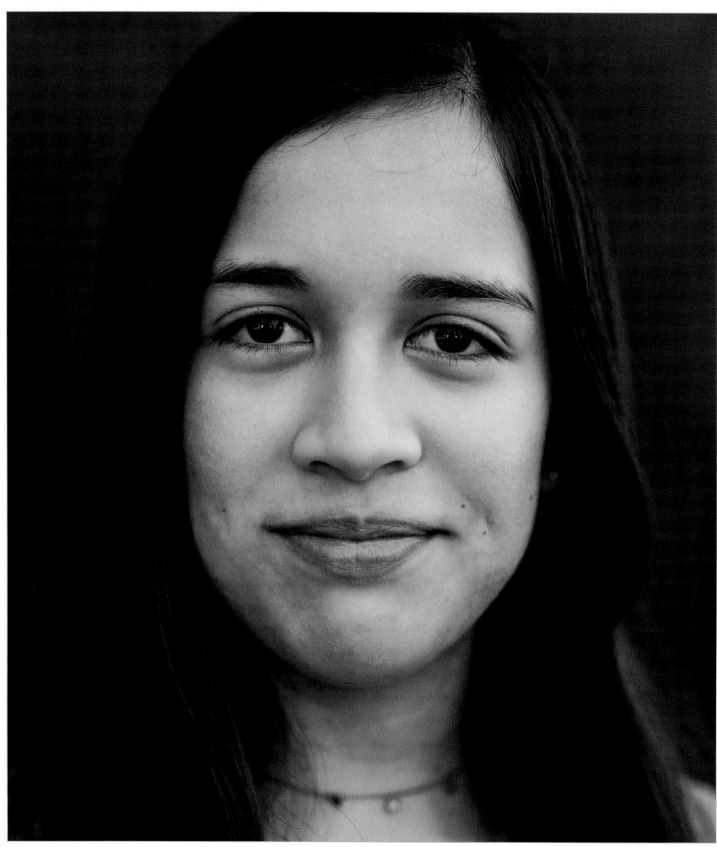

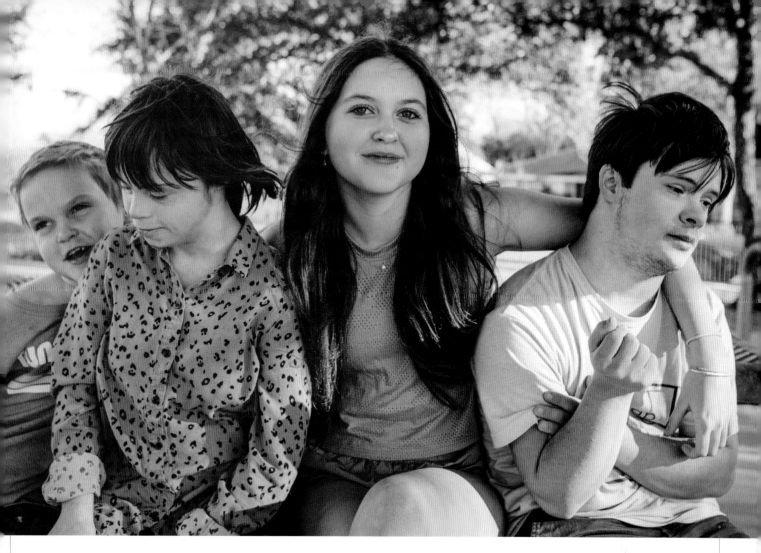

Two of my siblings have Down syndrome, and they're very special to me. People sometimes misunderstand them. I use my voice as their voice to help when I can. I just love them so much.

ACE AGE 13

I try to use my voice to speak out about what I believe, not influenced by what other people think.

CAROLINE AGE 12

I use my voice to make my ancestors proud. For over four hundred years in this country, my ancestors had no voice, and they had no choice. They were born, lived a difficult life, and died without ever having a say about their life. I hope I'm making them proud.

TAYLOR AGE 13

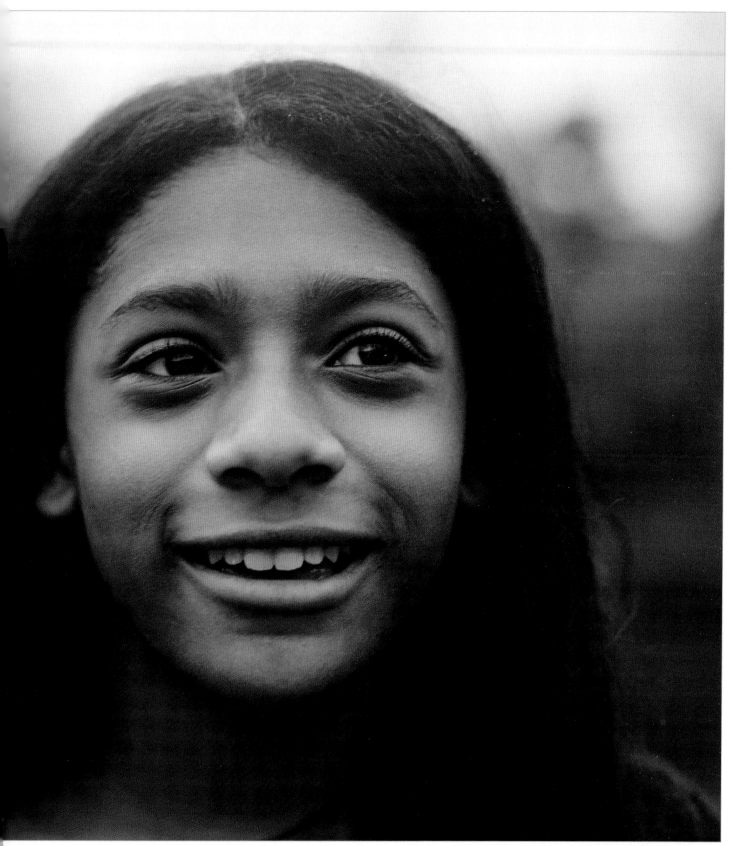

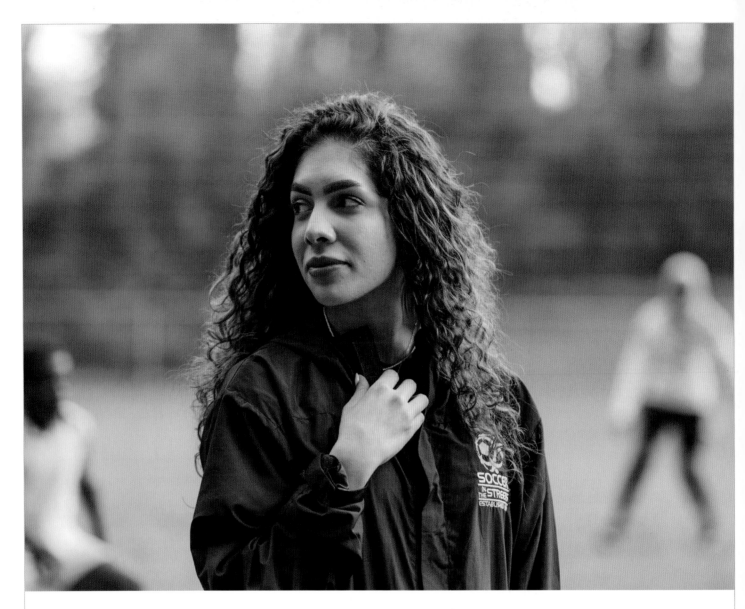

Your direction is more important than your speed. In other words, in the journey of life, the path you choose holds greater significance than the pace at which you move forward. Embrace the unwavering belief in your own abilities, for it is the key that unlocks doors to limitless possibilities.

SORAYA AGE 24

When I was in eighth grade, I worked on a project to help low-income families in my neighborhood collect underwear and socks for children. We made flyers to advertise our efforts and collected and catalogued and delivered the goods we received. I have learned to use my voice and my talents to help others in my community.

KAITLYN AGE 14

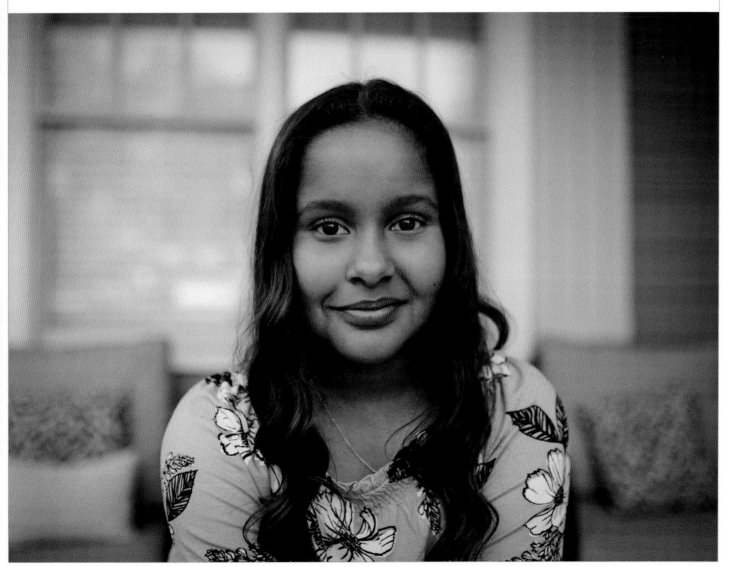

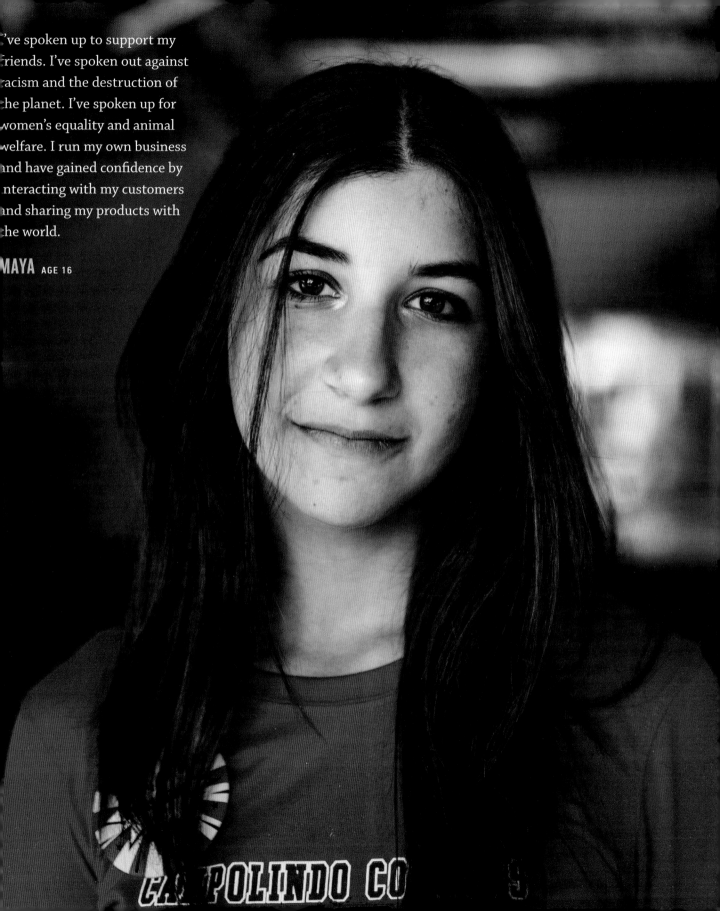

I've spoken up to support my friends. I've spoken out against racism and the destruction of the planet. I've spoken up for women's equality and animal welfare. I run my own business and have gained confidence by interacting with my customers and sharing my products with the world.

MAYA AGE 16

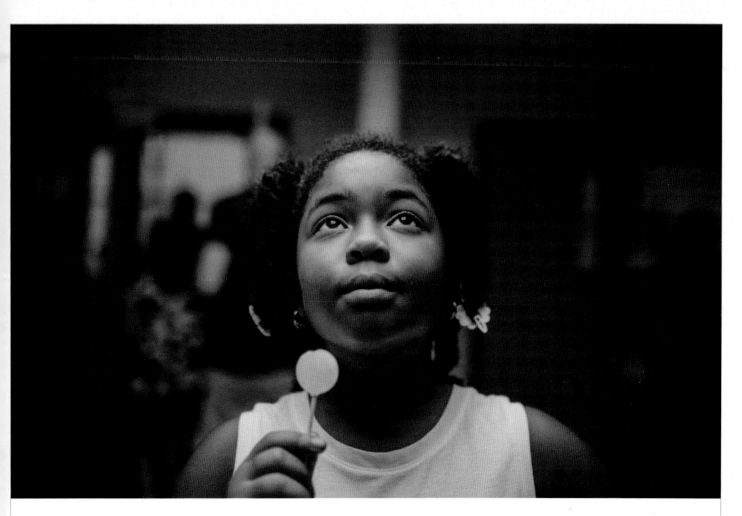

This image is of my daughter, Kaelyn, after trying out for basketball
for the first time. I loved how open she was to trying new things. I saw
the confidence that believing in herself gave her. Soon after this picture
was taken, she was diagnosed with a cancer that heartbreakingly took
her life. Her legacy continues to live on through friends and family
inspired by her confidence and bravery. I can still hear her voice.

KILAWNA, FOR KAELYN AGE 9

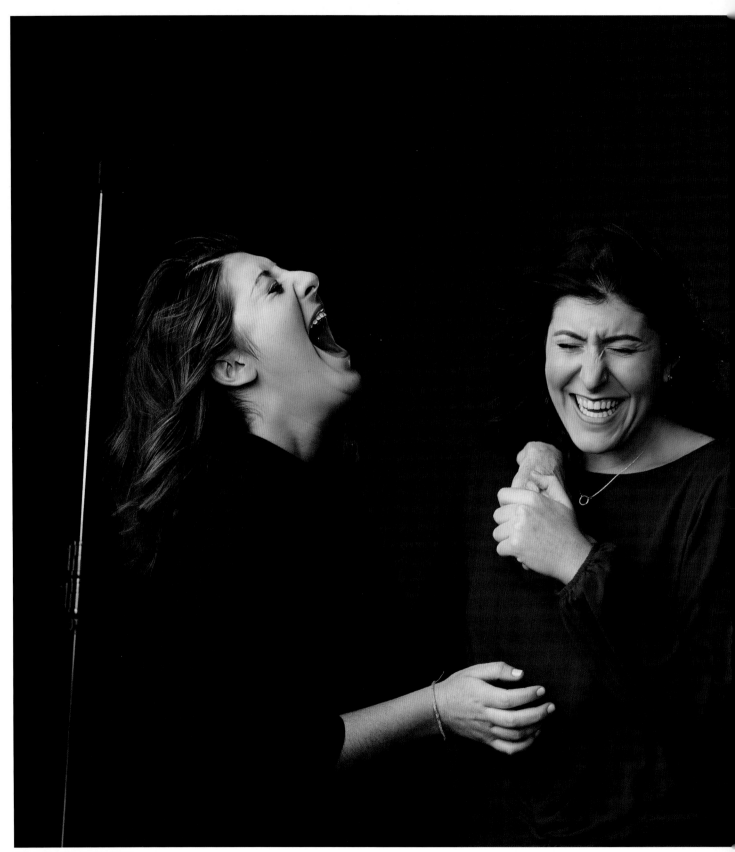

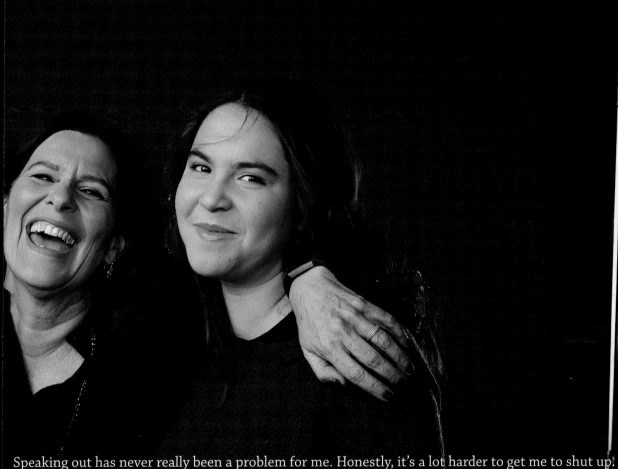

Speaking out has never really been a problem for me. Honestly, it's a lot harder to get me to shut up. I realize that this is an incredibly privileged position to be in, but it has really never crossed my mind *not* to speak out when something didn't feel right. I come from a family of exceptionally strong people. My mother is one of the strongest people I know. She's funny, sunny, courageous, and bold. My grandmother—Nana, as we call her—is a total force of charisma and charm. My great-grandmother Rebecca, whom I never met but have heard hundreds of stories about, was powerful and gracious (two qualities that not only can go hand in hand but also often support each other). Rebecca was a lawyer in the early twentieth century. If she could do that then, I feel unstoppable now.

KATE AGE 20 (WITH HER FAMILY)

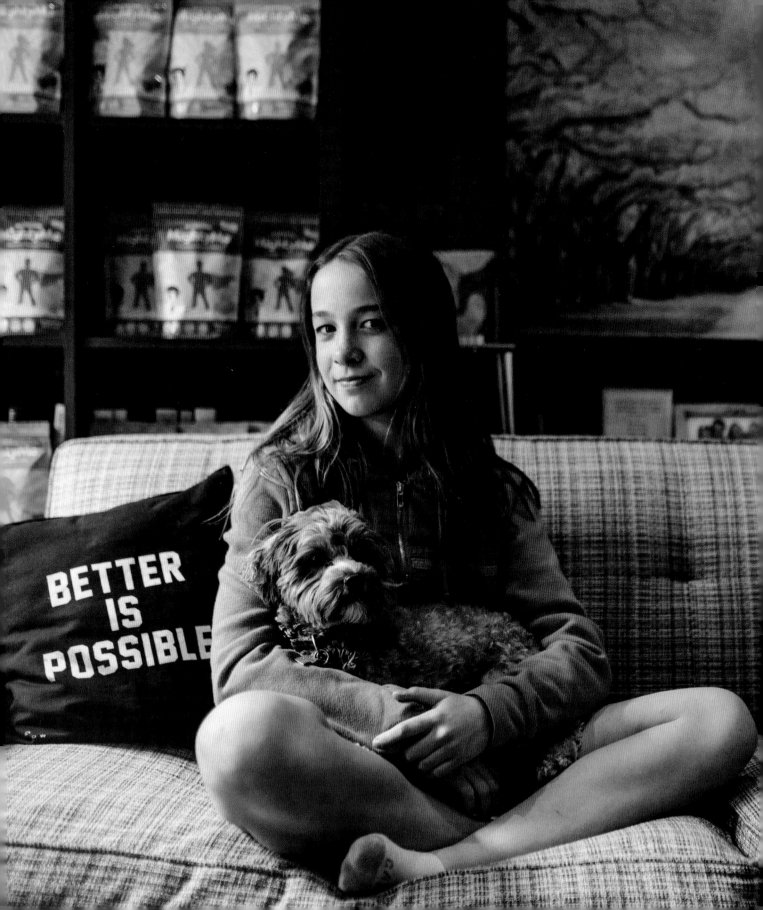

I'm allergic to tree nuts. I have to carry an EpiPen with me in case I have a reaction. Research came out after I was born showing that some food allergies can be prevented if babies are exposed to peanuts and other common allergens early on, before allergies develop. Because of my experience with food allergies, my family started a food company to help other families avoid getting allergies too. Our company is called Mission MightyMe, and the mission is to end the food allergy epidemic.

NIALL AGE 12

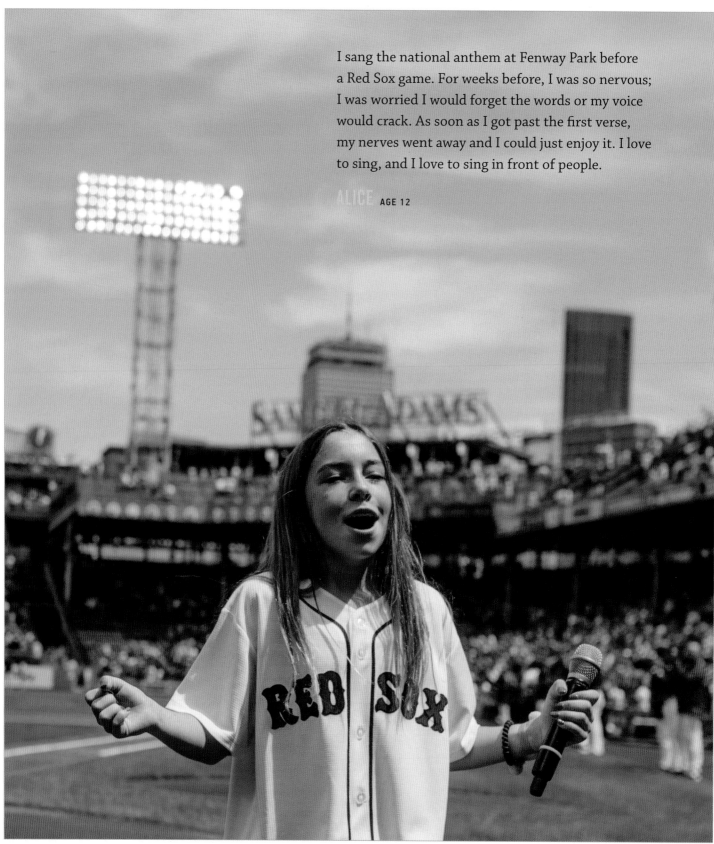

I sang the national anthem at Fenway Park before a Red Sox game. For weeks before, I was so nervous; I was worried I would forget the words or my voice would crack. As soon as I got past the first verse, my nerves went away and I could just enjoy it. I love to sing, and I love to sing in front of people.

ALICE AGE 12

People have to speak up and stand up for themselves. That can be difficult because it's not everyone's personality. But I think the most important thing is to work wisely, as well as loudly. As women, sometimes we can be too self-deprecating while being perfectly qualified for a job. I didn't go to film school, so it took me a while to say, "I'm a director." If you have a vision and a story to tell, you have just as much right to claim a moniker as anyone. So claim it—claim the thing that you are good at. No one is going to promote you as well as you can promote yourself. Of course there will be disappointments along the way, but you can only get a yes if you ask.

DAWN AGE 52

I was diagnosed with osteosarcoma, a bone cancer, when I was thirteen, and suffered through a life-changing surgery and nine months of aggressive chemotherapy. Now I raise money for the Rally Foundation, which funds research to find cures and kinder treatments for childhood cancer. I love to speak publicly for my charity and for childhood cancer awareness generally and have done radio and TV interviews, plus spoken at the Georgia State Capitol. I campaign because I do not want any other kid to go through what I have gone through.

ISLA AGE 13

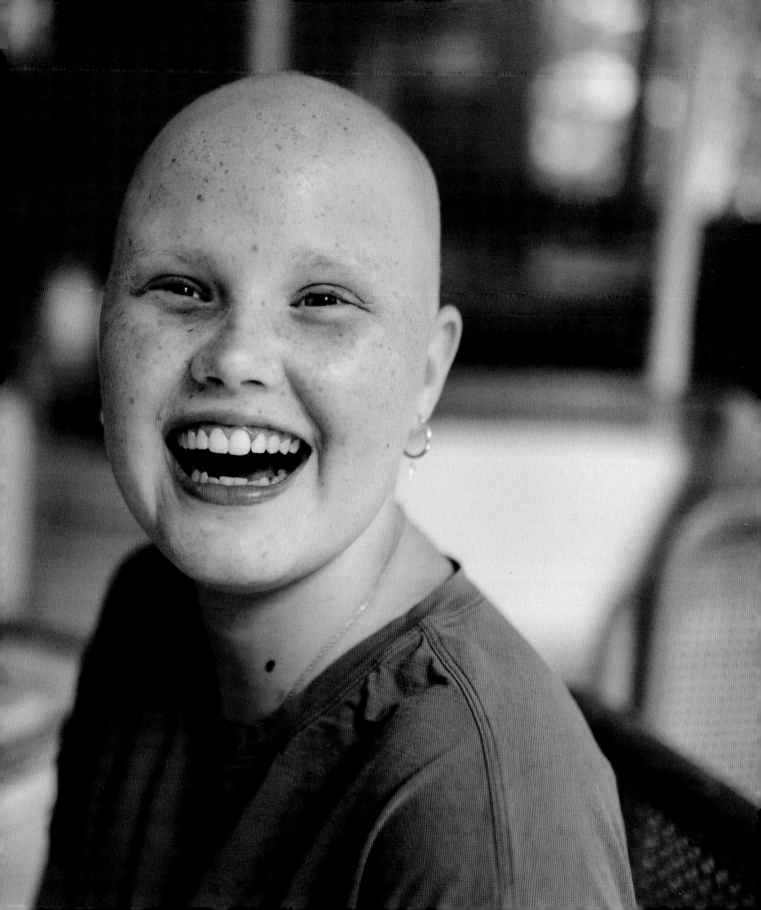

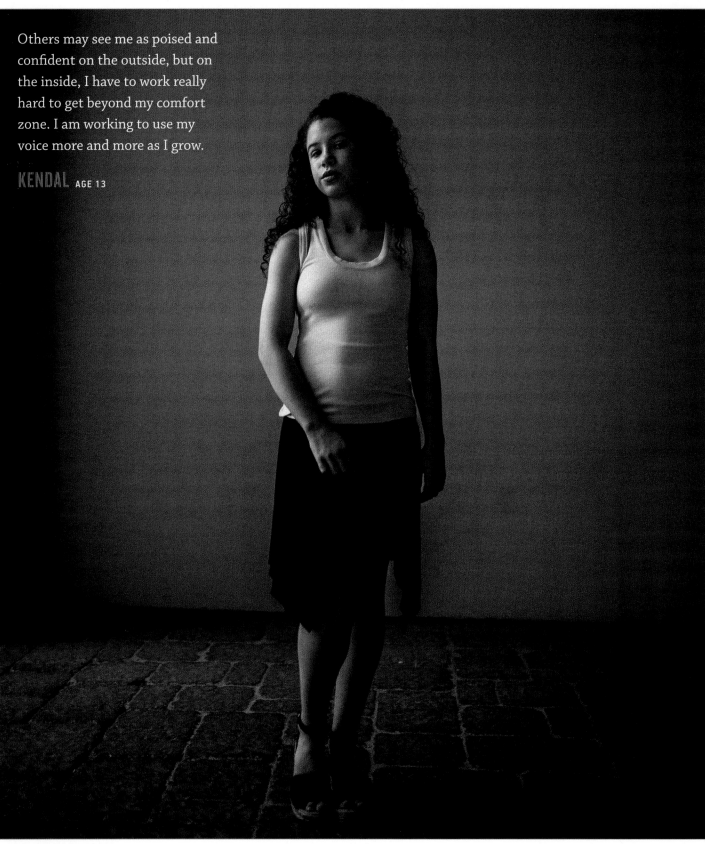

Others may see me as poised and confident on the outside, but on the inside, I have to work really hard to get beyond my comfort zone. I am working to use my voice more and more as I grow.

KENDAL AGE 13

I was Michael in my school's production of *Peter Pan*. I had to learn to not be afraid to speak in front of a large audience and my friends, and I realized that I actually love to act! I wish more kids knew they have a voice too. . . . Just because we are young doesn't mean we don't have a voice.

PRESLEY AGE 9

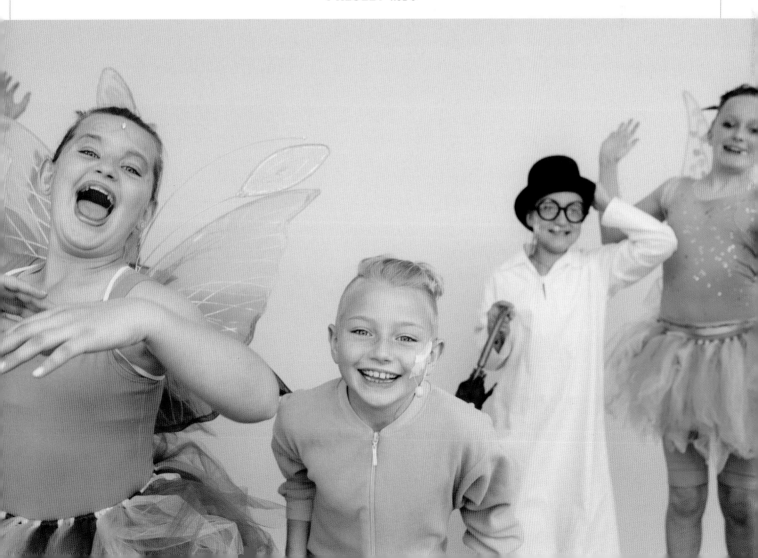

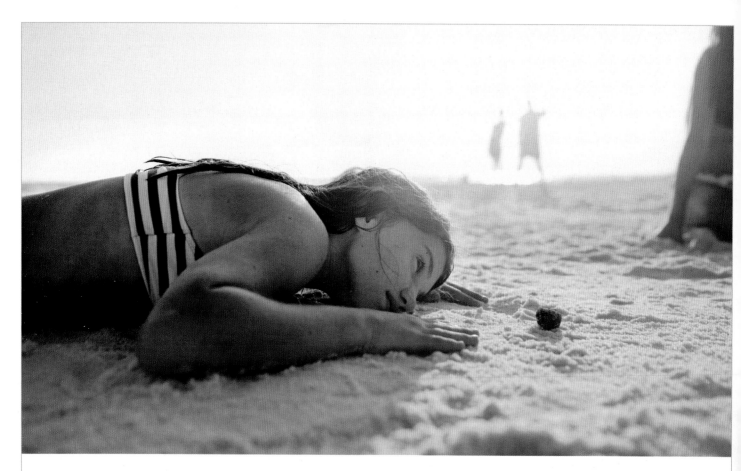

I had to be really quiet so the hermit crab would come out of his shell. Sometimes being loud scares them.

AVA AGE 12

I love using my voice to empower girls to use sports as a vehicle to be brave, to be tough, to have confidence, and to build self-esteem.

RITA AGE 46

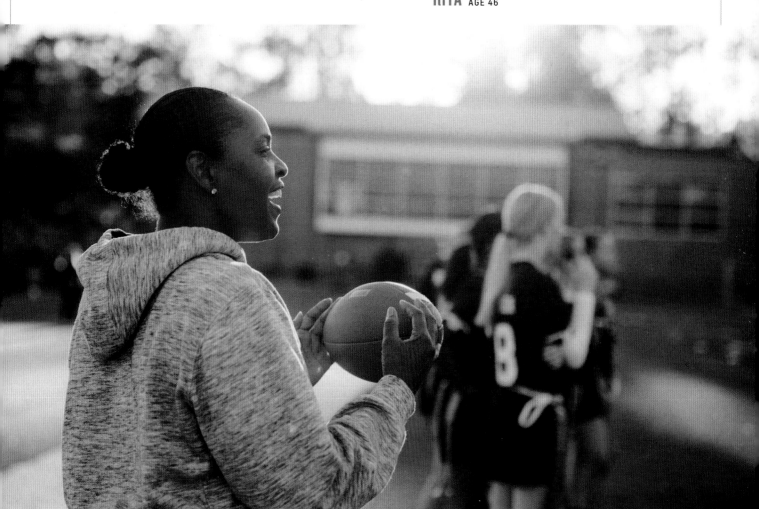

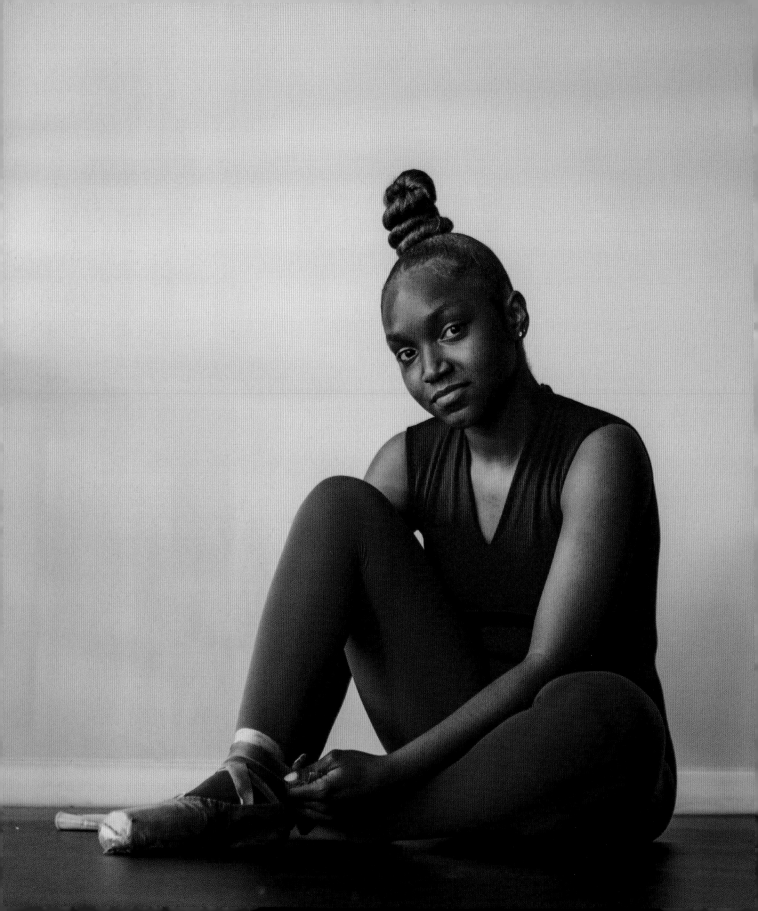

I take great pride in being an ambassador for Brown Girls Do Ballet. Brown Girls Do Ballet is an organization that promotes diversity in the arts by providing brown girls with a variety of ways to empower and impact their community. As an ambassador, I dance to help increase representation of underrepresented populations in ballet, which is our mission. When I dance, my movements tell a story: the story of a brown girl who loves the arts and the opportunity to express her inner feelings when she performs. I'm a brown dancer, an artist, an advocate, and a voice for the voiceless. My tights match my brown skin tone, which represents my past, my present, and my bright future. Can you hear me roar? Listen to me dance!

JAI AGE 17

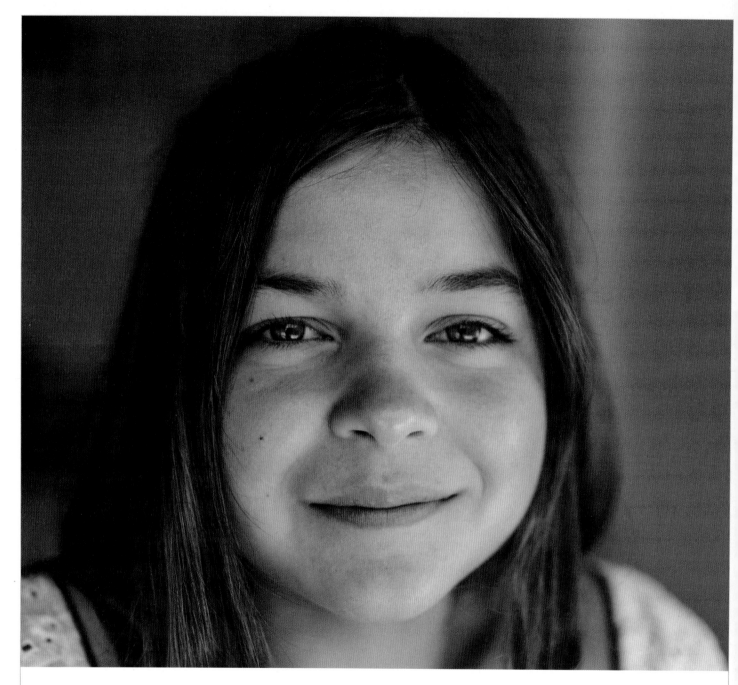

In my public speaking class, I was given an assignment to talk about something I cared about. I decided to talk about the effects of climate change and how regenerative farming can help reverse those effects, which I believe is super important to our future. After I gave my speech, my classmates became curious, and asked a lot of questions. This helped me realize the impact that I can have on others by simply talking.

SIERRA AGE 13

Shylah is our younger sister and she has autism. It's harder for her to do some things and pick up on social cues. If Shylah is upset, we try to help her calm herself down so she can use words and not just actions to express how she's feeling. That's the goal. We want to make sure that she knows she can use her voice even when it feels like she can't.

NISHAYE AND PRISEIS AGE 14 (WITH THEIR SISTER, SHYLAH, AGE 6)

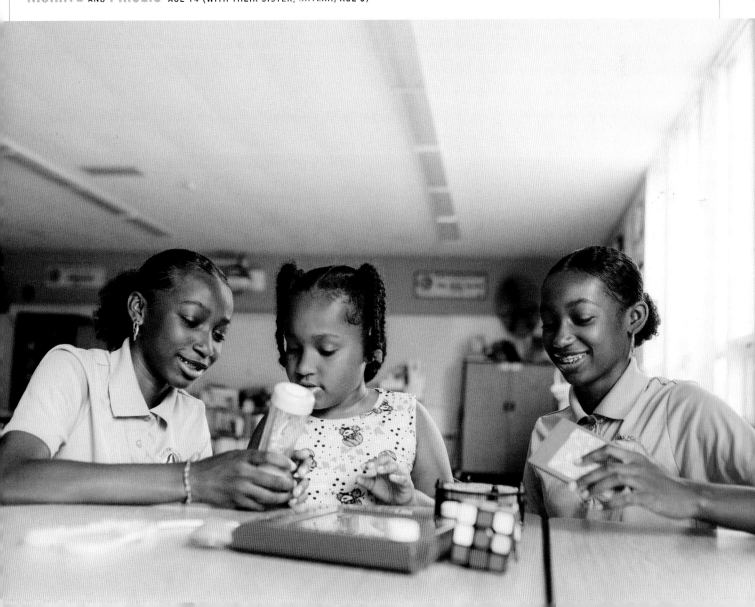

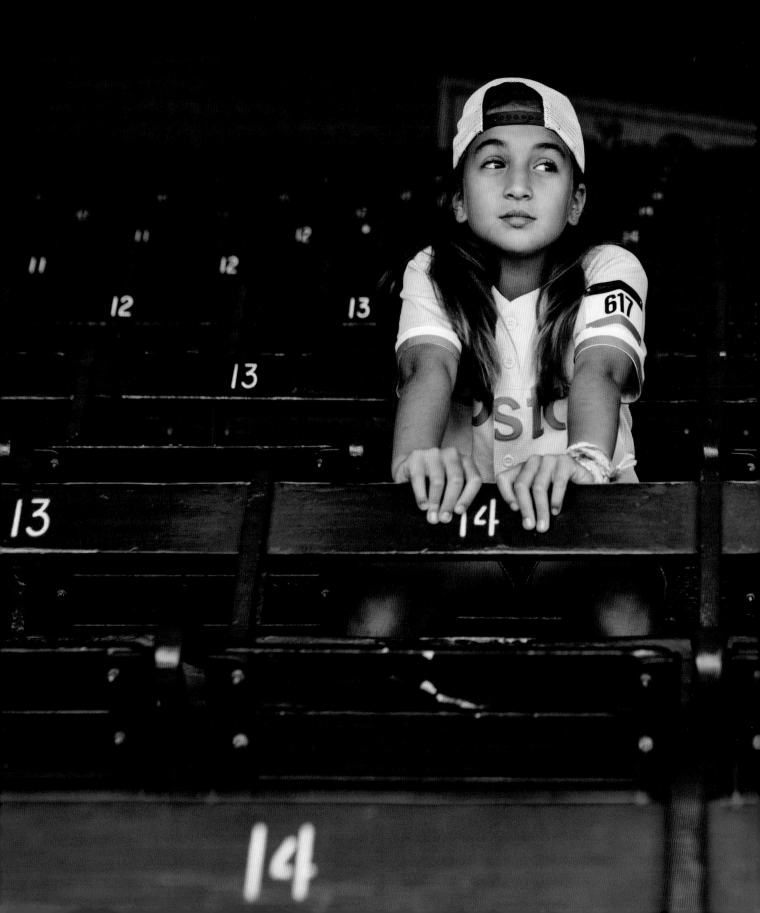

This year in fourth grade, all the boys played baseball at recess and wouldn't let the girls play. I love playing baseball, and this really annoyed me. This went on for a long time, and I finally was the only one who spoke up and said to the boys, "Let us play. What's wrong with that?" Then we all did. You should never be overshadowed by other people only because you're a girl.

STELLA AGE 10

When I was fifteen, I lost my sister—my best friend. Ever since that day, my mission has been to bring light to people all around the world about childhood cancer. I believe the only way to bring attention to something is to use your own voice; that's what I hope to accomplish each and every day. Through Smasherson, the foundation my family created to honor my sister, I am able to tell my sister's story to so many people and help them understand how important it is to support these causes. I am bringing light to my sister and what she went through.

REGAN AGE 18 (WITH HER SISTER, EMERSON)

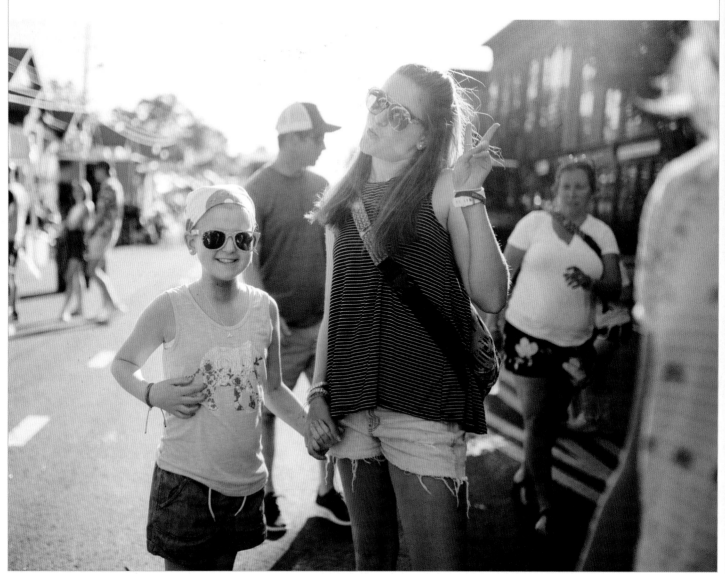

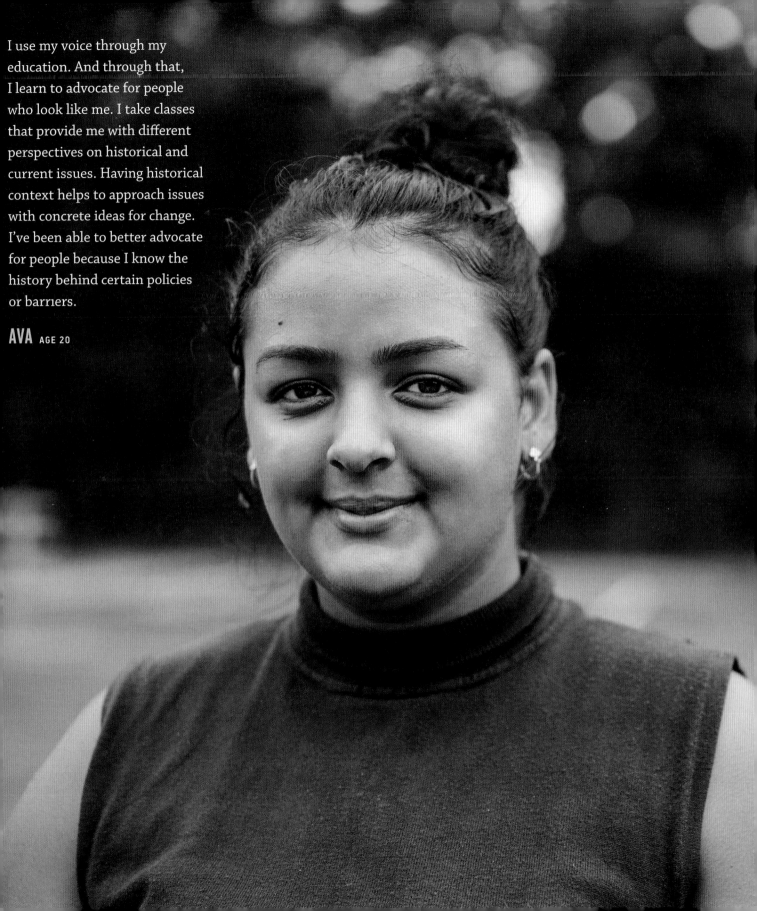

I use my voice through my education. And through that, I learn to advocate for people who look like me. I take classes that provide me with different perspectives on historical and current issues. Having historical context helps to approach issues with concrete ideas for change. I've been able to better advocate for people because I know the history behind certain policies or barriers.

AVA AGE 20

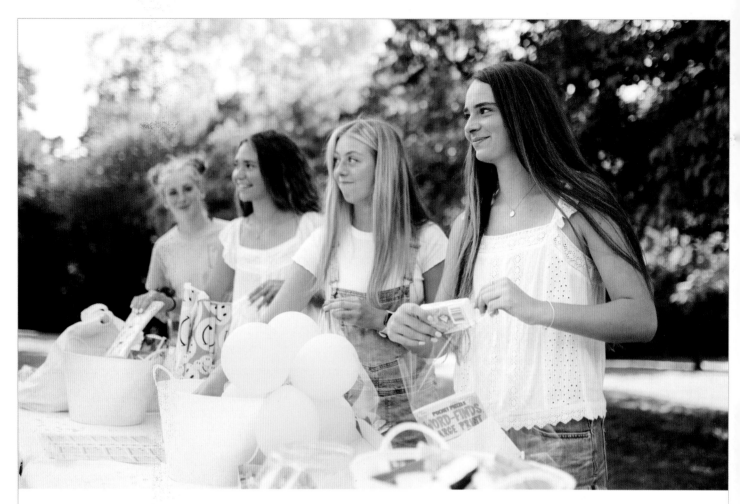

Our families started a nonprofit together after our moms were diagnosed with cancer. We really wanted to find a way to give back to the community that had helped us so much during a really hard time. We pack gift bags—just a little something like a handmade blanket—for patients receiving care where our moms received their treatment. Seeing the smiles on the faces of patients and knowing how much it means to them is really fulfilling.

JOJO AGE 17

At thirty-seven years old, I was diagnosed with stage 3C breast cancer. I had no family history. I discovered my enlarged lymph nodes, listened to my gut, and advocated for myself until I got answers. I earned the title of "Survivor," and it feels damn good! It's so important to know and listen to our bodies. If something doesn't feel right, speak out . . . it may save your life!

This image is of me shaving my head before round two of chemo. This photo brings me joy— and all the emotions of that day—every time I see it. Joy because I was surrounded by my family and friends. I can feel the strength and love that was being transferred to prepare me mentally for one of my greatest challenges. At that moment, I knew I could conquer anything.

AMY AGE 42

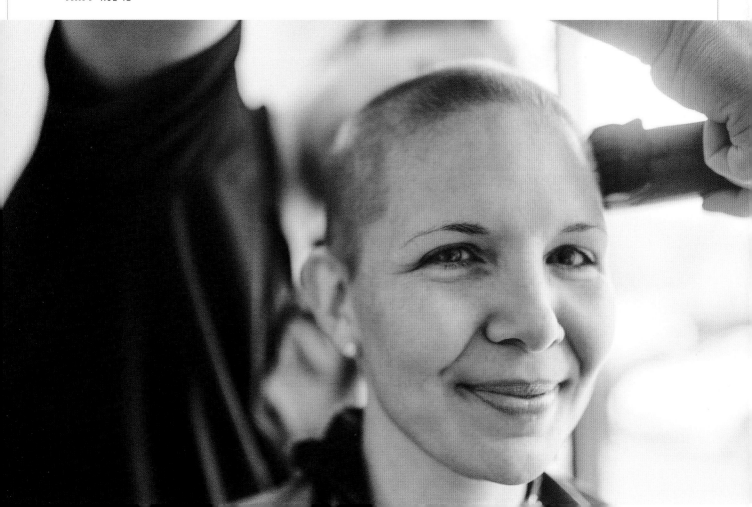

I want to know why there aren't any girl basketball players on the wall. It's not fair.

ALICE AGE 6

LINDSEY AGE 18

FROM A YOUNG AGE, I was aware that my identity as an Asian American girl influenced the way others viewed and treated me. By virtue of the community I was raised in, I found myself surrounded by politics and social justice issues as I got older. I gradually became more involved with advocacy and joined various identity-based clubs throughout high school. Working with organizations such as the Stop AAPI Hate Youth Campaign and coleading my school's Women's Student Union (WSU) gave me direct experience in policy reform and taught me how to initiate conversations about identity and advocacy and how to simultaneously work within and around the system.

I got involved in the WSU in my freshman year, alongside my friends who would later become my copresidents. Even before joining WSU, we ate lunch together every day, and after being inspired by WSU's booth at the club fair, we took a chance and attended a meeting. Throughout that year, we worked on projects related to Brett Kavanaugh's appointment to the Supreme Court. The next year, we attended club meetings less regularly, but when there were school-wide walkouts after a list of "boys to watch out 4" appeared on a girls' bathroom wall, we quickly reengaged in WSU's mission. A lawsuit alleging the school's failure to investigate an assault in a classroom on campus led to widespread demand for action from the school district, culminating in walkouts in 2020. Nearly the whole student body was out in the courtyard that day, holding up signs covered with phrases such as "We want change" and "Enough." The rest of the day was

> **Nearly the whole student body was out in the courtyard that day, holding up signs covered with phrases such as "We want change" and "Enough."**

spent listening to students speak about their experiences with sexual violence—their own and how it affected the people they love. I felt like I was in a daze; nothing felt real. As emotional and draining as this day was, however, it was also empowering, and it clearly demonstrated the support and passion of our student body. The next day, we went to the district office with an explicit list of demands, which were discussed with the superintendent. The walkouts and the ensuing demands would end up shaping the work my peers and I did in my senior year.

Effects of the Covid pandemic stalled our efforts, but when my friends and I were offered leadership positions in our junior year, we jumped enthusiastically into the venture. Though our school remained virtual for the 2020–2021 school year, we built a supportive and tight-knit community through weekly Zoom meetings where we discussed current political happenings and updates on Title IX work at school. More importantly, we talked about our days and how we were feeling, and played games. Our club gave underclassmen who had never actually been in high school a place to feel a part of the school community. These meetings were the highlight of our weeks, and it seems that the same can be said for our members.

Junior year was also the year that we took on our biggest project yet—a lawsuit against the U.S. Department of Education. In August 2020, Betsy DeVos—the Secretary of Education under President Trump—implemented numerous additions to Title IX. These new regulations severely limited the protections of those reporting Title IX

violations and decreased the school's responsibility to investigate, while increasing protections for the accused. I remember the day these regulations were publicized, our group chat swelled with angry yet discouraged messages. What could a group of high schoolers possibly do about a federal law? Turns out, we can use the power of the law ourselves. As we navigated building a case and taking it to court, we learned about how the law could be used as a form of protest. Although the lawsuit did not succeed, the Biden administration announced an executive order that overturned the DeVos regulations the same day our lawsuit went public. I gained invaluable experience that has shaped the way I approach the world. I was shown how age does not define our impact; the most important thing is a commitment to making positive change. Being able to advocate for myself has been one of the most valuable skills I have learned, so I use my voice to share my knowledge, passion, and power with others.

In my senior year, we returned to in-person school with high hopes to reform my high school, beginning with a new Title IX coordinator. Our district has a long track record of not being able to hold on to a Title IX coordinator for more than a year due to the low pay and enormous caseload. Working with the Sexual Harm Action Committee at my school, I interviewed candidates for the position when our previous coordinator unsurprisingly quit. We landed with our current coordinator, who has thrived in the position for over a year now. She has been the supportive figure we needed to get real, tangible change. Together we reworked the demands from the 2020 walkouts, worked on implementing a more efficient reporting system, and spread Title IX awareness through workshops and posters. There are still many changes to be made in our school and in the law, but I can look back and confidently say that we made a difference, and that's enough for me.

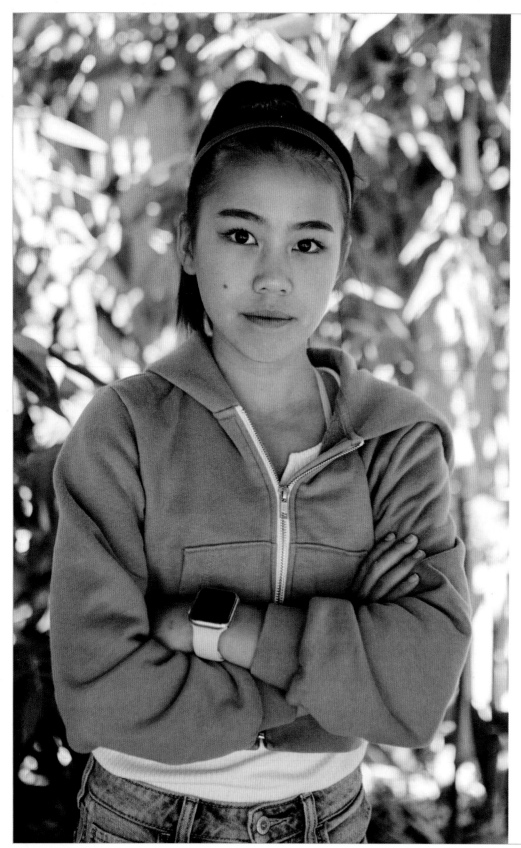

In my eyes, it's okay not to fit the mold. Everybody's unique and holds power in being different. I use my voice to speak up for the people I care for when they aren't able to do it themselves. My voice acts as a hand that pulls people up when they fall down. Speaking up about what matters to me takes courage, but I know that my voice can make a difference and provide freedom in not only my life but in other people's lives too.

EME AGE 13

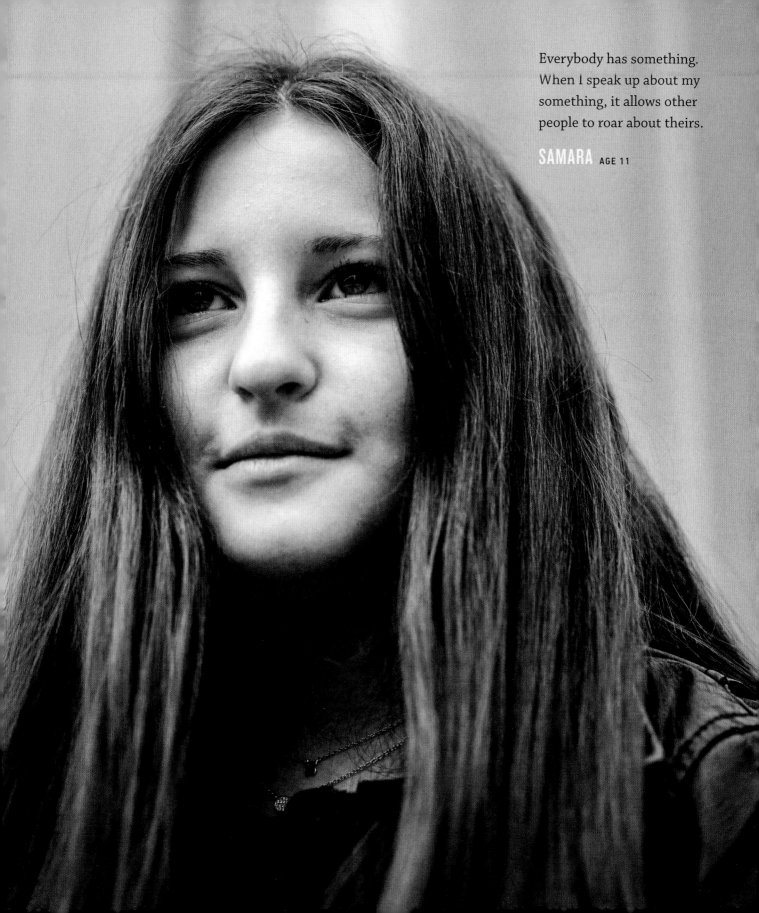

Everybody has something.
When I speak up about my
something, it allows other
people to roar about theirs.

SAMARA AGE 11

We are a team, and if one of us is down or has a bad game or makes a mistake, we need to hold that person up. You have to be positive toward them and make sure that they're feeling better. And you need to say, "Pick your head up," because it's all about positivity and attitude. We all have a voice and need to use it out there on the field.

PEYTON AGE 14
(WITH HER TEAMMATES)

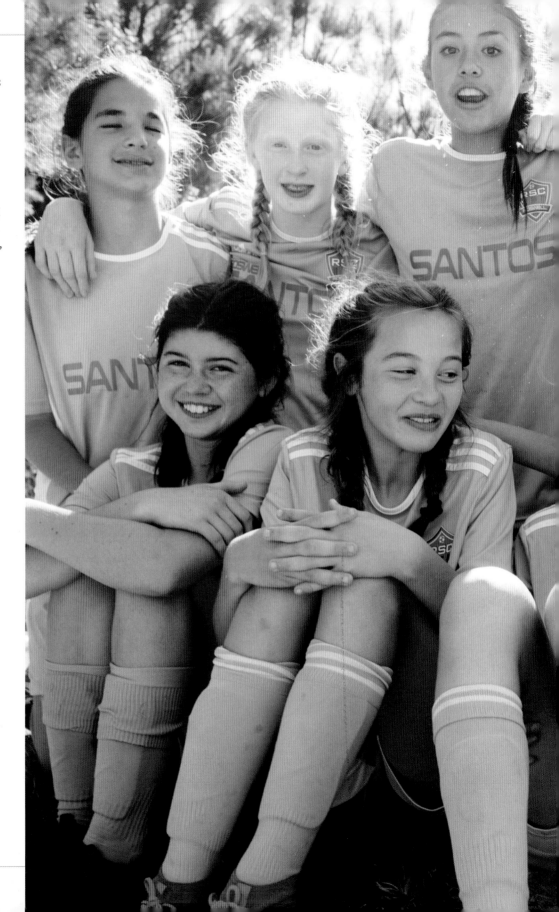

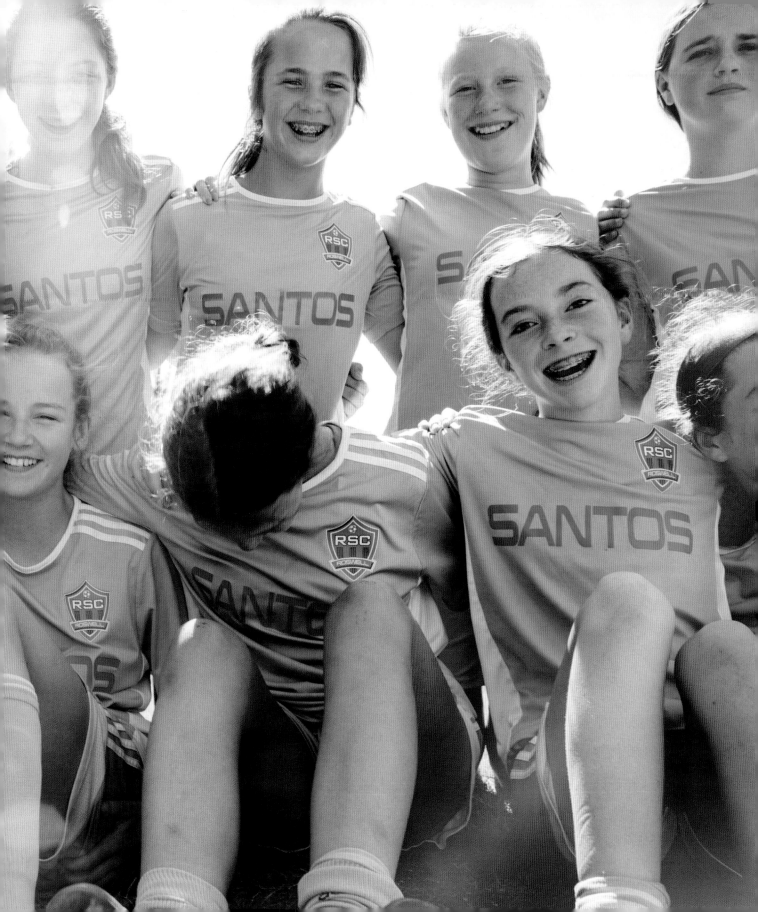

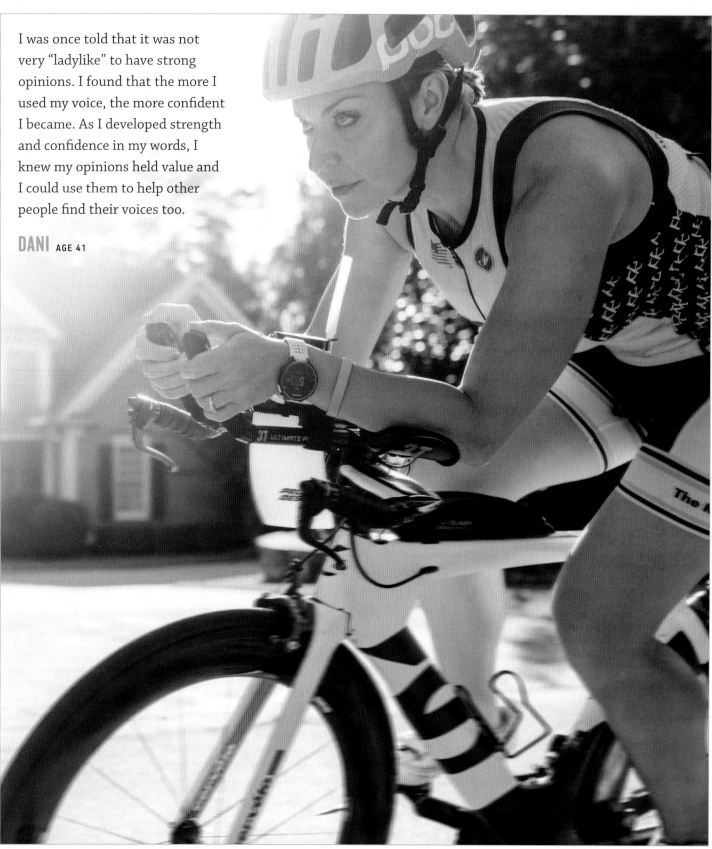

I was once told that it was not very "ladylike" to have strong opinions. I found that the more I used my voice, the more confident I became. As I developed strength and confidence in my words, I knew my opinions held value and I could use them to help other people find their voices too.

DANI AGE 41

I'm a soccer player who also plays basketball, and I'm an actress too. I use my voice on the field, onstage, and on the court—I encourage others when they are feeling upset because I want them to know they are loved.

KAMDEN AGE 8

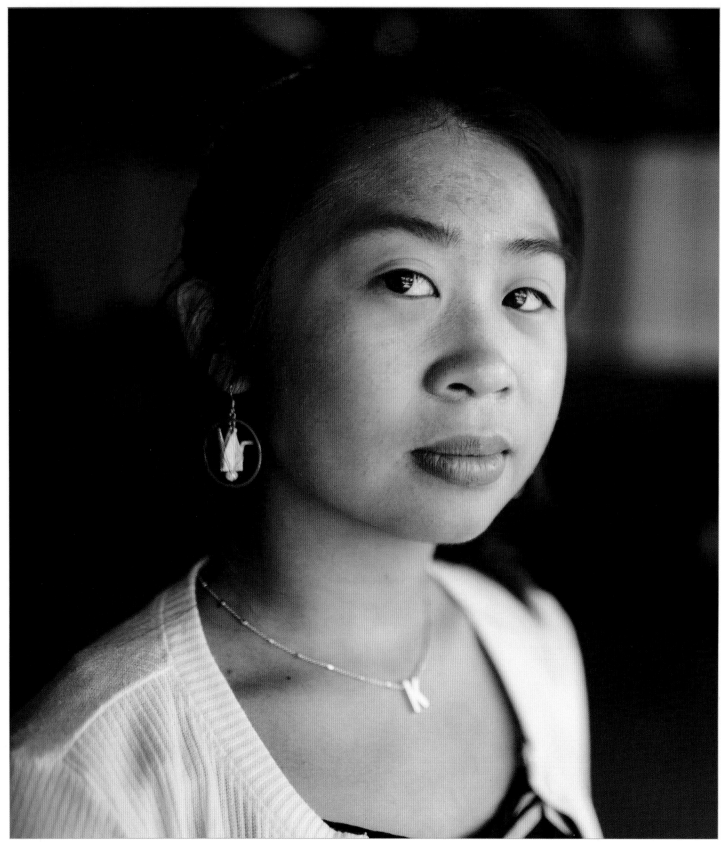

During the Covid pandemic in September 2020, while waking up to log into online class, all I could see was an eerie orange apocalyptic sky due to uncontrollable wildfires outside of San Francisco. There were ashes falling from the sky like rain, dotting cars, plants, and buildings. We couldn't go outside because the air quality was so poor. I felt so sick of being on the screen for hours without fresh air. I was sure other kids like me felt the same. Although I am usually a reserved, quiet person, I gathered up the courage to speak at our local city council meeting about keeping our city green and preserving nature for future generations, especially for kids like me who are not old enough to vote. (The mayor and board members were definitely surprised to hear from me because I was the youngest person there that evening!) Through the Youthpower Climate Action committee, I work with others to grow and give away tree seedlings and write postcards to remind people to vote for candidates who care for our environment. I believe it's the little things that can create a stronger community. Every single voice matters, and the smallest action can make a big difference. Even if only one of those seedlings survives, it can grow into a strong, sturdy oak and make an impact on slowing global warming.

KRISTEN AGE 13

Actions and words are the killer combination. Recently, the company
I founded, Title Nine, put both our actions and our words behind the
United States women's national soccer team's (USWNT) fight for pay
equity. I spoke across many media platforms about the need for change.
But we also took action as a company to help fund that fight. Initially it
seemed like our voices were small, insignificant. But six months later,
the USWNT achieved a major victory in their quest for pay equity.
We learned that change is a team sport and that every voice matters!

MISSY AGE 60

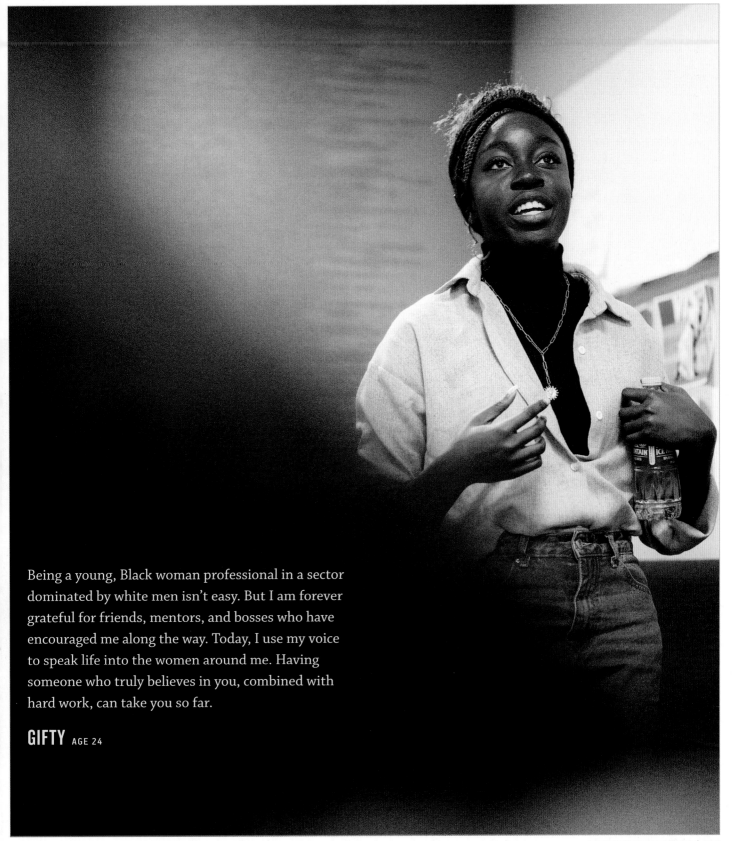

Being a young, Black woman professional in a sector dominated by white men isn't easy. But I am forever grateful for friends, mentors, and bosses who have encouraged me along the way. Today, I use my voice to speak life into the women around me. Having someone who truly believes in you, combined with hard work, can take you so far.

GIFTY AGE 24

**Transition can be hard,
but you'll get through it!**

MARLEY AGE 12

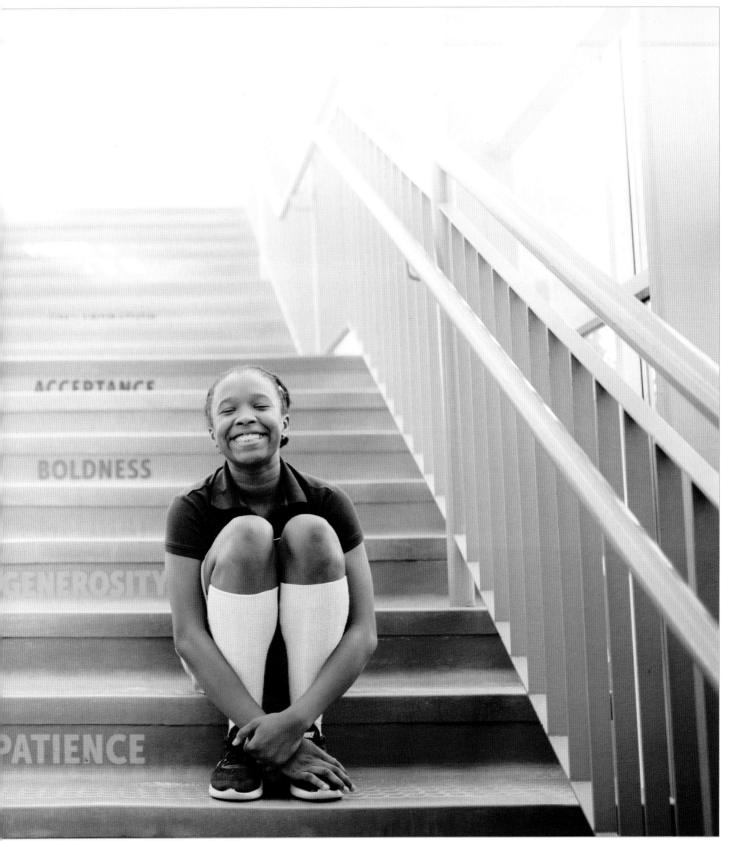

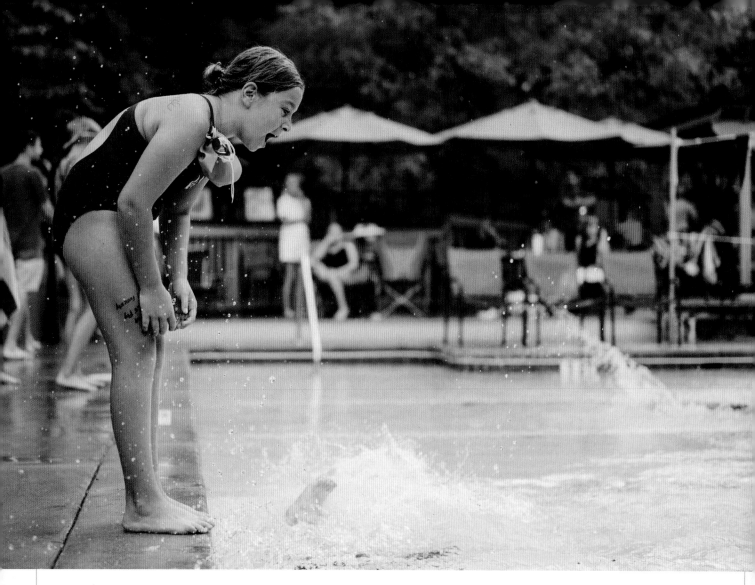

I used my voice to speak up at swim practice. I asked my coach what I needed to learn to move up to the next level. Swimming has taught me confidence and to believe in myself, and I want to continue to get stronger. I want everyone to know that you can do anything you want to if you put your mind to it.

BLAKE AGE 11

At an early age, I found empowerment and confidence through entrepreneurship. Now I use my voice to teach business to kids in underresourced communities. When kids lack resources, it can really set them back. I'm proud to be able to use my knowledge and experience to help others.

CHRISTOPHE AGE 15

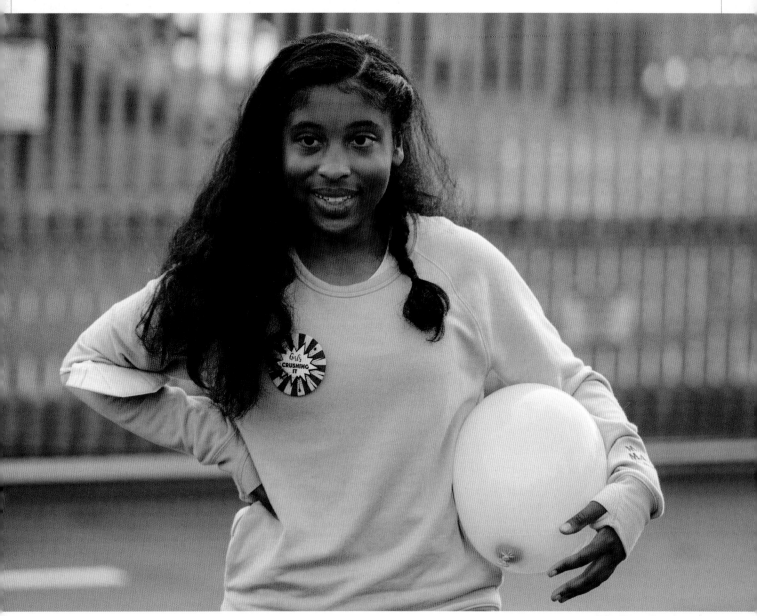

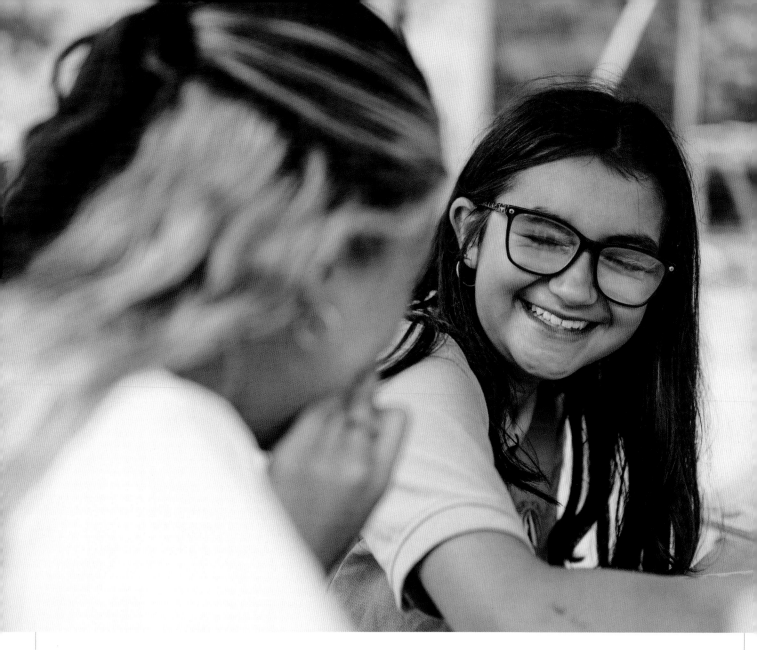

I've used my voice to speak up in many ways. After learning about what was happening between Ukraine and Russia, me and my classmates set out jars in the community to donate money to help Ukrainian families. We made posters to share more information, so the community knew where they were donating their money to.

HANNAH AGE 13

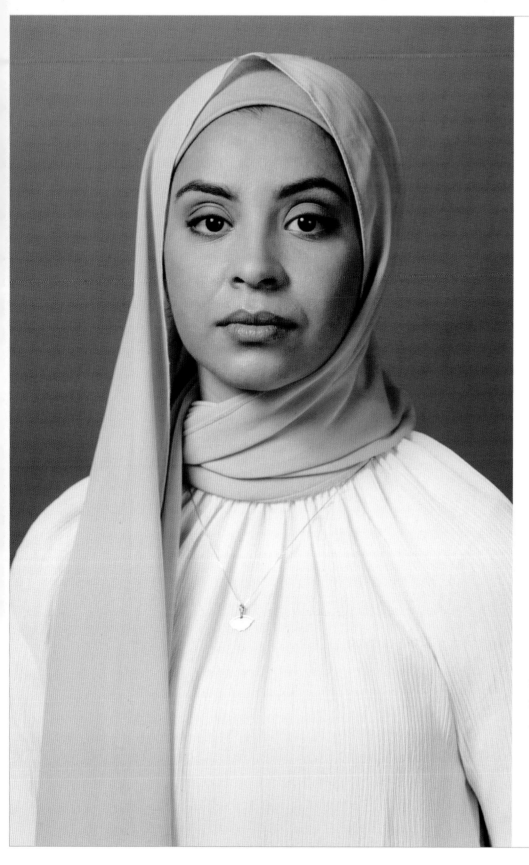

"Because of your hijab" were four words I never thought I'd hear. They're also the words that drive me to tell my story. After I was disqualified from a high school track event for wearing a hijab, I received many messages from people worldwide who had faced similar discrimination. My unfortunate but far from unique experience prompted the passing of an Ohio state law protecting students' rights to express religion, including wearing the hijab, in school sports and extracurricular activities. Placing barriers for athletes who wear the hijab, not providing the proper uniform accommodations, and policing them through waivers and regulations leads to fewer women embracing everything that sport offers. My mother always taught me that hijab is a part of my Muslim identity and that it will become a part of my identity as an athlete—and she was right.

NOOR AGE 18

I love to sing as
loud as I can in the
shower. It doesn't
matter what it
sounds like or
if anyone hears;
I just let it out.

ELLA AGE 12

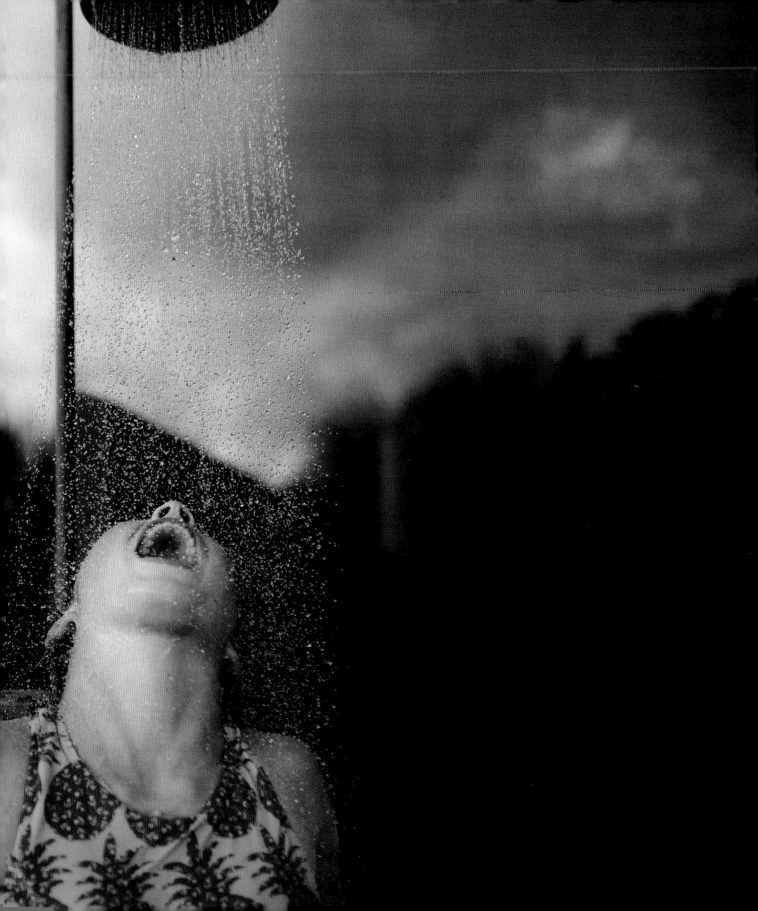

AANIKA AGE 18

So let's tell the women around us they're brave, let's tell them they're worth it, let's tell them they're enough and that they deserve it, because investing in a woman is like tossing a pebble across a pond, watching the ripples reach even the furthest shores, the ones you thought impossible.

Women, I imagine us with our hands clasped together. My mother and her mother and her mother before that. One day, if I am so lucky as to have a daughter, she will not think for a second that she walks this Earth alone. Not behind her, but beside her, there will be all the women who've come before her, all the women who will come after. A number too big to ignore.

–excerpted from "The Women Beside Us"

I WAS THE ATLANTA YOUTH POET LAUREATE. For me, it's super empowering to write. Poetry gives you this space to really explore. When you feel you can make a connection with someone and they feel a little bit less lonely or more seen, that's a very good feeling.

Body image and coming to terms with how I feel about my body is something I write about a lot. I also write about the experience of feeling like a foreigner sometimes. The idea of having a dual identity from growing up in America and also having Indian parents and family in India can lead to a feeling of dis-belonging in both. On the flip side, I love and appreciate that I can also find home in both spaces.

This past year, I heard about a movement to combat period poverty and address menstrual injustice. I attended Atlanta's first National Period Day Rally. That's where I heard from people who had experienced a lack of menstrual products and a lack of education about some menstrual disorders. One of the speakers was living with endometriosis, and when she spoke, it was the first time I heard firsthand how these things impact women in ways I had never fully considered before.

The experience made me interested in this realm of women's issues, fighting for the accessibility of menstrual products and education. Soon after, I hosted a lobby day at my school where we got some students from throughout the district to come and put pressure on our school board members to, with their higher-ups, advocate for getting menstrual products available in schools, and also change health curriculums to be more inclusive of menstruation.

Whether it's improving education, providing physical products, or simply helping someone feel less alone—it's all poetry. It connects us.

> **When you feel you can make a connection with someone and they feel a little bit less lonely or more seen, that's a very good feeling.**

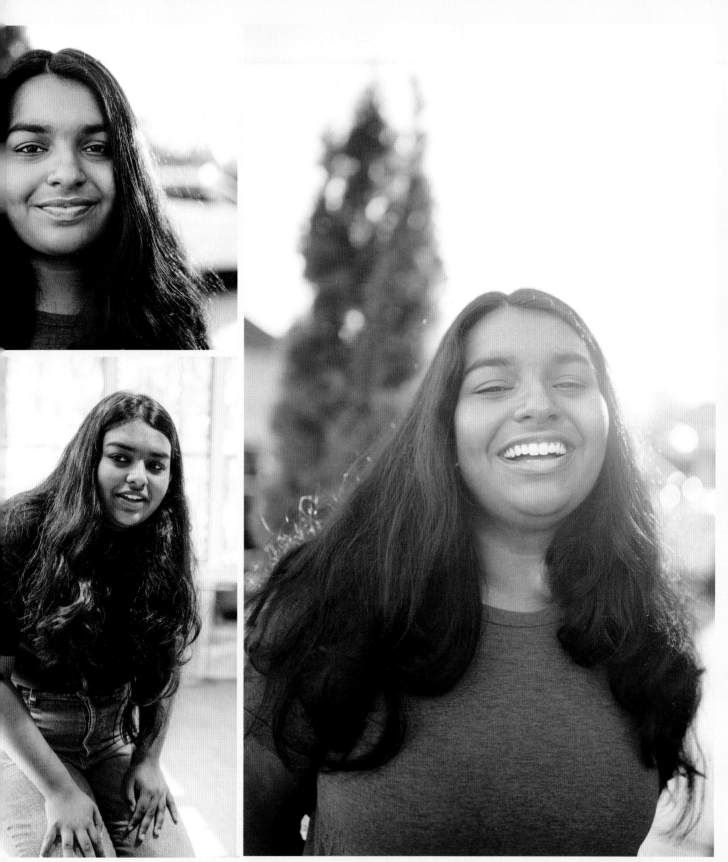

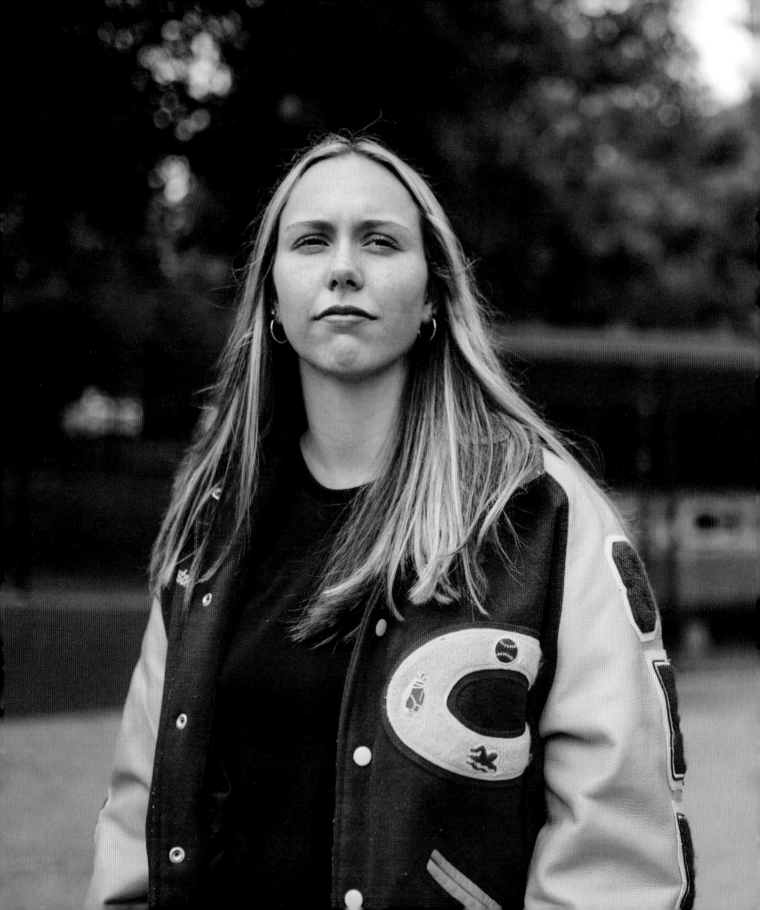

I wrote an article in my school newspaper about some of the inequities between the sports facilities at my high school. I was an athlete, but also the sports editor at the paper, and I noticed differences between what was offered to the girls and the boys. There is a shed for softball, but baseball has a locker room attached to their dugout. And for female weight lifting, there is no locker room, so team members use the coach's locker room, which is just a single-stall bathroom. But the boys' team gets to use the football locker room, which is much larger. The story got reposted thousands of times.

Just by pointing out the truth, I made people angry. There were groups that were saying that the pictures and stories were fake. I learned a lot about standing my ground and sticking with the facts. If nobody else is going to stick up for what is right, you have to be the person to say, "This is true, and you need to listen." I also learned through this experience that in order to actually make change, it's important to find the people that are sticking up for what you believe in. There's so much power in unity.

GRETCHEN AGE 18

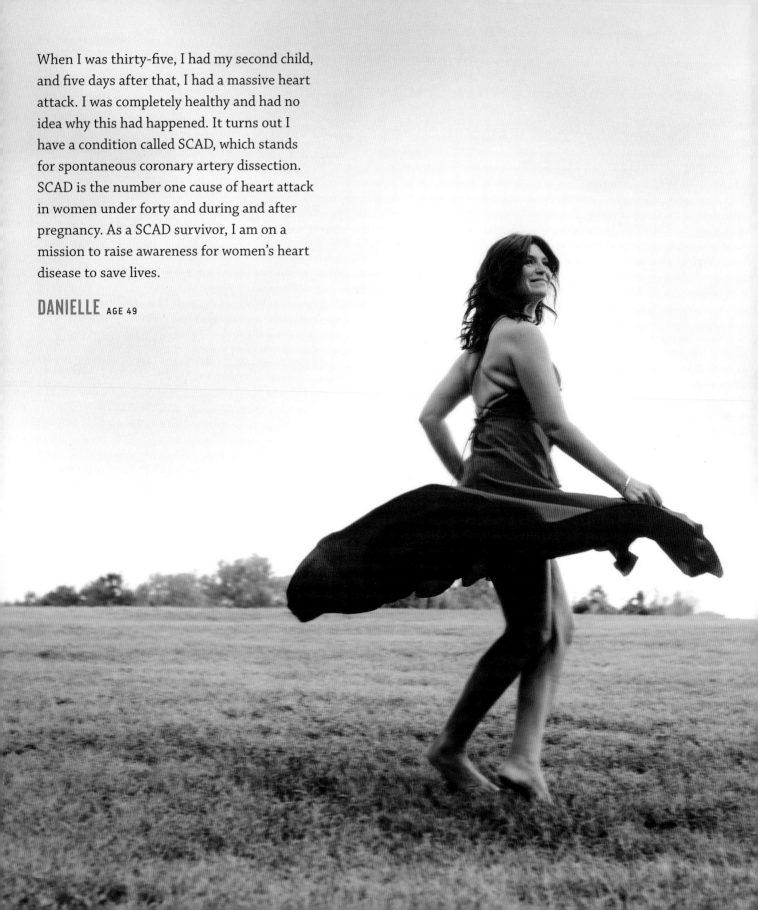

When I was thirty-five, I had my second child, and five days after that, I had a massive heart attack. I was completely healthy and had no idea why this had happened. It turns out I have a condition called SCAD, which stands for spontaneous coronary artery dissection. SCAD is the number one cause of heart attack in women under forty and during and after pregnancy. As a SCAD survivor, I am on a mission to raise awareness for women's heart disease to save lives.

DANIELLE AGE 49

SUSTAIN YOUR VOICE

FINDING THE ENERGY TO KEEP USING YOUR VOICE, again and again, can be exhausting. Summoning the courage and confidence to speak out is hard, especially in environments and circumstances where your opinions or ideas may be dismissed or overlooked—and summoning the *patience* to continue the work can be downright crushing. But change is made when we sustain our voices. (Remember Elizabeth Warren on the senate floor in 2017? "She was warned. She was given an explanation. Nevertheless, she persisted.") When we continue to speak up (and maintain our platforms for doing so), we force the world at large to listen. Tennis champion and social activist Billie Jean (page 213) has been speaking up for and on behalf of women for most of her life. And while setbacks have been part of her story, her perseverance is her legacy.

Like Billie Jean, many of the subjects I photographed for this chapter are adults—they've been at it longer and have the wisdom of time and experience. And yet we can also learn plenty from girls like Alice (one of my daughters; page 204), who rightly notes that "sometimes you need to remind yourself that you're awesome." It's in those moments, not just as a photographer but as a mother, that I am reminded that we need to keep using our voices to make space and change for the next generation. Our collective daughters will also sustain our voices.

Sustaining any movement requires patience and constant change: Keep educating yourself about the topics you care about. This can help you feel more confident when sharing your opinions and ideas. Surround yourself with people—friends, family members, even online communities of like-minded individuals—who encourage and support you. Embrace your vulnerability. It can be your superpower. Mistakes are not only okay, but they also lead to growth, and that growth is a model for sustainability. Find some female role models, leaders, or speakers who inspire you, and learn from their experiences. Seeing other women succeed can be empowering and help you find the courage to speak out yourself. And lastly, trust yourself. Pay attention to your gut feelings and allow them to guide you in a way that feels true to you.

The photographs and stories in this chapter remind me that finding one's voice takes time and isn't always a linear journey. I'm reminded to be patient with myself and stay true to who I am.

Sometimes you need to remind yourself that you're awesome.

ALICE AGE 11

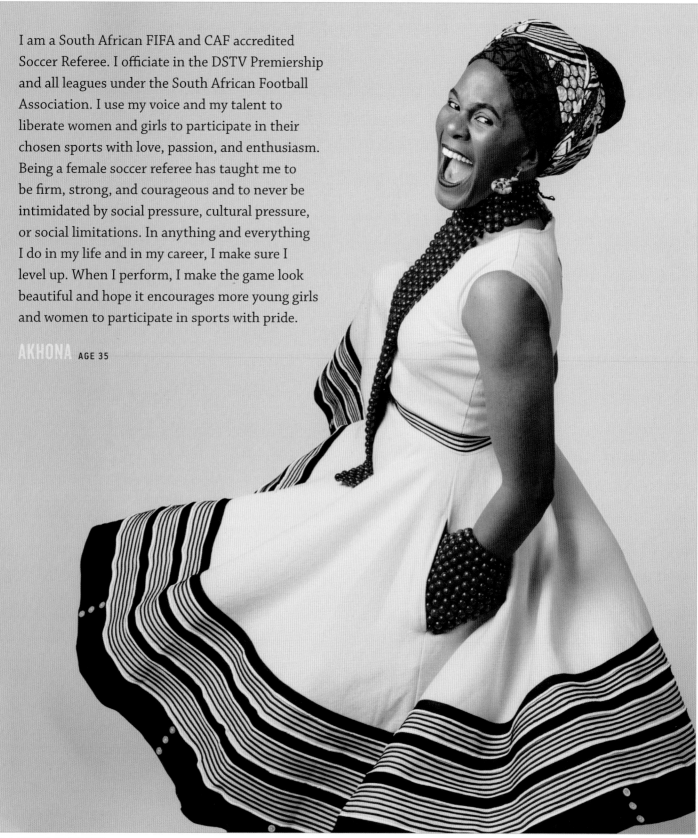

I am a South African FIFA and CAF accredited Soccer Referee. I officiate in the DSTV Premiership and all leagues under the South African Football Association. I use my voice and my talent to liberate women and girls to participate in their chosen sports with love, passion, and enthusiasm. Being a female soccer referee has taught me to be firm, strong, and courageous and to never be intimidated by social pressure, cultural pressure, or social limitations. In anything and everything I do in my life and in my career, I make sure I level up. When I perform, I make the game look beautiful and hope it encourages more young girls and women to participate in sports with pride.

AKHONA AGE 35

I love that I've been raised by a family and in a community where I've always felt safe and encouraged to use my voice. Whether I'm at school or playing sports, I have never been afraid to speak up. I am able to express myself and share my thoughts as loud as I want each and every day, and there are no amount of words that could convey how grateful I am for that.

LAYLA AGE 13

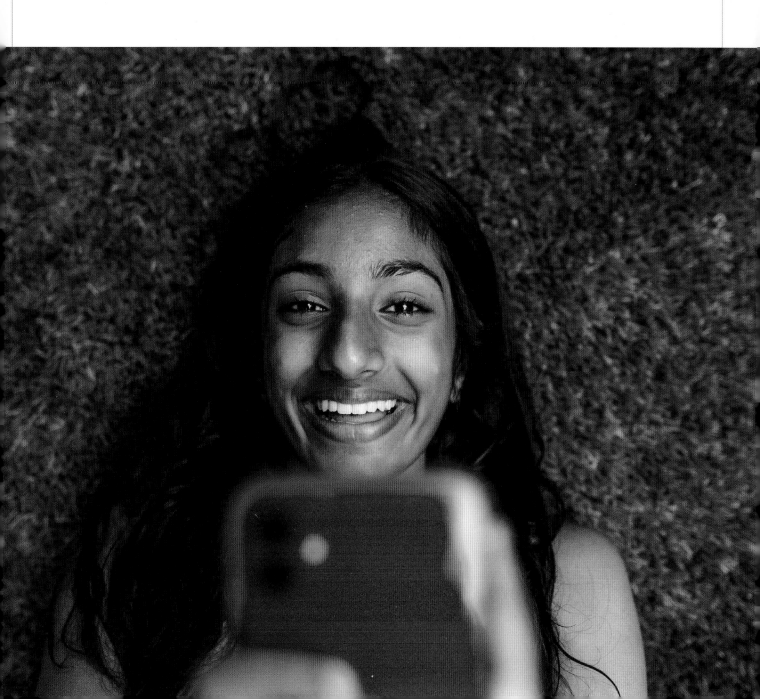

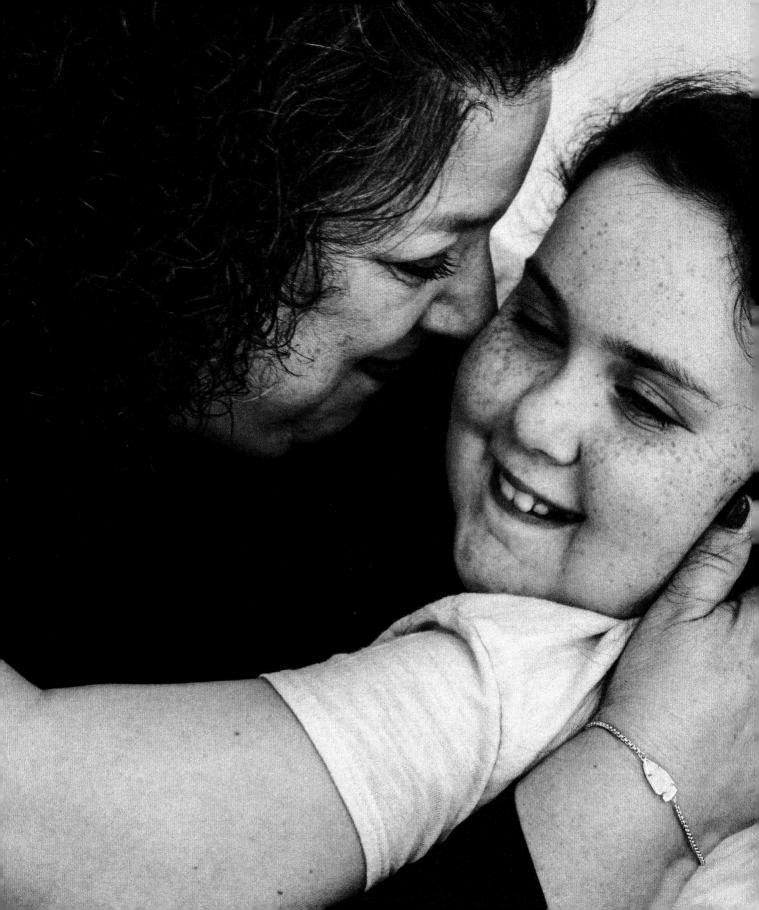

My gigi has always taught me to be a leader to my peers and always spread the idea of unity in the community. She never fails to stand up for what is right and constantly demonstrates that every day in her own community and life. She teaches me never to let anyone tear me down and always to treat others with respect and kindness. Just knowing my gigi is a safe space and I can talk to her about anything helps me know that I can ask her advice any time about *everything*.

ELLA HART AGE 15

As a fourth-grade teacher at an all-girls school, I use my voice every day to teach young people to speak up and speak out. It is important to me that young people feel empowered, confident, and proud to be themselves. As a child, I was surrounded by impactful mentors at home and school who modeled confidence and advocacy. Their guidance and leadership shaped me into the person I am today. I hope to provide that same guidance for all young people I work with and meet.

JANE AGE 27

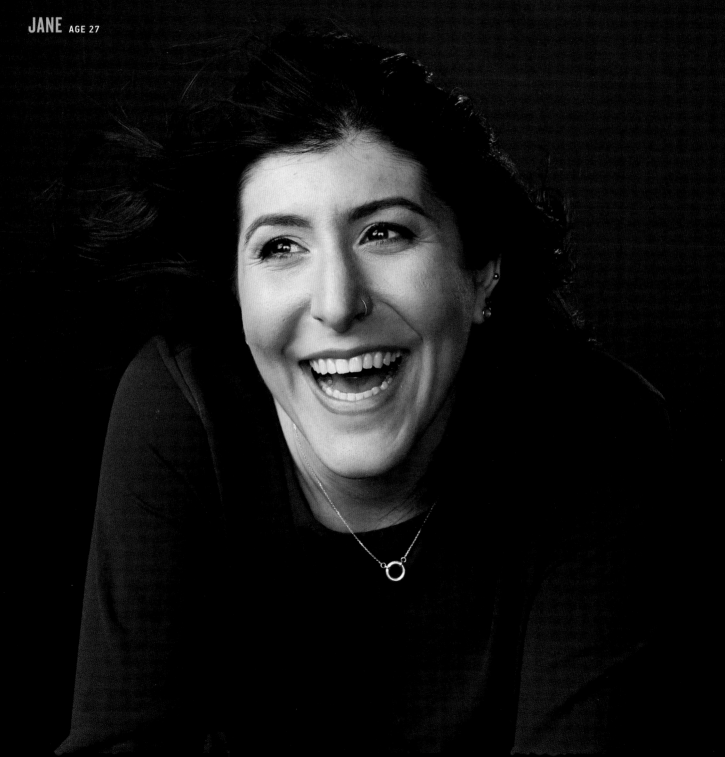

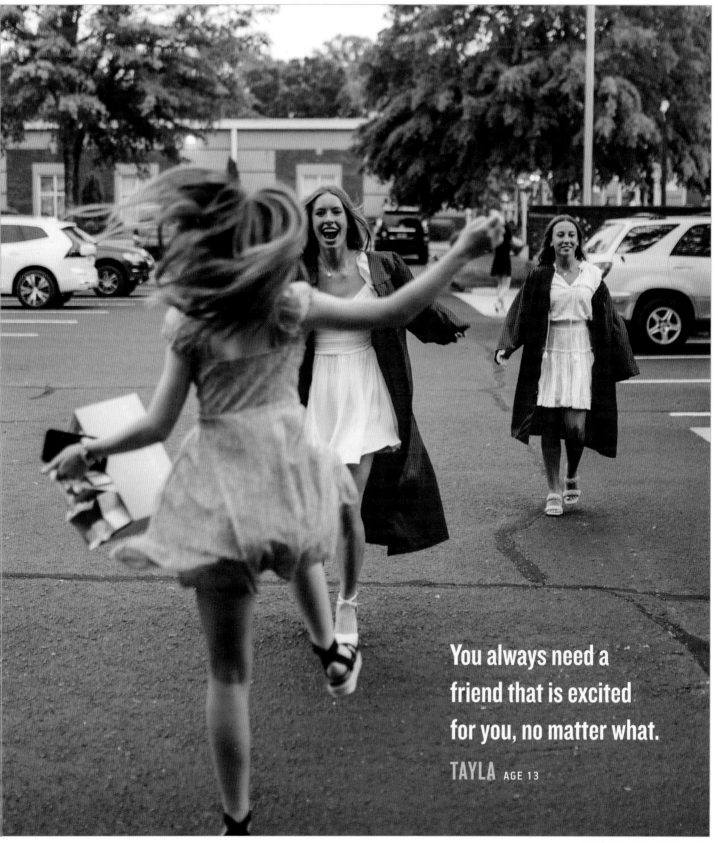

You always need a
friend that is excited
for you, no matter what.

TAYLA AGE 13

Whatever you care about, you can make a difference. You really can. Don't ever underestimate yourself. Do not underestimate the human spirit.

BILLIE JEAN AGE 79

I use my voice to empower girls and women to pursue their dreams despite challenges they may be facing in their lives. I help them remove physical, mental, and emotional barriers and open doors that sustain their well-being.

MICHELLE AGE 32

In my forties, I was diagnosed with bipolar II disorder. I am fortunate enough to sit in front of a microphone every day and fortunate enough to work with people who support me in speaking out. Rather than keep my diagnosis to myself, I shared it on my morning radio show in hopes that what I'm going through may help someone listening. Living with mental illness isn't easy, but when I share the light, it helps me—and it might help another person through a rough day too. Your light is needed, my friends!

KENNEDY AGE 51

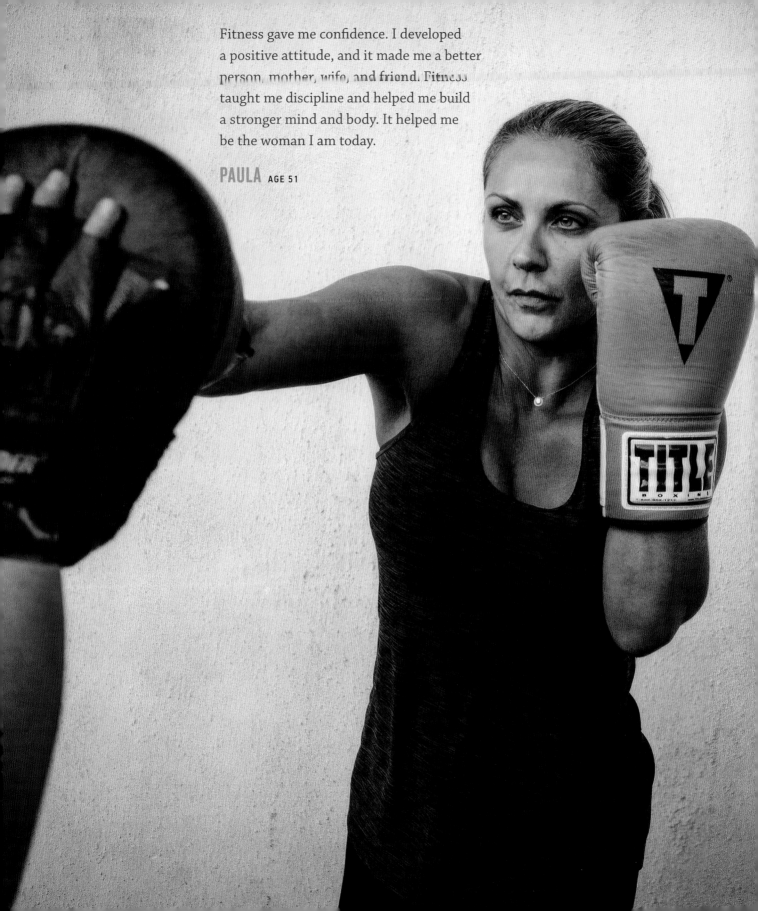

Fitness gave me confidence. I developed a positive attitude, and it made me a better person, mother, wife, and friend. Fitness taught me discipline and helped me build a stronger mind and body. It helped me be the woman I am today.

PAULA AGE 51

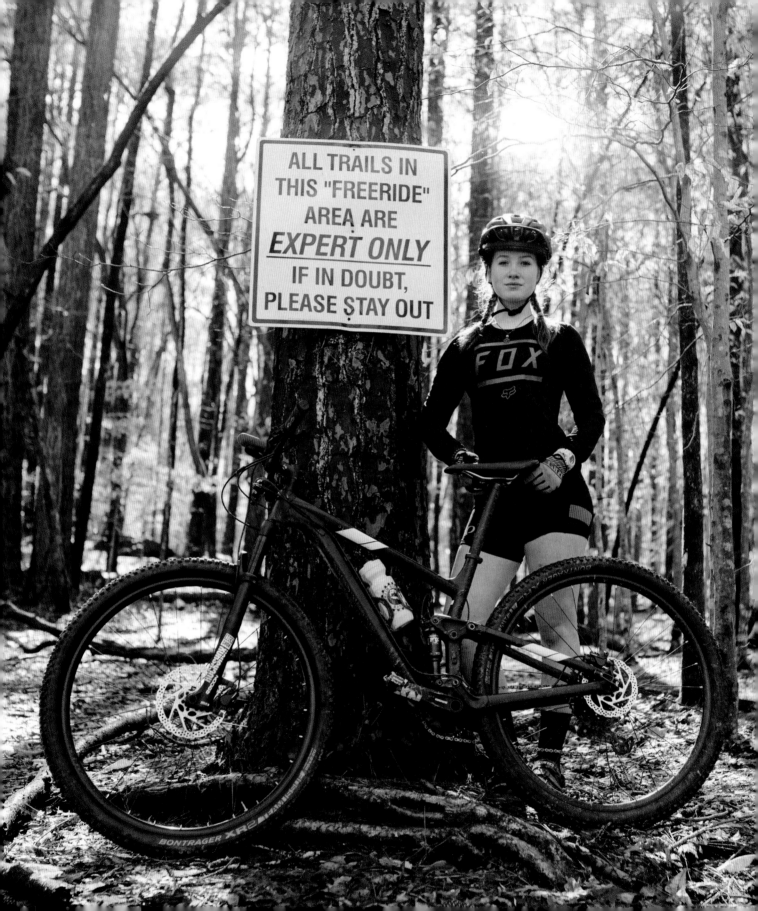

I have found myself speaking less with my words and more with my actions. I want to show women how capable they are. I want to show them how to break boundaries. I want to show them how to light their inner fires. I want to show them that anything is possible. I want to show them that everyone deserves to be heard and respected. I have found my true strength by finding my inner passions and letting them roar. I want the same for all young girls.

KATHRYN AGE 18

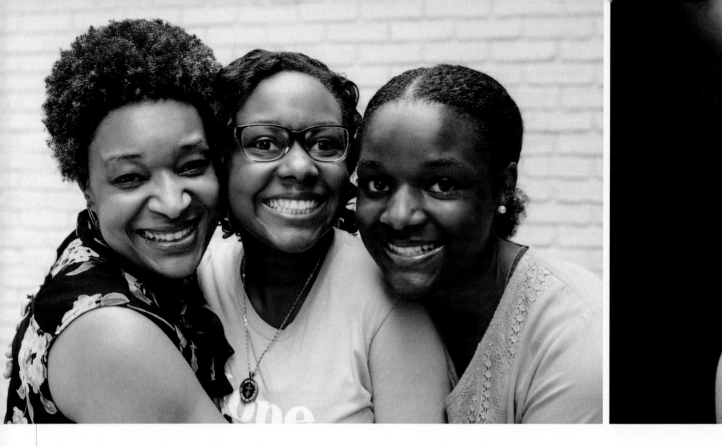

EMERIL AGE 21

I USE MY VOICE TO SPEAK OUT about a lot of things, but adaptive sports and disability awareness are at the top of my list and so important to me. Growing up, I didn't have role models with disabilities, much less visible high-level athletes with disabilities to look to. I still remember feeling so unheard—and misunderstood when I *was* heard—whether I was trying to explain to a swim instructor or teammates and coaches on my soccer team why I had trouble using my left side and getting blank stares back, or trying to explain to people why I had to wear special braces on my leg or couldn't keep up taking notes at school. I felt like a burden, and it left me upset and frustrated with myself even when I knew I was capable of so much. I longed for a coach and people who understood who I was and that even with my disability, I could still do ordinary

and extraordinary things—just a little differently in some cases. I suffered with these feelings for years, and to be truthful, they still haunt me even though I now know about the Paralympics (and am grateful to be a part of the growing Paralympic Movement) and am a thriving college student who finished her degree a year early and can now study other things. I am an elite para-athlete with my eyes set on the 2024 Paralympic Games and the upcoming competitions with Team USA and the U.S. Women's Cerebral Palsy National Team.

Much of raising my voice has come through social media platforms like Instagram and Snapchat—I can reach and educate large audiences as well as people I don't even know. But I have also made an impact through public speaking on panels and podcasts and other similar media. I've learned a great deal of self-advocacy in

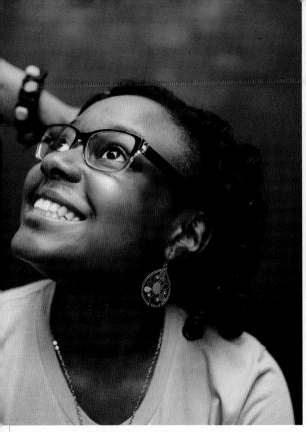
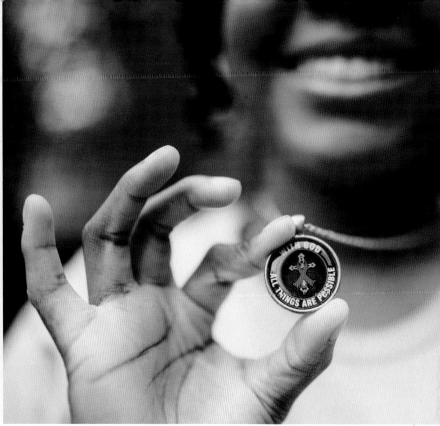

the process too. Which is probably the hardest for me. All of these opportunities and platforms have shown me how rampant and horrible ableism in our society is. It's an area for much-needed change that often gets ignored in the diversity, equity, and inclusion conversation. Many of the battles I've fought were tough and pure agony (I suppose that's what battles are), but I do it all so that members of the next generation don't have to wait fourteen years before they hear that disabled people can indeed compete at the highest level in the world or that they can have multiple bylines and hyphenates to their name because their work is exceptional. I want for them all the belief, visibility, and respect that I did not have.

It has been hard, as an African American woman, to be shut down or over-looked, but I remind myself that I was given my platforms to speak out for a reason and I will use them because I never know how impactful what I am doing can be for someone else.

My model has always been to change the game, and it starts with raising my voice on issues that are important to me. It has been hard, as an African American woman, to be shut down or over-looked, but I remind myself that I was given my platforms to speak out for a reason and I will use them because I never know how impactful what I am doing can be for someone else. I want to see more people with disabilities in all sectors be recognized for their worth.

Things still aren't easy, and I doubt they ever will be, but it was raising my voice that led me to where I am today.

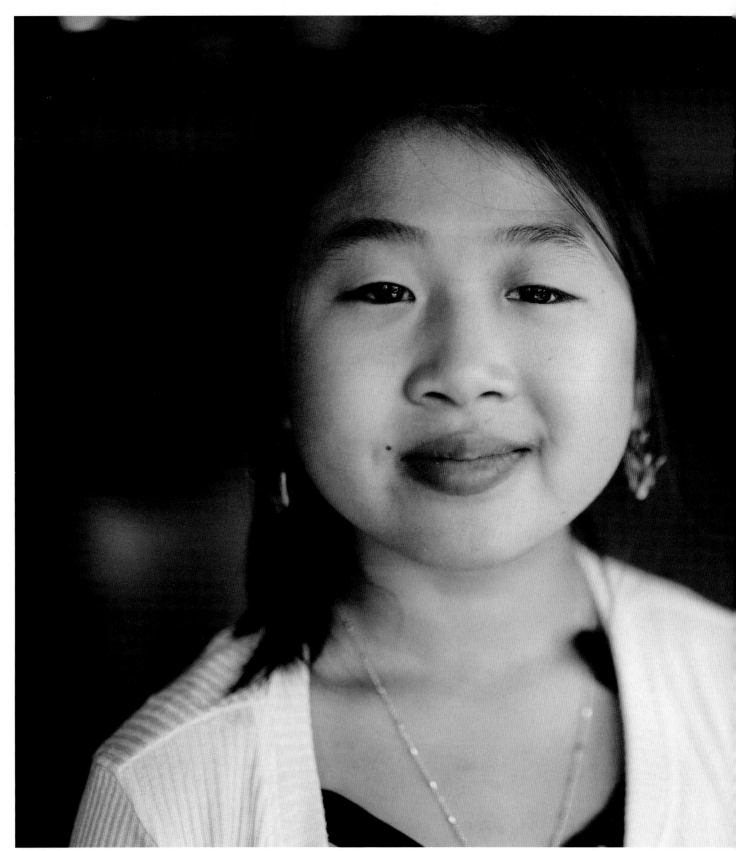

I started thinking about problems in the world in second grade because we were isolated at home during Covid. Seeing terrible things like George Floyd's murder and elderly Asians being mistreated made me sad and angry. Why does there have to be racism and inequality? Why are adults behaving so badly? What happened to kindness? I used my voice to tell people that Covid doesn't discriminate. I wrote about this in an essay called "Being Different Is Like Sushi and Fried Chicken." My mom was surprised because one day she got a phone call informing her that I had been chosen as one of the ten finalists in a regional Growing Up Asian in America contest in 2020.

There are so many delicious foods where I live in the Bay Area, but nothing compares to fried chicken, catfish, and beignets from the Deep South. When people look at me, they do not know I have this connection because I look different from what they expect. You see, my mom is from Mississippi. And something about flying there and staying a few days or weeks is special. Maybe because, as my mom says, time slows down. There are grassy fields, large oak trees, and kudzu everywhere. You can see the stars in the sky, and there is hardly any traffic. People are friendly and love to talk. But most of all, I feel a comforting warm sense of belonging because this is where my popo and gongong built a life together. So a part of me feels that this is also my home.

KATELYN AGE 10

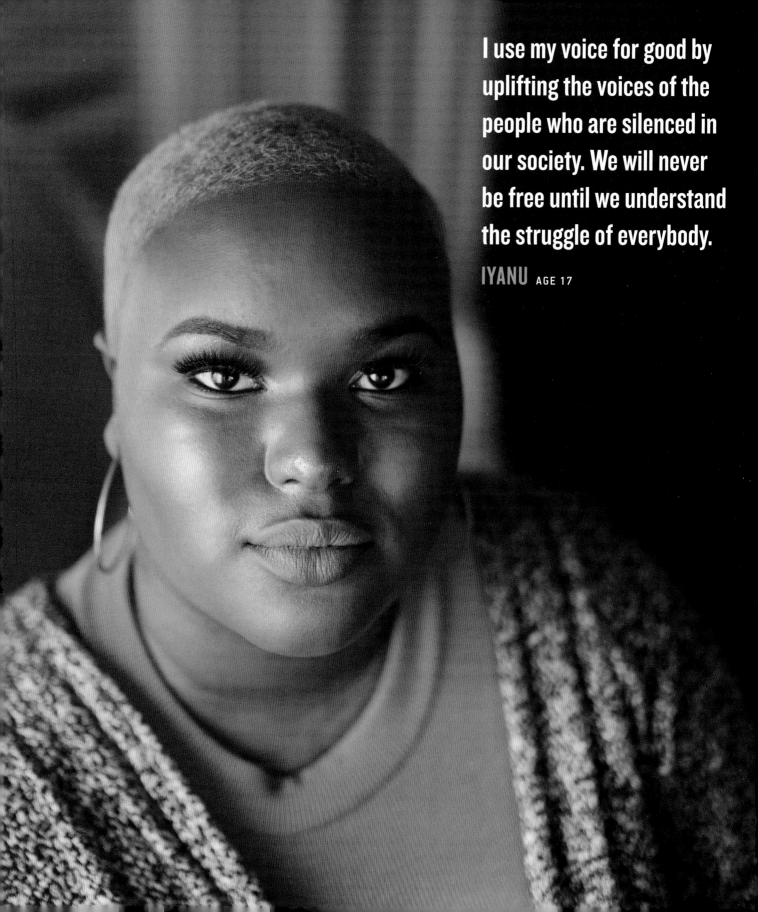

I use my voice for good by uplifting the voices of the people who are silenced in our society. We will never be free until we understand the struggle of everybody.

IYANU AGE 17

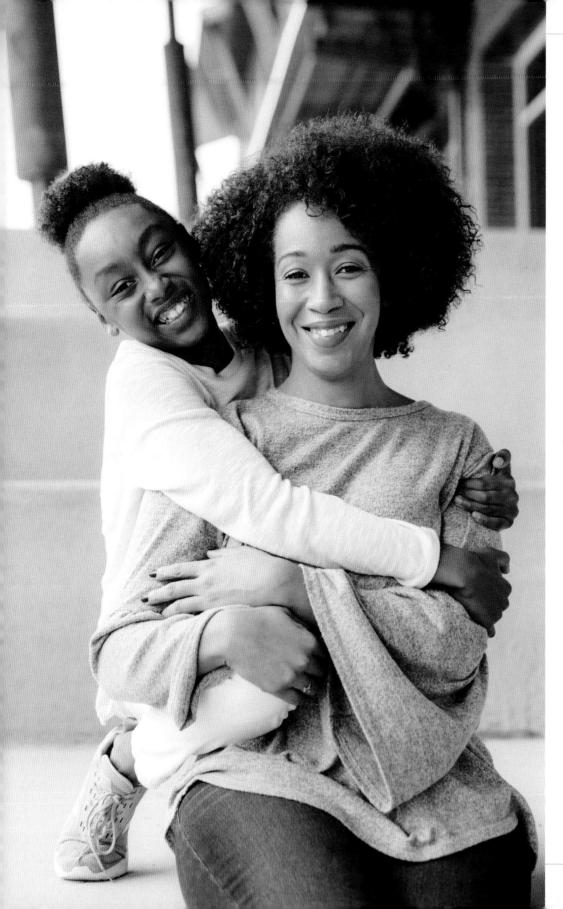

I always tell my daughter and the girls I mentor to "use their words." Our society wants instant gratification by communicating directly through our devices, but the simple form of communication by opening your mouth and using your words can and does help us understand one another and build a better place for all.

ALICIA AGE 36

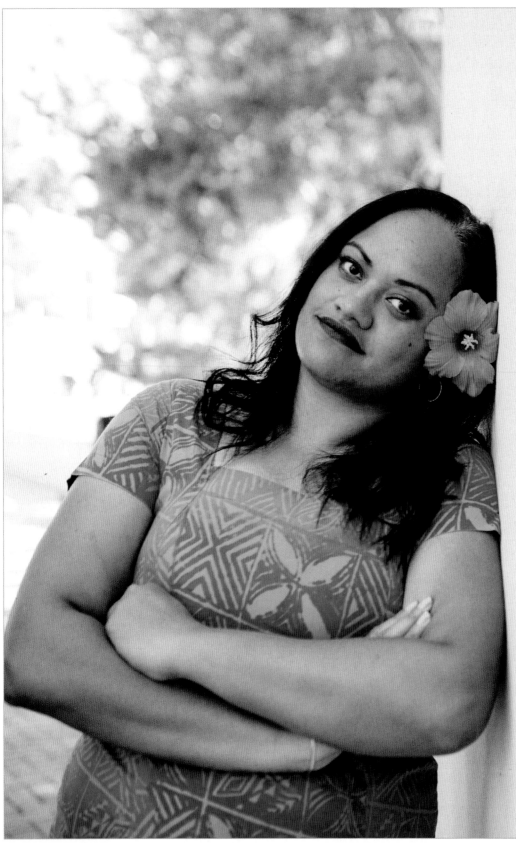

In the Pacific, we are taught from a young age to use our voices to bring about change. My mission—regardless of the roles I play as a mum, a coach, or a leader—is to use my voice to provide stronger and more visible pathways for girls to build our community and region.

PHILIPPA AGE 36

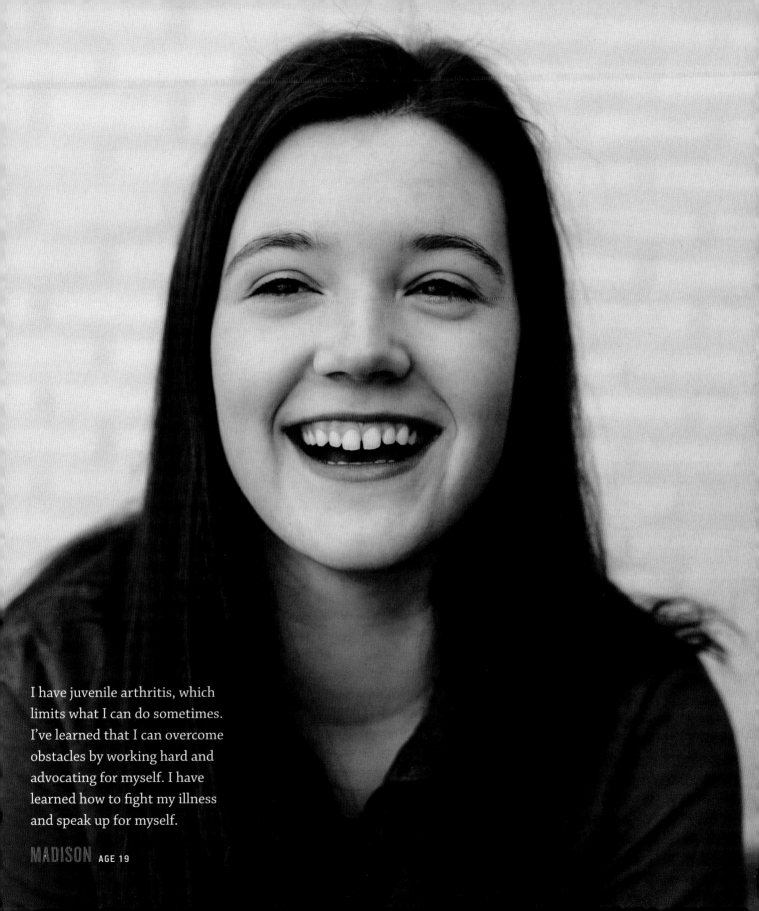

I have juvenile arthritis, which
limits what I can do sometimes.
I've learned that I can overcome
obstacles by working hard and
advocating for myself. I have
learned how to fight my illness
and speak up for myself.

MADISON AGE 19

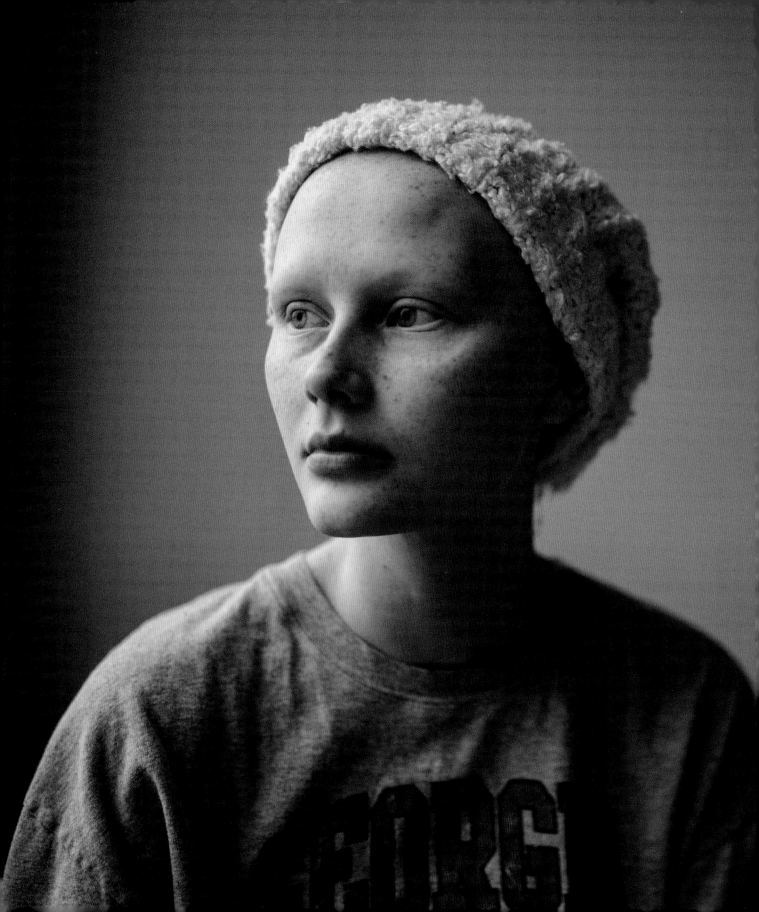

After being diagnosed with bone cancer in high school, I decided that my perspective on facing this incredible challenge was going to be up to me. I fought every day to approach cancer with perseverance and with a positive mindset. My positivity gave me the courage to face many sick hospital days with peace and with resilience. This mindset also gave me the strength to emotionally be there for the newly admitted children who were scared to begin this journey and wanted a friend in the hospital who could understand them and help them fight.

ELLIE AGE 20

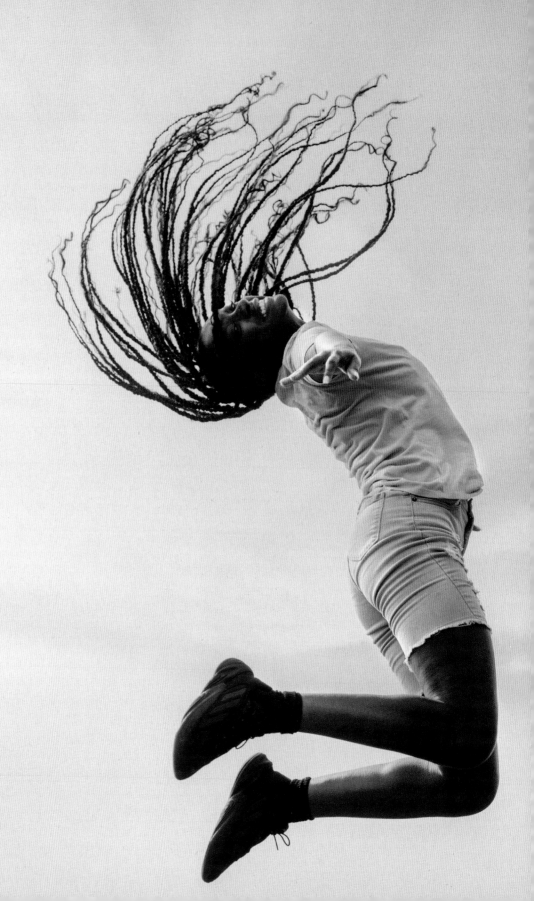

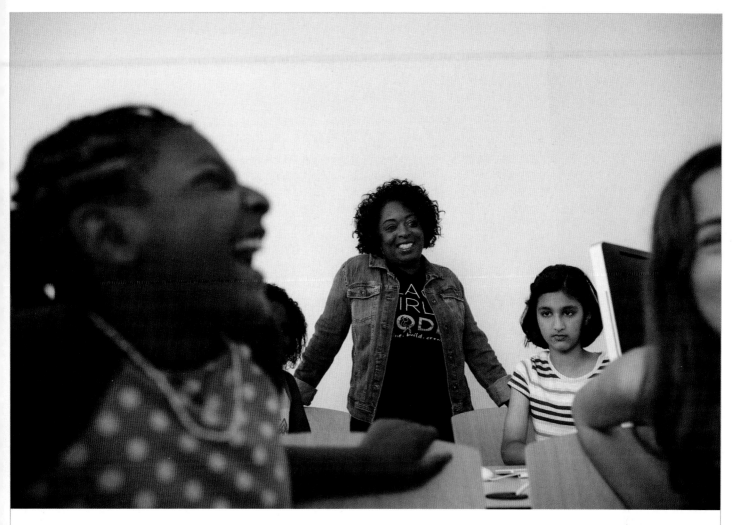

I grew up a relatively quiet and reserved child by most accounts. When I did learn to use my voice, it was in front of a church pew or much later in life as a rallying call around issues of social justice and equity. I use my voice as both a testimony and to test the bounds and limitations of society. I use my voice to light the path for others and to make right the many inequalities and unfairness that stand in the way of a more just society.

KIMBERLY AGE 55

If it's worth tackling, it can be conquered. I believe that whatever you go after you can accomplish now or in the future.

SANAA AGE 17

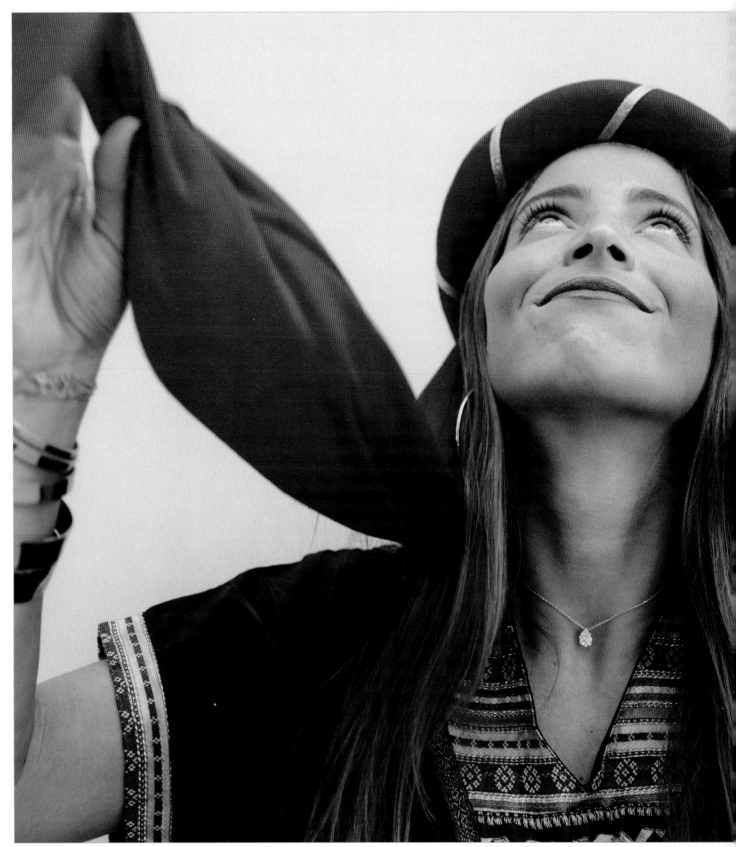

Life only comes around once—do what you like and what makes you happy. Don't be distracted by criticism. Fight for what you love and do it for yourself.

The image shared is of me wearing a typical Lebanese outfit. With Lebanon going through the most severe crisis, I am proud to be Lebanese, and no one and nothing will ever take that pride away from us. I fought for Lebanon, and I will keep on doing so as long as I am alive!

KAREN AGE 29

SYDNEY AGE 14

WHEN I WAS BORN, I was diagnosed with a rare liver disease known as biliary atresia (BA). BA is characterized by an abnormal biliary system, in which bile ducts inside and outside the liver fail to develop normally. Most babies with BA need a liver transplant as soon as they are born. However, I was in okay condition and was healthy enough that I didn't need a transplant right away.

For the first thirteen years of my life, I managed the disease fairly well, along with many doctor's appointments and hospital stays. I went to school, I was on a travel basketball team, I ran competitively, and I participated in music. But that life stopped abruptly in 2020 when my family and I noticed that my breathing began getting heavier when I was playing sports. As a fairly active kid, paying attention to my breathing was something that never occurred to me. My family notified my doctors, who told me that I had another rare condition called hepatopulmonary syndrome. Hepatopulmonary syndrome occurs in people with advanced liver disease, and it affects the lungs, causing them to deteriorate and not receive enough oxygen. At this point, my breathing had become so bad that it was hard for me to walk up the stairs, change clothes, and do other simple tasks without making it seem like I was climbing Mount Everest. The only cure for this disease is a liver transplant.

In March 2021, I was officially placed on the liver transplant waiting list. The waiting was the hardest part. I couldn't get out and do anything for fear of getting sick. My family couldn't travel. We never knew when we would get the call. While I waited, I became restless.

> I hope my story shows other girls that there might be bumps in the road, but no matter what situation you're in, don't be afraid to reach for the stars.

Instead of sitting around, I wanted to *do* something. So I decided to put on a benefit concert for other kids like me, kids with BA. There isn't a ton of money that goes into research about this disease because it is so rare, and most people don't even know it exists. I planned, created, practiced, and recruited other people to be a part of my concert. I have always loved music, and throughout those four months of waiting, it felt like music was the only thing I could do and could count on being there for me when I needed it. I knew that music wasn't leaving me.

I held my first concert in May 2021, and it was a huge success and a lot of fun. That year, I raised over $12,000 that went directly to my local children's hospital. Two months later, we finally got a call from the transplant team saying that they had a donor, and it was finally time for me to have another chance at life. I went into surgery on July 3 at 11:00 p.m. and came out of surgery at 8:00 a.m. on July 4. My liver transplant anniversary is July 4, since that was the day the blood was restored. I get fireworks every year to celebrate!

The recovery immediately following the transplant was intense. I was in the ICU, where I was watched carefully for three days. To be honest, I don't remember much about those days since I was under a heavy amount of anesthesia and pain medications. After being in the ICU, I was put on the transplant floor for two weeks. In those two weeks, I tried walking, changing clothes, and taking a shower while being in such pain. Finally, I was able to go home.

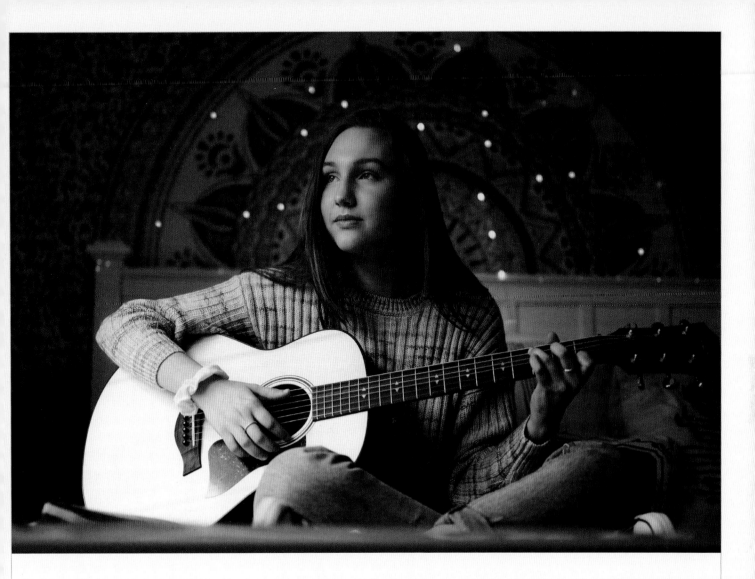

Even though it was exciting being back home, I still wasn't able to do much. Most of my time was spent going to doctor's offices, getting labs drawn, and taking medication. A *lot* of medication. I completely missed my first semester of eighth grade and was in total isolation while doing so, except for the times that everyone was home and when I went to Egleston for the transplant clinic.

The best parts of my week were when I met with my homeschool teacher and when I had music lessons. I have always loved school but didn't realize how much I missed it until I couldn't go anymore. My entire journey has made me realize that you don't appreciate things enough until they are taken away from you. Eventually,

I regained enough strength to be able to go back to school for the second semester. I became a lot happier then, but things were still very hard for me in terms of breathing, and I remained on supplemental oxygen for several more months. During the summer, I did my second concert, raising even more money, for a total of over $25,000 in two years.

I am now a freshman in high school and have had so much fun participating in sports, going to all of my classes, and making awesome friends. I am even planning another concert, hopefully raising even more money this year. I hope my story shows other girls that there might be bumps in the road, but no matter what situation you're in, don't be afraid to reach for the stars.

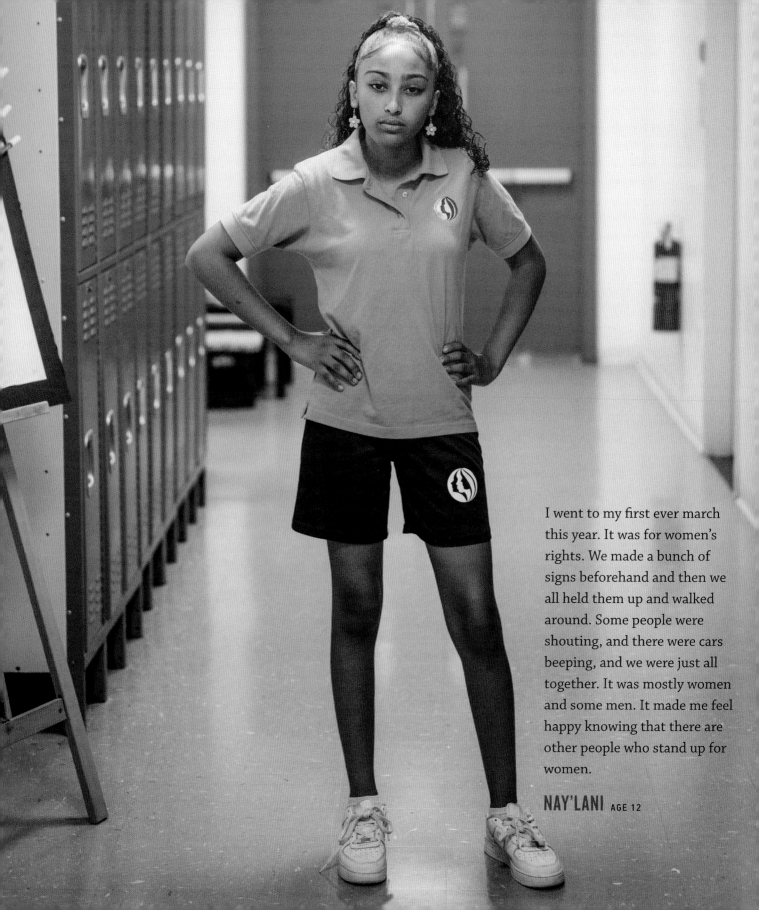

I went to my first ever march this year. It was for women's rights. We made a bunch of signs beforehand and then we all held them up and walked around. Some people were shouting, and there were cars beeping, and we were just all together. It was mostly women and some men. It made me feel happy knowing that there are other people who stand up for women.

NAY'LANI AGE 12

When I was five, my family was interned during the war and because my father had immigrated from Japan, we were deported—even though my mother, siblings, and I were US citizens. I spent about ten years in Japan until my mother moved back to the Bay Area and then, one by one, brought us back to the US. I use my voice to tell my story. I want the next generation to know how important it is to work toward a better life. If you want it, you can achieve it. Anything is possible.

SATSUKI AGE 84

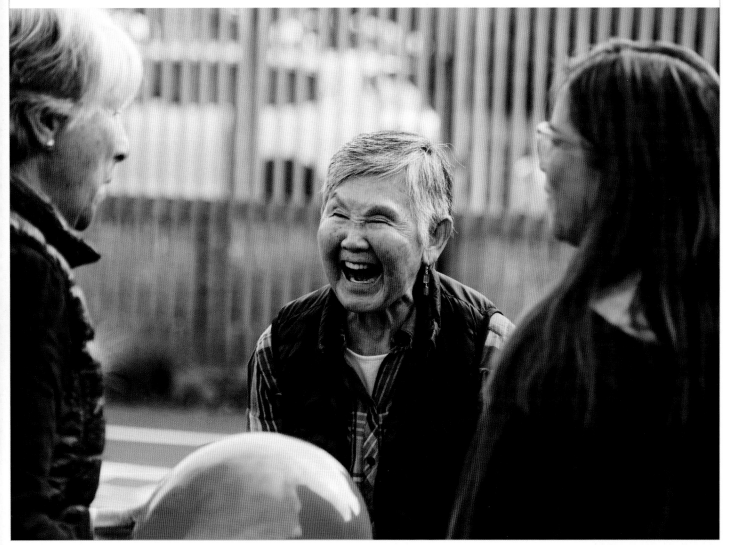

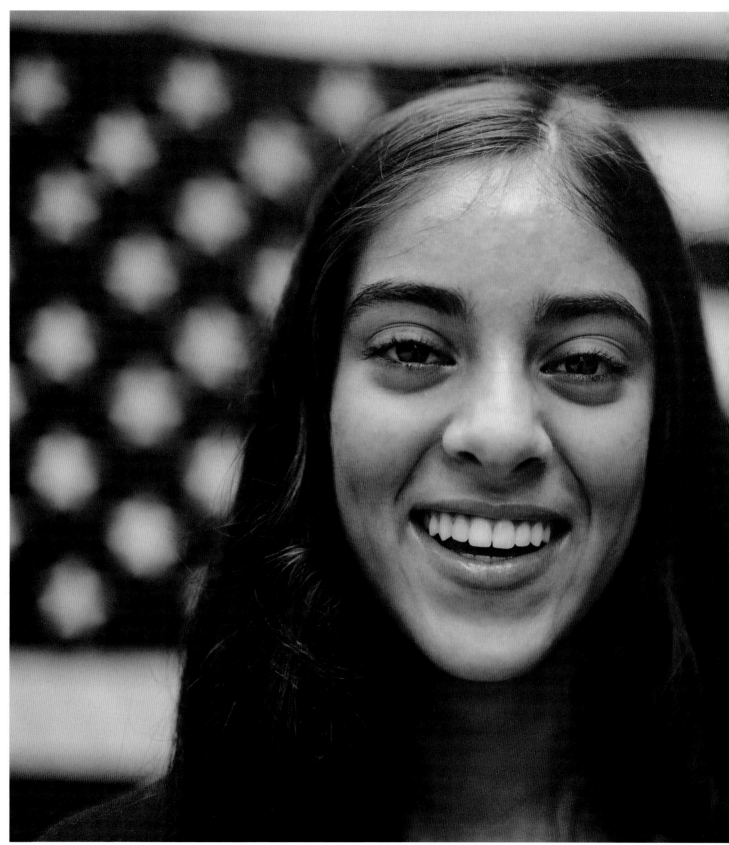

I use my voice to speak out for myself because if I don't, who else will? I think it's important to speak up and be confident in yourself so you're not dependent on anyone else. Girls especially need to be their own biggest advocates.

SIYONA AGE 16

Documentary film has the power to reanimate overlooked or forgotten stories in all of their humanity and beauty. By lifting my voice and perspective through this art form, I work to re-gift stories of liberation and personal transformation as a galvanizing force for change.

NICOLE AGE 53

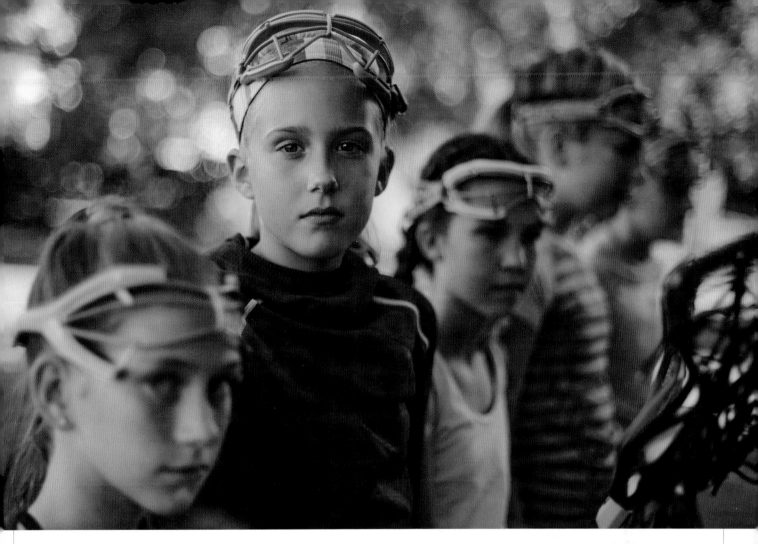

I use my voice on the field to lift people up when they are down!

LINDSAY AGE 12

I wrote an essay highlighting food deserts in a
nearby community and sent it to our local lawmakers.
I wrote the essay because this issue is important to me.

LAILA AGE 13

I'm so proud of my bold and
brilliant daughter!

RASHIDA AGE 41

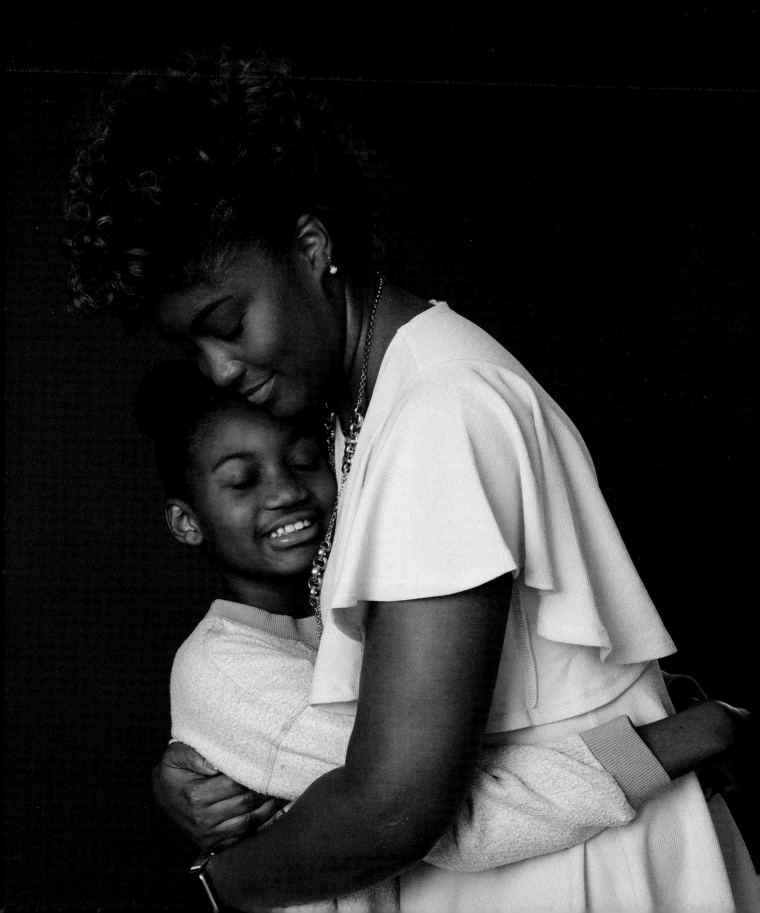

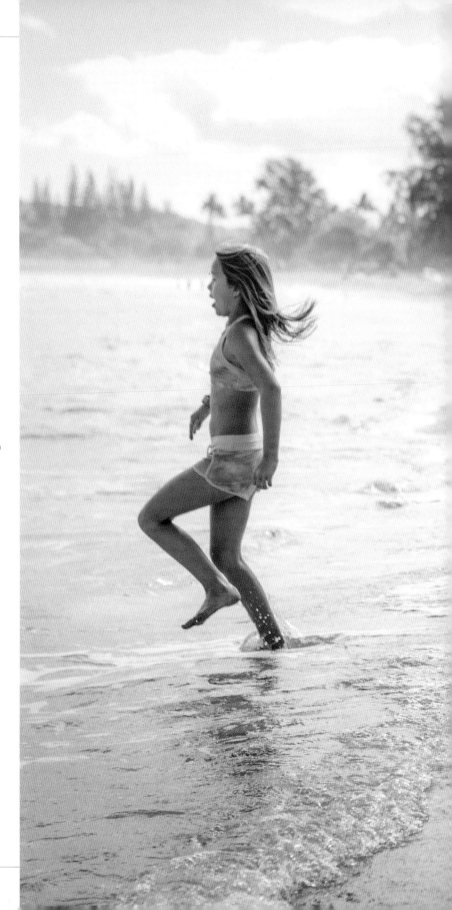

The three of us are best friends. One time at recess, after Kailee got braces, some bullies were making fun and judging her for them. We saw what was happening and were like **NOPE**. This isn't going to happen.

McKENNA AGE 9

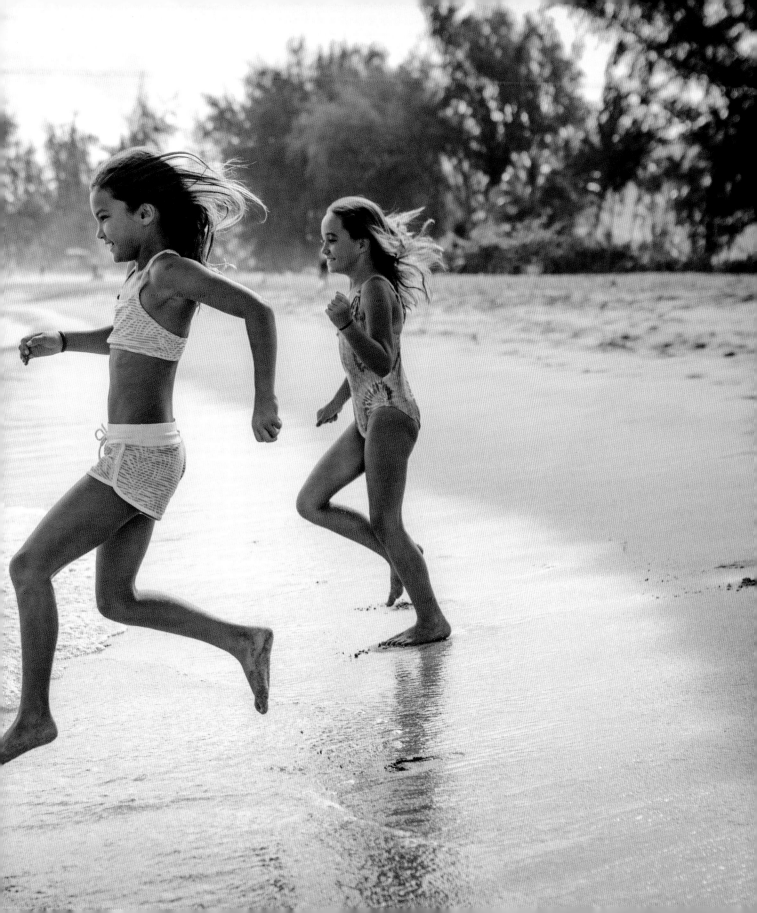

I will change the WORLD!

Our words, our voices—they matter.

GABBY AGE 16

ACKNOWLEDGMENTS

I AM FOREVER THANKFUL to the amazing people who make books like this one possible.

I am so thankful to the girls and women who shared their stories, their victories, their struggles, their advice, and most importantly, their voices among these pages. Thank you for helping others see the value in who they are and what they have to say.

Thank you to the friends, family, and strangers on the internet who suggest and share the incredible stories of inspiring girls and women and say, "You need to hear about this girl!" Keep sending them my way! I am so thankful for all your eyes and ears.

Thank you, as always, to my family. Mike, Ella, and Alice, and of course the dogs, Tobin, Mabel, and Betty. You all are my favorites in the world and I am endlessly grateful knowing you have my back.

Marikate, I could not have finished this without your ridiculous organizational skills. I am forever in your debt and in awe of you. I cannot wait to see where you go and what you do in life, and will be cheering you on. William Callahan, always grateful for your advice, levelheadedness, and insight. Thank you for always believing in me.

And finally, thank you to everyone at Workman for believing in this work and project and always recognizing how important it is we share these kinds of stories and voices. Megan Nicolay, this is our fifth book together and I am so proud of the work we have done. I trust your gut and am always so lucky to be working with you. Jessica Weil, thank you for keeping me on track and all the hard work you did to help make this book come to life. And to the rest of the crew at Workman—especially Beth Levy, Kim Daly, Claire McKean, Sarah Smith, Lisa Hollander, Barbara Peragine, Julie Primavera, and Chloe Puton—thank you for making this book look amazing. It is a privilege to make books that matter with this team.

ABOUT THE AUTHOR

KATE T. PARKER is a mother, wife, former collegiate soccer player, Ironman triathlete, and professional photographer who shoots both fine art projects and commercial work for clients across North America. She is the author of five bestselling books, including *Strong Is the New Pretty*, *The Heart of a Boy*, and *Play Like a Girl*. Her *Strong Is the New Pretty* photo series has led to collaborations with brands like Athleta, Kellogg's, Oxygen, and Girls on the Run. The project has also inspired Kate to launch a philanthropic arm of *Strong Is the New Pretty*, partnering with organizations that invest in girls' health and education. She lives with her family in Atlanta, Georgia. For more, visit katetparker.com.